A
STUDY
OF
Vermeer

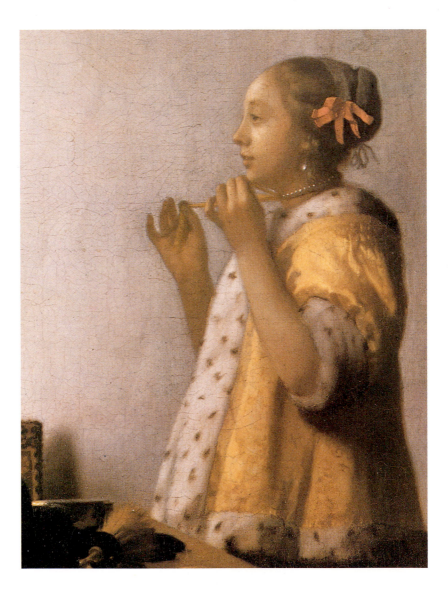

Woman Putting on Pearls (detail of 57).

A
STUDY
OF
Vermeer

REVISED AND ENLARGED EDITION

EDWARD SNOW

UNIVERSITY
OF CALIFORNIA
PRESS
BERKELEY
LOS ANGELES
OXFORD

University of California Press
Berkeley and Los Angeles, California

University of California Press, Ltd.
Oxford, England

© 1994 by
Edward Snow

Library of Congress Cataloging-in-Publication Data

Snow, Edward A.
 A study of Vermeer / Edward Snow.—Rev. and enl. ed.
 p. cm.
 Includes bibliographical references (p.) and index.
 ISBN 0-520-07130-1 (alk. paper).—ISBN 0-520-07132-8
(pbk. : alk. paper)
 1. Vermeer, Johannes, 1632–1675—Criticism and interpretation.
 I. Vermeer, Johannes, 1632–1675. II. Title.
 ND653.V5S66 1994
 759.9492—dc20 92-21860

The publishers wish to acknowledge with gratitude
the contribution provided by the
Art Book Fund of the Associates of the University of California Press,
which is supported by a major gift from the Ahmanson Foundation.
In addition, a contribution from an anonymous donor
has helped support the special color work in this book.

Printed in Korea

9 8 7 6 5 4 3 2 1

CONTENTS

ILLUSTRATIONS

ILLUSTRATIONS

PREFACE TO THE NEW EDITION

Writing tends to be a way of getting something out of one's system. It is difficult to go back to old loves and old selves, especially after they have been committed to discourse. But both Vermeer and *A Study of Vermeer* have proved different in this respect. In the years since the book's completion, Vermeer's paintings have retained their hold on me and have encouraged continual rethinking and return. Hence this newly enlarged version of the book, which incorporates a process of revision that has been going on more or less continuously for the past fifteen years. Most often the catalyst for rethinking has been a detail overlooked in the original study and belatedly perceived as crucial—the mysterious shadow on the background wall of *Young Woman at a Window with a Pitcher*, for instance, or the barred reflection in the window of *Girl Reading a Letter at an Open Window*, or the column of light that rises from the footwarmer in *Woman Pouring Milk*. Sometimes it has been something discussed in the first version but insufficiently observed there—the grip of the gold coin in *The Procuress*, or the cropped painting in *Couple Standing at a Virginal*, or the background the map provides in *Artist in His Studio*. Almost everything new about this second version of the book has originated in some small, specific perception. And each new perception has required additions and adjustments to the book's larger argument, which concerns Vermeer's negotiations between skepticism and belief, distance and connection, desire and restraint—all those opposites out of which his paintings achieve their equilibrium.

The long process of rethinking *A Study of Vermeer* has included countless exchanges with friends and colleagues; to them I would like to acknowledge a general indebtedness, since over the years the disagreements and the shared outlooks have blurred into a single conversation. I would also like to acknowledge two specific debts. The first is to Yvonne Fern and Winifred Hamilton, who during the actual process of rewriting forced me to steer a

narrow course—the one urging me not to betray the book's original voice, the other encouraging me to curb its excesses. Both were endlessly generous in their willingness to serve as controls, as well as to help with particularly knotty passages. A second and heartfelt debt is to the undergraduate students at Rice who have studied Vermeer with me over the past ten years. They have continually provided fresh eyes and rekindled old enthusiasms. Much of what is new in this revised version of *A Study of Vermeer* derives explicitly from their perceptions. I am especially indebted to Linda Lee Cox (for the overall reading of *The Concert*), Neil Liss (for the sense of "slippage" in *Couple Standing at a Virginal*), Katharine Eggert and Dianne Morrow (for the way hands work in *The Procuress* and *Soldier and Young Girl Smiling*), Karen Wishnev (for a Magritte-like effect in *Artist in His Studio*), Katie McCoskrie (for the kinetics of *Girl Reading a Letter at an Open Window*), Harry Wade (for the poetry of the reflected image in that same painting), Melissa Rawlins (for the shadow-hand in *Woman Holding a Balance*), and Lia Hotchkiss (for oneiric elements in *Girl Asleep at a Table*). There are doubtless other students whose ideas have more deviously mingled with my own, and who equally deserve acknowledgment here. To them I offer my thanks as well as my apologies. In *To the Lighthouse* Lily Briscoe muses (thinking of Mrs. Ramsay) that "one wanted fifty pairs of eyes to see with." Not a class on Vermeer has gone by without that statement coming to mind. Even as I write this preface the next year's seminar on Vermeer is scheduled, and I wait to be startled into seeing something new again.

Edward Snow
November 1992

PART ONE

HEAD OF A YOUNG GIRL

The evening is deep inside me forever.
Many a blond, northern moonrise,
like a muted reflection, will softly
remind me and remind me again and again.
It will be my bride, my alter ego.
An incentive to find myself. I myself
am the moonrise of the south.

 PAUL KLEE, *The Tunisian Diaries*

Those are pearls that were his eyes.

 SHAKESPEARE, *The Tempest*

PAUL KLEE SPOKE of a moment in the act of painting when the free inspiration of the artist must yield to the demands of the thing coming into being. He described it as the moment in which the painting acquired a face. "Now it looks at me," he would declare. But in *Head of a Young Girl* [1] it is as if Vermeer undertakes to paint this threshold, and prolong the act of looking-back across a void. Imagine sitting before your easel with brush in hand and watching *Head of a Young Girl* with each deliberate, self-effacing stroke of paint slowly materialize on (or emerge from) the empty canvas, finally to confront you with *its* look, across the arm's length that defines both your physical and metaphysical distance from it.

Perhaps this passionately unrequited face looks at us from all Vermeer's most cherished canvases, even though it has been veiled with images of sufficiency and calm. Perhaps it is the face that art itself is meant to mask.

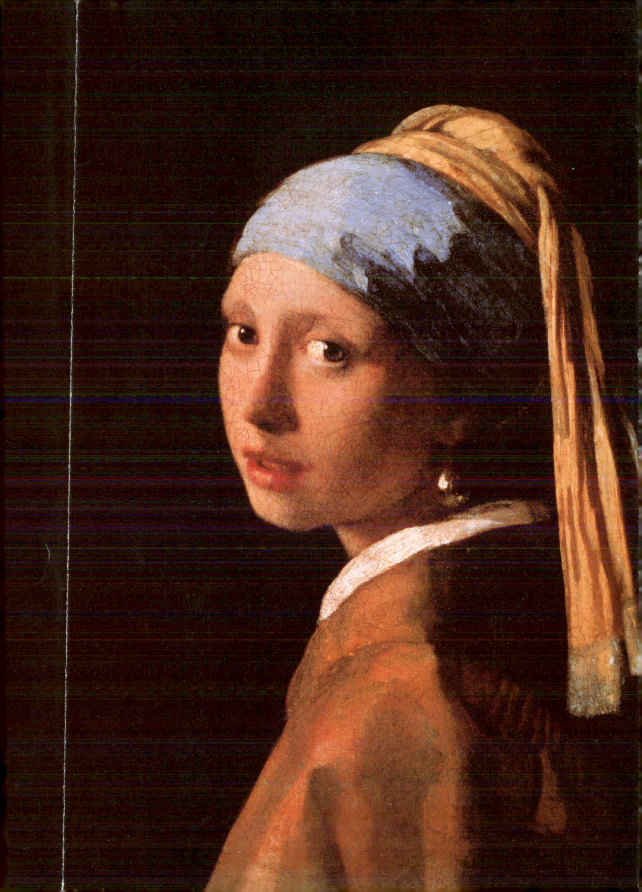

1. OVERLEAF Vermeer: *Head of a Young Girl*.
18¼ × 15¾ in. Mauritshuis, The Hague.

IT IS THE BEAUTY of this portrait head—its purity, freshness, radiance, sensuality—that is almost always singled out for comment. Vermeer himself, as Gowing notes, provides the metaphor: she is like a pearl.[1] Yet such a response, however accurate, evades the issue of the painting. For to meet this young girl's gaze is to be implicated in its urgency. To take that instinctive step backward into aesthetic appreciation would seem in this case a defensive measure, even an act of betrayal or bad faith. It is *me* at whom she gazes, with real, unguarded human emotions, and with an intensity that demands something just as real and human in return. The relationship may be only with an image, yet it involves all that art as "beauty" is meant to keep at bay.

Faced with an expression that seems *already* to have elicited our response, that not only seeks out but isolates and takes possession of our gaze, we can scarcely separate what is visible on the canvas from what happens inside us as we look at it. Nor do we really want to. Indeed, it seems the essence of the image to subvert distinctions between seeing and feeling, to deny the whole vocabulary of objective and subjective experience. Few paintings hold their viewers so accountable. Deprived of distance and context, placed at the extreme verge, one finds oneself straining to stay open to the image, to sustain it in view. And in this effort—to hold her here, to let her penetrate or break free—one grows complicit with the painting's own impossible desires.

The experience of *Head of a Young Girl*, for all its singleness of impact, is one of unresolved, almost viscerally enforced contradictions. An intimate mirroring that is also a passionate estrangement. A yearning—patient, gentle, yet all-engulfing—composed equally of desire and renunciation. An accomplished image that evokes with almost Michelangelesque force the sense of art as an urging on of "the hard beauty that finally coagulates from the endless ceremonials of sadness";[2] yet a fragile apparition at whose edges *Macbeth*'s witches might be chanting: "Show his eyes, grieve his heart,/ come like shadows, so depart."

The common element in these tangled feelings is a grief that seems lodged in vision. Loss seems, if not the subject, then the medium of the painting, the stuff from which its image forms. (As if to add: "Yet how like a tear that pearl.") She may reach out to us as an icon of desire, but sorrow is the element in which she takes shape and from which she is never really freed. Her eyes sharpen the underlying mood into something poignant and piercing, and focus it on the artist/viewer with a mixture of reproach and regret that isolates and utterly discloses him.[3] The act of looking is haunted here by suggestions of violation and betrayal, and by a certain attendant guilt.

Yet everything that cuts so quickly is at the same time softened on the threshold of a strangely sensual letting-go. A startled expression that mingles pain, apprehension, and bewilderment (it might almost have been wonder) dissolves, in the moment it registers, into a wistful, languidly acceptant look of understanding and relinquishment. That acceptance, however, only tightens the knot from which she would release us. Her eyes accuse yet have compassion, offer consolation yet give expression to the very wishes of which the heart despairs. They capture the present instant in the foreground and expand it, yet at the same time signal to us from the distance into which she already recedes.

The solipsism and sharp emotion in which *Head of a Young Girl* involves us seems at odds with the reserve Vermeer's art normally requires of its viewer. Consider, for instance, *Woman in Blue Reading a Letter* [2]. It is only natural to wonder whom the letter of that painting is from, and what its contents are, and how the depicted woman feels as she reads it. If the painting were by another Dutch artist, experiencing the work would consist largely in piecing together the story of these things. But to seek such answers in *Woman in Blue Reading a Letter* seems an imposition, an inability to let things be. Vermeer's painting evokes the prying, domesticating tendencies of the imagination only in order to subdue them. The letter, the map, the woman's pregnancy, the empty chair, the open box, the unseen window—

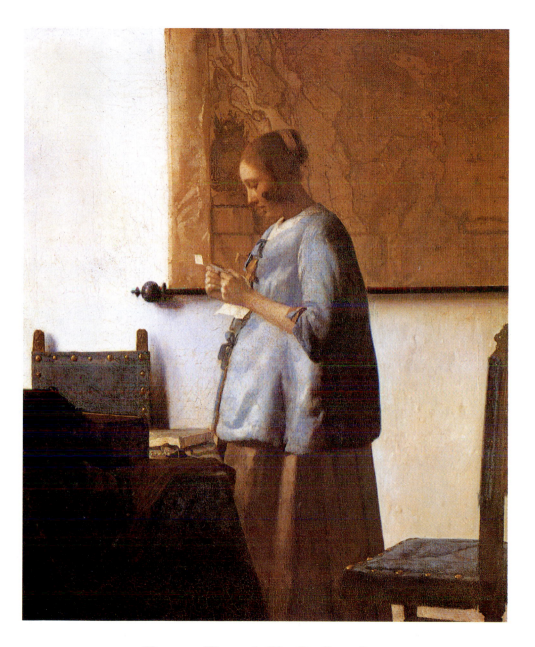

2. Vermeer: *Woman in Blue Reading a Letter*.
18¼ × 15½ in. Rijksmuseum, Amsterdam.

all are intimations of absence, of invisibility, of other minds, wills, times and places, of past and future, of birth and perhaps loss and death. Yet with all these signs of mixed feelings and a larger context, Vermeer insists on the fullness and sufficiency of the depicted moment—with such force that its capacity to orient and contain takes on metaphysical value.[4]

And although a core of human inwardness holds the world of *Woman in Blue* in place, what Vermeer stresses is the private, inaccessible nature of that experience, constructing a veritable force field around its otherness. Strangely, the result is not so much remoteness as imaginative influx. Life comes uncannily close. The eyes, accepting distance and what might seem an impersonal view, unwittingly incorporate horizons. They bear the space of the letter-reader's world. Her pregnancy, without ceasing to be actual, becomes an emblem for the fullness of inner life that requires our acceptance of her as other than ourselves.[5] It counters longing and nostalgia with a stable present that bears within itself the assurance of a continuous future. But if we attempt to force a story out of *Woman in Blue*, we violate our agreement with the painting and become voyeurs peering into a world that our own gaze renders distant and superficial.

Vermeer himself constructs just such a viewing experience in *The Love Letter* [3]. That painting, as the anecdotal title it has come to be known by suggests, encourages by its very structure the prying interest that most Vermeers transform. Its shallowness as image seems inseparable from the claustral gaze for which its interior scene exists.[6] (The framed view can even appear to lie flush with the doorway, as if it were another painting or an image in a mirror, not an opening at all.) Against this painting's ensconced narrative curiosity, the unobtrusive background wall in *Woman in Blue Reading a Letter*, suffused with blueness where the letter reader reads, might serve as a truer instance of the rapport toward which vision in Vermeer aspires.[7]

Yet the empathy that other Vermeers instill seems strangely inapposite when one turns to *Head of a Young Girl*. We are farther than ever from the anecdotal, yet suddenly the most personal responses, drawn from the most private, well-protected regions of the self, are required. Against the sense

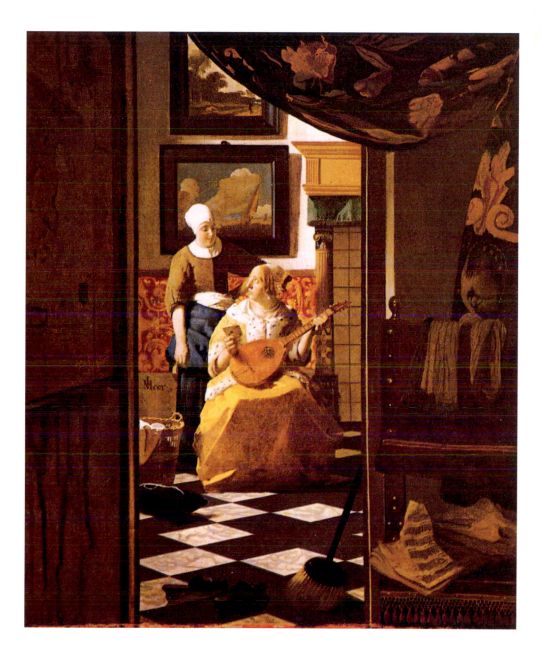

3. Vermeer: *The Love Letter*.
18¼ × 15¾ in. Rijksmuseum, Amsterdam.

of timelessness and autonomy one associates with Vermeer's work, *Head of a Young Girl* insists on our involvement in something that is happening now, in a viewing instant that reaches toward us instead of taking root in self-contained space and time. Gone is the measuring, the stepping back, the weight and comfort of context; instead we are confronted with an immediate relation that spans an unquantifiable abyss of distance.

The painting appears to resist, even protest against, the division into inner and outer, self and world, artist and work that the other Vermeers, by so radically accepting, so strangely transcend. *Woman in Blue Reading a Letter* is like a wish-fulfillment of the artistic impulse itself. There, viewing consciousness is released from the perspective of the isolated self and reabsorbed into the field of vision. It becomes invested with reality, located in being.[8] But the impetus of *Head of a Young Girl* is in the opposite direction, toward a confrontation with the desire that engenders it. Instead of granting us invisibility, it exposes us to—and in—the light of our own transgressive vision. Art here intensifies rather than eases the sensation of consciousness as hermetically opposite itself. (The expression on her face becomes, in spite of the disruptive otherness of her presence, the look of how *we* feel as we look at her.)[9] The image with which it confronts us is disorientingly immediate, inward, *pre*subjective. She seems to exist inside the eyes as well as at the end of their gaze. Yet the result is to make us only that much more self-conscious of our solitary presence outside the frame, concentrated in an exchange of emotional energy with an image that looks back at us from the other side of a metaphysical divide. Does the desire maintained across this threshold seek to draw her out of the canvas, or to follow her over into the realm into which she recedes? If it is our life that makes her real, it is her vibrancy of being (as image, as art) that we lack, and long for.

The creator of the *Mona Lisa* was able to boast that "if the painter desires things of beauty to enchant him, he alone is the master to create them." But *Head of a Young Girl* acknowledges all that is delusive as well as compelling about such investment in art's powers. The *Mona Lisa* serves as a vantage point from which Leonardo, hidden behind his work, can confront his audience with the enigma of his creativity. But there is no place apart

(for audience, author, or created thing), no sense of final arrival, in *Head of a Young Girl*. The impact of the image derives in part from a sense of its own inadequacy, even from a sense of the futility of creation itself. If the quotation from Klee chosen as an epigraph for this chapter underscores the sense of imminent promise that enlivens *Head of a Young Girl*, the following passage from Nietzsche touches on its passionate despair:

> "For me, the dearest thing would be to love the earth as the moon loves it, and to touch its beauty with the eyes alone"—thus the seduced one seduces itself. . . .
>
> Where is innocence? Where there is will to begetting. And for me, he who wants to create beyond himself has the purest will.
>
> Where is beauty? Where I *have to will* with all my will; where I want to love and perish, that an image may not remain merely an image.
>
> Loving and perishing: these have gone together from eternity. Willing to love: that means willing to die, too. Thus I speak to you cowards!
>
> But now your leering wants to be called "contemplation"! And that which lets cowardly eyes touch it shall be christened "beautiful"! Oh, you befoulers of noble names!
>
> But it shall be your curse, you immaculate men, you of pure knowledge, that you will never bring forth, even if you lie broad and pregnant on the horizon.[10]

• • •

Vermeer, despite the images of repose and wholeness that appear to dominate his work, is one of the most dialectical of painters. His greatest paintings generate conviction in an objective order of things permanently achieved, yet balance against that the impression of a world tenuously poised, as in some Rilkean hand. Images of full presence invoke feelings of

absence and aloneness; opening on the here and now yields to the impression of a remote, already encapsulated world of the perfect tense. Completeness of being resonates with evanescence and impending loss; an atmosphere of timelessness evokes thoughts of life passing, and passing by. One has only to study the "poetry of brick and vapour, resistance and penetration"[11] in *A View of Delft* [4], or the calculated play in so many of Vermeer's interior scenes between things distant and near, horizontal and upright, open and closed, heavy and light, suspended and at rest, to realize the extent to which such tensions inhere in the very fabric of his world.

Woman Pouring Milk [5], for example, is a melody of contrasting textures. The pair of hanging baskets [6] provides the key: rough and smooth, hard and soft, woven and molded, curved and angular, open and shut. They even initiate opposing vectors: one tilting downward toward the footwarmer on the floor,[12] the other jutting outward toward the pitcher pouring milk. Similar oppositions create the weave, the weft and warp, of the painting. Consider especially the shifting interplay of organic and manufactured forms (the bread and milk against the containers and the table; the wicker basket against the metal one; or both baskets against the footwarmer), or the counterpoint between various states of suspension (the hanging baskets and the cradled pitcher suggest contrasting modes) and groundedness (the things on the table evoke one mood, the footwarmer another), or the downward progression through things at hand (the baskets on the wall), in hand (the pitcher pouring milk), and abandoned, out of reach or ken (the footwarmer on the floor). Such patterns subsume even material presence within a network of differential aspects and imply a concern with ontological categories embedded in the object-world.

The same is true of time and place. The setting of the painting is a neglected and impoverished-looking corner of the mundane world, yet what one discovers there feels like a still and mythical center, plentiful and self-replenishing.[13] The painting depicts a moment lifted from the present, suspended in eternity; yet the steady fall of milk and the light that floods the rear wall make time a visible element. The bread, the milk, and the morning light suggest newness and pristine, regenerative beginnings; but

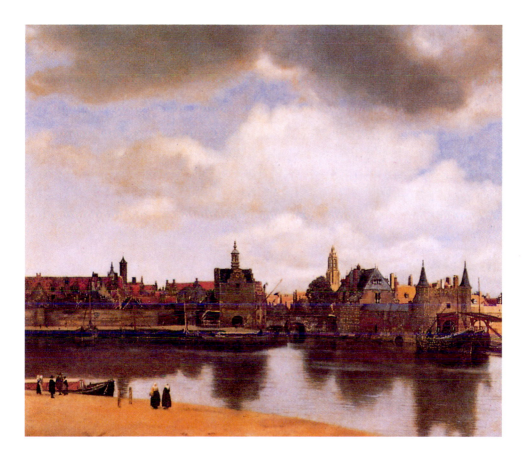

4. Vermeer: *A View of Delft*.
38½ × 46¼ in. Mauritshuis, The Hague.

the deterioration beneath the windowsill is a sign of unchecked temporal erosion, and the rear wall, with its holes where nails once protruded and its nails where objects once hung, provides a background of absence, provisionality, and disrepair.

Even the woman's solid, reassuring presence subsumes opposing aspects. Most obvious, perhaps, is the sense of contrast between her muscular forearms and her featherlight touch—itself contradicted by the jug's obvious weight. The expression on her face is similarly multiple. Concentrated and diffuse, focused on a task and lost in thought, conveying at the same time rapture, contentment, and measured detachment, it condenses complex feelings about being part of a world that is itself an intricate commerce of things inner and outer, visible and unseen.

The terms of that world comment on her presence. Note the elaborately contrasted images of things open and closed (the brass and the wicker basket, the pitcher and the standing jug, the whole and the broken loaf), full and empty (the basket on the table and those fastened to the wall, the blue overskirt and the cloth hanging from the table, the dense bread and the cavernous jug); and of interiors disclosed and concealed (the lifted overskirt and the covered table, the pitcher and the standing jug again, different aspects of the footwarmer), unknown (the standing jug) and known on trust (the table under the tablecloth, the emptiness of the hanging baskets). These counterpointed objects are like facets of a meditation on both the woman's presence and the "worldness" of the world.

Bachelard's words cast light on this painting and Vermeer's entire universe: "On the surface of being, where being *wants* to be both visible and hidden, the movements of opening and closing are so numerous, so frequently inverted, and so charged with hesitation, that we could conclude on the following formula: 'man is half-open being.' "[14] One of the bafflements of Vermeer's art is how it can be so attuned to the ambiguities and evasions of this half-open realm, yet bring icons of quiet assurance into being and secure them in a world that seems fully present to the viewer, *before* the eyes in both space and time.

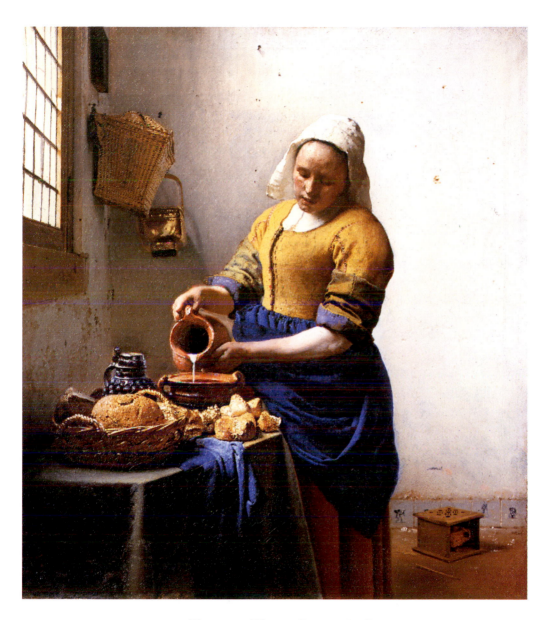

5. Vermeer: *Woman Pouring Milk*.
18 × 16⅛ in. Rijksmuseum, Amsterdam.

But the tensions of *Head of a Young Girl*, instead of spreading over the "zone of emotional neutrality"[15] in which Vermeer usually suspends his subjects, converge on a threshold of dynamic unrest that insists on the viewer's direct involvement. Instead of feeling an agreement between things distant and near, we experience a conflict between emergence and recession. In place of a detached meditation on what passes and abides, we are given immediate, almost visceral sensations of intensification and easing, quickening and fading, clutching and letting go, labor and deliverance, suddenness and attenuation. And if in the other Vermeers we fill the absence left by the artist's effacement from (or disappearance into) his work, here we occupy his place inside the act of painting. This is the face that *Vermeer* nursed toward being, the face that unblinkingly returned his gaze. The same gaze now meets ours, caught at the edge of becoming or escaping.

These vitally intermixed feelings are given form by a complex set of oppositions, which both structure *Head of a Young Girl* and help secure its hold on us. They become the means by which the spectator, that always belated one, is woven into the primal moment of becoming (and becoming other) where artist and image still face each other in desire [7]. Let us consider these oppositions, pair by pair:

THE EYES AND THE LIPS. One can see the mouth as "abject and patient,"[16] the parted lips suggesting expiration or acquiescence; yet the eyes counter this impression by seizing the foreground and holding there, anxious, startled, demanding. But these same eyes can appear wistful, somnolent, already remote as they recede into the darkness. Then the lips come into the foreground vibrant with anticipation, parted, like those of Hermione's statue ("The very life seems warm upon her lip"),[17] on the threshold of an impossible first breath with which art would emerge—responsively, redemptively—into articulate human life. While these oscillations do cohere in a single, inescapable expression, they do not resolve. It is difficult, if not impossible, to read either urgency or acquiescence in *both* the eyes and the lips at the same time.

14

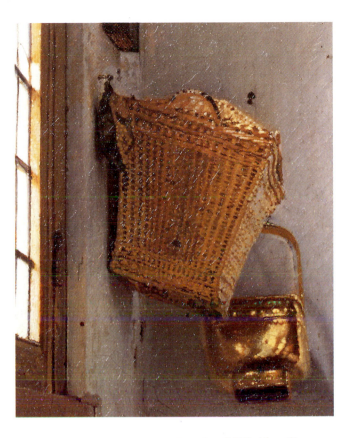

6. Vermeer: *Woman Pouring Milk* (detail).

Their interplay also holds suggestions of an erotic conflict. The appeal of the lips is frankly sensual; their vibrancy is carnal, and their invitation is not to sight but touch ("Good my lord forbear; / The ruddiness upon her lip is wet; / You'll mar it if you kiss it; stain your own / With oily painting"). But the eyes reach out to consciousness, and to conscience. They posit the charged distance between looks that meet, and at the same time express (it is eyes, not lips, that are agents of articulation here) all those inward, isolating apprehensions that hold one back. The impulse to identify the subject of the painting as Vermeer's daughter is understandable, even though everything about the image conspires to define her *here*, in *this* everpresent instant, abstracted from any reference to the world beyond. The erotic im-

15

mediacy of the painting—the sense of something private that it both does and does not consummate—seems to long to transgress fundamental distances, to undo renunciations which real life demands.

THE FACE AND THE HEAD. There is something strangely twin-aspected about this portrait head. Vermeer has managed to impart to the head itself a presence subtly detached from, even at odds with, the face stamped on its surface. Cover the face and what remains will promise something much closer to a profile than what actually confronts us. A force appears to be striving (from within or beyond?) to pull the face round toward a frontal view, and flatten it against the surface of the canvas, as if in resistance to the head's own tendencies to turn away into its own shadowed world. The head withdraws from us like the dark side of the moon: remote and impassive, mysterious yet impenetrable, calmly indifferent to the human concern with personality, expression, and inwardness.

The face, on the contrary, withholds nothing. It lies vulnerable and exposed on the surface of the canvas, despite the logic of the three-quarter view—open, beyond secrecy or evasion, possessed by a candidness that seems imposed, not chosen. (In this, again, the *Mona Lisa* is her opposite.) And the face seems entirely, unreservedly a response to the presence of the artist/viewer: it might almost be imprinted by the light that seems to come from our side of the canvas, charged with the hunger for expression that originates with us. Between this expressive immediacy determined by the facing presence of another, and the aloof, monumental impersonality of the head that bears it, there seems no middle ground for the securely inhabited, self-possessed interior dimension that is time and again the subject of Vermeer's work.[18]

The surrounding black accentuates this feeling. Its very application seems a gesture of denial: the enameled-on paint counters the canvas's porous, receptive qualities. It ruthlessly defines the face as an image on a surface, making the young girl stand out magically but refusing to support the fiction of her presence. There seems no matrix here, no "space" where subjects lend themselves or images take refuge.

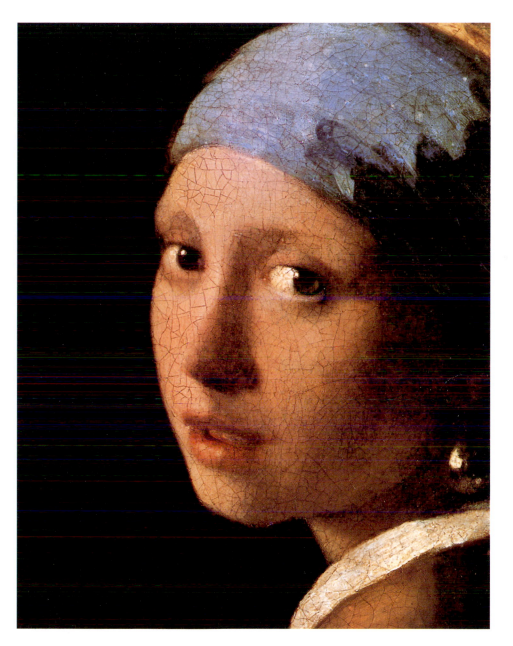

7. Vermeer: *Head of a Young Girl* (detail of 1).

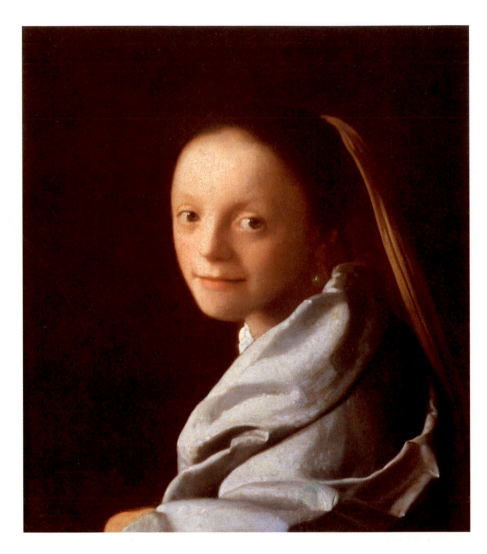

8. Vermeer: *Girl with a Veil*.
17¾ × 15¾ in. The Metropolitan Museum of Art, New York.
Gift of Mr. and Mrs. Charles Wrightsman, 1979.

The background of Vermeer's later but closely related *Girl with a Veil* [8] defines by contrast what is at stake. The subject here too is a "daughter," and lacks just as radically any context other than our vision. But now the canvas is admitted and can accept the image: its weft visibly soaks up the black paint that frames the young girl, just as she absorbs the conscience-calmed light that her blue garment wraps tenderly around her. She is even given an arm and hand with which to pose herself against the lower frame. This painting—its context still mutual vulnerability and the viewer's look—seeks to convert unrest into trust, apprehension into reassurance, the desire for beauty and perfection into a loving acceptance of what is flawed. It accepts necessities—perhaps even bestows the grace—that *Head of a Young Girl* passionately refuses.

THE TWO PARTS OF THE TURBAN. The turban, like so many of the inanimate objects in Vermeer's paintings, gathers up invisible, half-sensed elements that resonate at the human center—in this case, the viscerally felt grief and desire, capture and release. Its knotted portion is wound in tight repetitions—as if to define, contain, defend, hold tightly to the pearl-like integrity of the head. The pendant, however, lies outside the compulsion to conserve and/or repeat: it falls, once and for all, out into the element of gravity—yet remains attached to the knot from which it issues. And this polarity between the two parts of the turban is itself unstable; there is a stiffness about the pendant that undermines the release and self-abandon of its fall, whereas the knot folds softly in upon itself with lotuslike contentment. The pendant, moreover, falls slightly forward and to the right, subtly in tension with the vertical it seems at first glance to define.

The resulting dynamic both compounds and complicates the strains within the portrait head itself. The deviation from the vertical by the pendant imparts a torsion to the head: we tend to perceive the young girl as turning toward or away from us (and in either case resisted by a force acting either upon or from within her) rather than confronting us like an icon. And against the tendency of the brilliant yellow of the spreading counterweight

to surge forward into the light, and thus rotate her away from us into the void at the left, the limpid, absorptive blue that wraps her head recedes in circles toward the shadows at her neck, holding her face steady, turning it tenderly toward the light.[19]

As the yellow of the pendant opens in the light that rakes the canvas, the object's bright surface provides a counterpoint to the ambiguities of exposure and manifestness that haunt the face. (A right-hand strip of blue borders the yellow, as if to mimic the way the shadowy left cheek cradles the young girl's visage.) But the inert pendant responds to the light with a brightness less equivocal than that of the enlivened face. Both are extreme definitions of the foreground, yet the face seems to hesitate on a plane just behind the falling part of the turban. Compared to the way the yellow of the pendant stands out against the background, the face seems to shrink from us, clinging to the head, attempting to wrap itself around it like the blue circles of the turban. The pendant, in its featurelessness, in its immunity to the human gaze, achieves the foreground and the light beyond with a completeness that the face, more vulnerable and responsive, can never quite manage—even when the forces that strive to bring it to the surface are felt to be most strenuously engaged.[20]

THE "TEAR-LIKE" PEARL. The pearl is suspended in a quiet recess of illusionary space, spared the conflicts that charge the surface of the canvas.[21] It hangs free, yet at the same time nestles up against the hollow of the neck—tentatively evoking, in a painting that sets extremes of immediacy and remoteness against each other, the reassurances of a benign middle distance. We normally think of Vermeer's entire world as inhabiting such a space. One could entertain—if as nothing more than a heuristic fancy—an analogy between this pearl and that world, and think of the painting as a mapping of the vast, restive forces within which such images of seclusion as *Woman in Blue Reading a Letter* are suspended. Reduced by the light to scarcely more than a liquid glimmer (a few touches of paint create it on the canvas), it yet hangs there as a concentration, a condensa-

tion—of value as well as substance. It alone of all the elements achieves a stabilizing vertical; and in its pull against the delicate register of the ear-lobe—it hangs much farther from the ear than Vermeer's other pearls and in contrast to their ovoid shape tends in its drop toward the heavy fullness of a sphere—it conveys an experience of weight and volume in many ways more convincing than the turban's massive fall.

The transformation of this pearl into tear-likeness generates tensions that lie near the heart of the painting. The pearl is hard, durable, complete; while the tear it resembles is fragile, momentary, always in process. The one is the sign of grief, a cathartic rending outward; the other coalesces around something invasive, evoking the slow, enclosed time of gestation and self-reparation.[22] As a tear it clings precariously to the human subject ("It seems she hangs upon the cheek of night"), bonded to a disruption of the inner life; as a pearl it hangs exotically apart ("as a rich jewel in an Ethiop's ear"), an object of desire and a counterweight to human imperfection and its sudden, wrenching needs.[23]

There is, moreover, within the metaphorical tear a dialectic of vertical pull and spherical insistence that mirrors and inverts the dynamic of the turban. While the tensions that gather in the circles of the turban are knotted and then released in the pendant's fall, the pearl/tear grows weightier as it descends through the spherical resistances that strain against it. Against the finality and release of the turban's plummet, the pearl/tear suggests a deferred or suspended inevitability and marks the precarious, charged threshold of the about-to-fall. It thus locates in microcosm the dialectic between fullness of being and imminent loss that broods over *Head of a Young Girl*. Pregnant and heavy (even overfull, as if the moment of its natural fall were past), it appears held in the space of its last possible instant, as if one might value it there as something whole and autonomous yet preserve its link with the subjective experience that coins it. Another instant and it will break free, attain the purity of the sphere; yet that will be the moment of its fall, away from attachment and toward its own dissolution—to be the cause of yet more grief.[24] (From the way Vermeer has emphasized its dis-

21

tance from the ear, and all but erased what holds it there, it might already be falling.)[25]

At the threshold of this fall, the lateral, temporizing force of metaphor intervenes, not so much annulling as diverting it: the tear is displaced from eye to ear and "figured" as a pearl.[26] The passage from transience to permanence, from expression to creation, from personal sorrow to a hard, impersonal beauty, is thus achieved. But in the process the pearl takes on the qualities of what is elided in it. Its tear-likeness betrays, in the very place of art's triumph, a reluctance and a powerlessness at the heart of art's transformative urges. It condenses, renews, and gives visible form to the grief transcended in it. In this it is like *Head of a Young Girl* itself, where the author's parental care for his creation, already overdetermined by the erotics of image-making, becomes implicated in an unwillingness to let go, to deliver over into iconicity and otherness. It is as if there can still be felt within the finished painting a conflict between the slow, loving, self-forgetful time of bringing it into being and the spectatorial instant of confronting it as an accomplished work of art, immaculate, closed, apart, abandoned at the threshold of life. A desire to remain lost in an open, endlessly prolonged act of creation fuses with the knowledge that painting is from the first an act of parting, and that those who make art are destined to confront not just love and new life but death, loss, and subjective isolation.

One recalls that Plato banished the poets from his ideal state not just because they trafficked in falsehoods and created only images of things, but also (as if there were a connection) because they dwelt on sorrow and went out of their way to keep loss fresh. *Head of a Young Girl* might for all the world be the image etched on the retina of Orpheus as he looked back to make sure that Eurydice was still there behind him. Yet while we look, can there be any question of priorities, whatever unrest this image stirs? In front of perhaps no other painting is there such a feeling that what one desires has been found. We lack only the means to reach.

PART TWO
ART
AND
SEXUALITY

In public we had our little
collusions; a wink would be enough.
In a store, in a tea-shop, the
salesgirl or waitress would seem
funny to us; when we left, my mother
would say: "I didn't look at you.
I was afraid of laughing in her face,"
and I would feel proud of my power:
there weren't many children who could
make their mother laugh just by a look.
We were shy and afraid together.
One day, on the quays, I came upon
twelve numbers of Buffalo Bill that
I did not yet have. She was about to
pay for them when a man approached.
He was stout and pale, with anthracite
eyes, a waxed moustache, a straw hat,
and that slick look which the gay
blades of the period like to affect.
He stared at my mother, but it was to
me that he spoke: "They're spoiling
you, kid, they're spoiling you!"
he repeated breathlessly. At first
I merely took offense; I resented such
familiarity. But I noticed the maniacal
look on his face, and Anne Marie and I

were suddenly a single, frightened girl
who stepped away. I have forgotten
thousands of faces, but I still re-
member that blubbery mug. I knew
nothing about the things of the flesh, and
I couldn't imagine what the man wanted
of us, but the manifestation of desire
is such that I seemed to understand,
and in a way, everything became clear
to me. I had felt that desire through
Anne Marie; through her I had learned
to scent the male, to fear him, to
hate him. The incident tightened the
bonds between us. I would trot along
with a stern look, my hand in hers,
and I felt sure I was protecting her. Is
it the memory of those years? Even now,
I have a feeling of pleasure whenever
I see a serious child talking gravely
and tenderly to his child-mother.
I like those sweet friendships that
come into being far away from men
and against them. I stare at those
childish couples, and then I remember
that I am a man and I look away.

JEAN-PAUL SARTRE, *The Words*
(trans. Bernard Frechtman)

I

PAINTERLY INHIBITIONS

OF ALL MODERN PAINTERS, it is Degas who has most to tell us about Vermeer. The comparison could be sanctioned on technical grounds alone, yet what most profoundly links the two artists is an emotional affinity. In both there is a curiosity about female realms and rituals, an emphasis on the distance that separates the artist/viewer from them, and a deep erotic investment in the aesthetic space that results from such preoccupations. The nudes of Degas's last period, especially, seem in their quietly charged solitude to answer to the same emotional and psychological pressures that underlie Vermeer's depictions of female privacy. Given this affinity, it is initially disconcerting, then gradually revealing, to find that Degas's nudes have been traditionally viewed as the expressions of a misogynist. No one would think of attributing misogynistic impulses to the painter of *Woman Pouring Milk*; yet the issues involved in this misinterpretation of Degas relate directly to Vermeer's achievement.

The habit of viewing Degas's nudes as acts of aggression and contempt originates with his contemporary J. K. Huysmans, who, projecting the fashionable misogyny of *A rebours* onto the artist, found in the paintings a spirit of "lingering cruelty" and "patient hatred" and characterized them as strategies for degrading women by subjecting them to humiliating postures that expose the sad, graceless flesh beneath cosmetic deceptions.[1] The paintings have proved extraordinarily vulnerable to this account of them; even today it remains, in diluted form, more or less the standard view.[2] The passages below are exceptional only in the degree of subjective energy invested in them:

> There is, with Degas, dried-up will power, and a line that cuts like a knife. . . . The angular and flabby bodies squatting in the pale metal of the tub with its splashing water, render hygiene as sad as

27

a hidden vice. He shows us meager forms with protrusive bones, a poor aspect, harsh and distorted, of the animal machine when it is seen from too near by, without love, with the single pitiless desire to describe it in its precise action, unrestrained by any sense of shame, and without the quality of heroism which might have been given to the all too clear eyes by a lyrical impulse. . . . As soon as his sharp eyes surprise the thinness of elbows, the disjointed appearance of shoulders, the broken appearance of thighs, and the flattening of hips, he tells of all this without pity.[3]

"Painting is one's private life." Thus, in his studies of women, whom he distorted like mysterious and vaguely hostile mechanisms, Degas revealed his true feelings, those of a misogynist and bachelor. . . . One feels ill at ease in front of this too intimate perfection of the features, this analysis which seeks to be objective when in reality it is passionate. . . . Pastels are a precious, worldly technique, well suited to the transience of the thing seen. But here we are far from the appealing charm of the eighteenth-century portrait painters. This naturalism grates, and the attitudes of women washing themselves, drying themselves, and combing their hair in which Degas persisted in his representation of the human body are the secret and pitiful avowals of a solitary man devoid of all kindly feelings.[4]

One can only defend oneself from the half-truths of criticism like this by *looking* at the paintings [9–13], and noting the hesitancy of Degas's approach, the tenderness with which he creates for these women their own bodies, their own privacies, their own solicitous spaces, and the protectiveness with which he insists on measuring and respecting the distance that separates them from him. What these canvases witness is not misogyny but its poignant, complex inverse: the artist's need to absent himself from the scene constituted by his gaze, his attempt to redeem sexual desire by transforming it, through art, into a reparative impulse. It is as if these images are offered to the women themselves rather than to the audience that beholds them. They are rendered as incarnate selves rather than as projected, com-

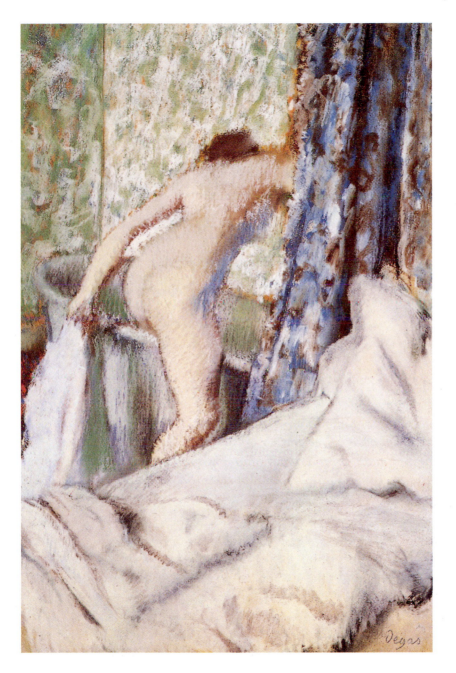

9. Degas: *The Morning Bath*.
Pastel, 27¾ × 17 in.
The Art Institute of Chicago, Potter Palmer Collection.

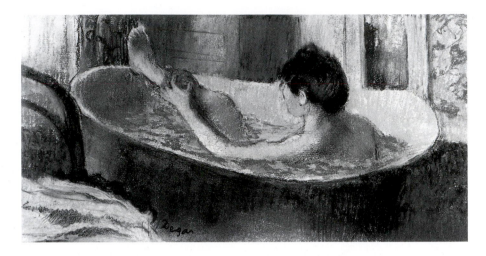

10. Degas: *Woman in Her Bath Sponging Her Leg.*
Pastel over monotype, 7½ × 15¾ in. Musée d'Orsay, Paris.
Photograph from Musées Nationaux.

plicit objects of masculine desire, delivered not only from the male gaze but from any introjected awareness of it. Degas's violation of the traditional canons does not entail, as Huysmans claimed, an aggression on the idea of feminine beauty per se—for again, one has only to look to discover one breathtakingly achieved image after another of poise, balance, grace, and sensual elation—but an insistence on locating it in the woman's own intrinsic experience, in the mundane, unselfconscious life of the body. Even the contortions to which Degas so often subjects his models usually wind up conveying the wholeness of the body and the quiet exhilaration of stretching out or curling up inside it.

Yet something about these paintings does reinforce the idea of Degas as a sterile, isolated "bachelor." Their atmosphere is one of primal discovery and arrival: the realm of grace opens before the artist—but upon moments from which men and all thoughts of men are absent. The erotic intensity of these canvases is predicated on a denial of masculine will, desire, and,

30

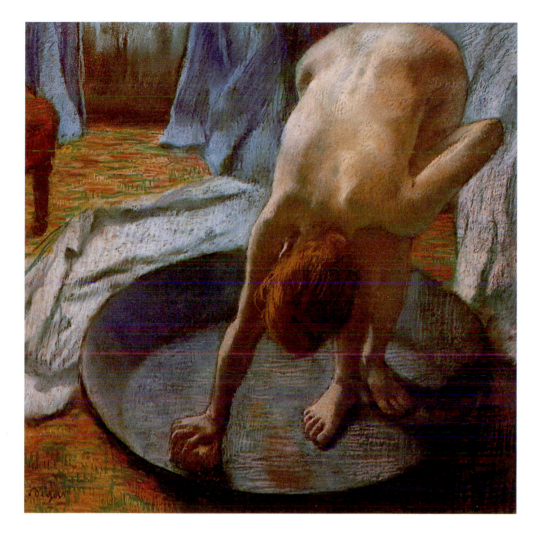

11. Degas: *Woman Standing in a Tub*.
Pastel, 27½ × 27½ in. Hill-Stead Museum, Farmington, Connecticut.

above all, sexual presence. As a result, the sensation of creative fulfillment in these paintings—the way the "handwork" of the pastels seems to recreate the matrix of desire—is haunted by the ghost of someone still there at the threshold, looking on, invisible and excluded.[5]

Robert Greer Cohn has described Flaubert's relationship to his female protagonist in terms that may help us grasp both the resolution these paintings achieve and the spectatorial unease they generate:

> Flaubert, as is well known, had been bullied by his friends into re- nouncing his well-known romanticism, so it came back with a ven- geance, like the banished demon of the Gospels, in this restrained, complex, ashamed, and profoundly accepted form. Keeping his dis- tance from his anima or heroine by cruel lucid irony, the virile cre- ator in him thus paid the price that allowed the timid tenderness to flood back, via a back route, into our unsuspecting and gradually grateful readers' souls.[6]

Degas's objectivity is the inverse of this. The distance that separates him from the women of his paintings is a distance imposed by the artist between his animus and everything conciliatory about his project. It places his sub- jects beyond the reach of the methods and energies through which Flaubert achieves his distance. What can immediately, even unsettlingly, strike one about Degas's nudes (in spite of the fate they have suffered at the hands of art criticism) is how safe they seem, how apart they are in their unguarded self-absorption from any eye that might want to dissect them, distort them, or appropriate them into either sexual fantasy or abstract form. Yet it would never occur to us to remark how "safe" the nudes of, say, Renoir are, even though that may be as true of them as it is irrelevant to the impression they make on us. The capacity of Degas's late nudes to move us has to do with the way they cathect the viewing situation, and subliminally evoke all the guilts and vulnerabilities that attach to it. The temptations of voyeurism and its underlying Oedipal nostalgias are transcended in the creation of scenes untroubled by the onlooker's presence; the impulses to objectify, attack, and

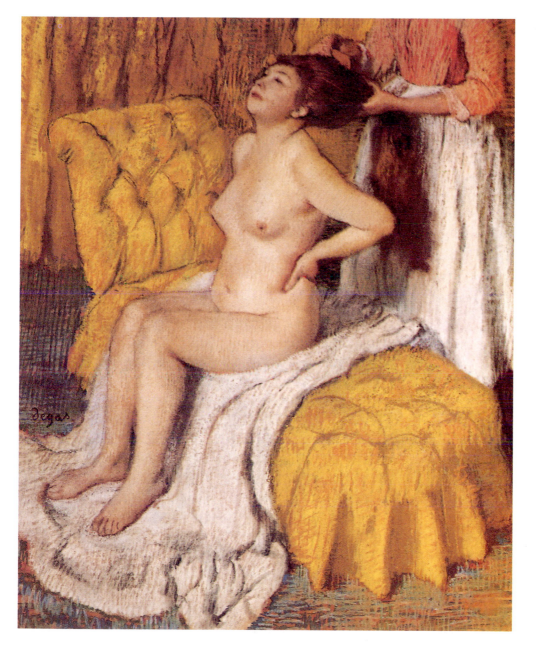

12. Degas: *Woman Having Her Hair Combed.*
Pastel, 29⅛ × 23⅞ in. The Metropolitan Museum of Art, New York.
Widener Collection.

degrade (sometimes the underlying sadistic fantasy is still visible) are made to yield tender acknowledgments of a separate life.

Degas may thus achieve (but for whom, as whom?) genuine liberation of and from the romanticism that in Flaubert (in *Madame Bovary* at least) continues to oppress, in both its mocked and secretly reappropriated forms. Degas's pastels, with their seemingly inexhaustible views of women bathing, washing, toweling, and combing, aspire toward an ablutionary vision. They are like ritual purifications of the space in which they are conceived. Disencumbered of all excrescences of guilt, shame, and embarrassment, the flesh glows with innocence. The imagination breathes (and revels) in an atmosphere that seems clear and new.

Yet Degas was able to achieve this communion with women and with the feminine in himself only by exacerbating at the level of self-commentary the image of the antisentimental, ruthlessly aggressive eye of the male animus. He spoke the language of the modernist male with a vengeance. "I show them deprived of their airs and affectations, reduced to the level of animals cleaning themselves." This is the statement of an artist who knows what his achievement is, but who, in order to paint, has to keep at a distance from it, ward off its threat. What we receive from Degas, as from Flaubert, is a function of something denied by the artist to himself. (And of course "we" are an element of Degas's authorial consciousness, just as "Degas" is a facet of our spectatorial awareness.) But this denial seems for Degas more absolute than it is for Flaubert. Flaubert, through his complex betrayals of his heroine, displaces onto her, or onto the structure of his presentation of her, his own inner conflicts, to the extent that he can say, "Madame Bovary, c'est moi"; while Degas is compelled to stress over and over the unrelatedness to him of the women invited to serve as pretexts for experiments in form and color, even though his relationship to them as artist is one of fidelity and intimate communion.

To turn from Degas to Vermeer is as if to make a final renunciation, and with it take a last step, into finished creation and full, integrated consciousness. Compare, for instance, *Woman Drying Her Feet* [13] and *Woman*

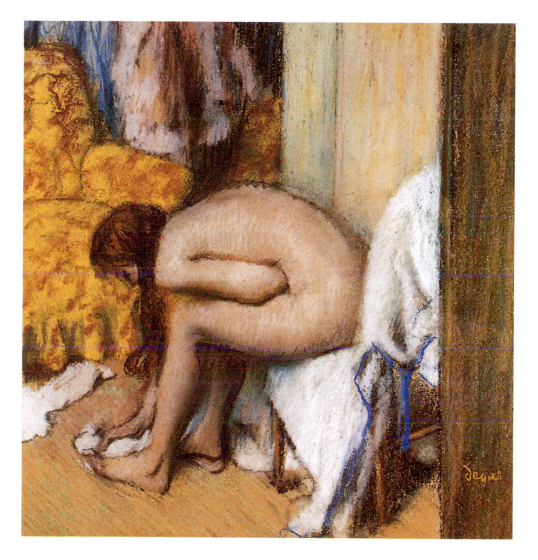

13. Degas: *Woman Drying Her Feet*.
Pastel, 21¼ × 20½ in. Musée d'Orsay, Paris. Photograph from Musées Nationaux.

Holding a Balance [14]—paintings that represent both artists at the height of their achievements. The Vermeer can in comparison seem for a moment almost cold and hard, so uncompromising is its existence as something painted, so complete its autonomy from the viewer's gaze. The pathos of nearness and distance one feels in the Degas—the lingering desire not so much to possess as to prolong, to be there where his vision is—has been transcended in the Vermeer. Indeed, part of the aura of well-being that radiates from the painting has to do with its self-contained celebration of its freedom, its happy sense of itself as something finished and apart.

A letting-go, then, and with it a moment of access and relatedness. Vermeer's distance, although it is as emotionally charged as Degas's, transcends pathos altogether. It becomes the medium of a mutual acknowledgment, an engagement of male and female aspects. Across it love circulates. Look at the expression on the face of the woman in *Woman Holding a Balance*. In some only half-figurative sense she knows that we are here, and accepts, even sensually absorbs, our presence. She lets us in, and at the same time deflects our gaze toward the scales with which she seems to weigh, again only half-figuratively, something in our attention to her. These scales become both symbol and focal point for the relatedness achieved in the painting. As our gaze unites with hers in a common object, we share in some strange way both her secret and the place from which she looks. However distant she may remain to us, we behold her in the space of an open, articulated understanding.

And Vermeer seems perfectly aware of all this. Although *Woman Holding a Balance* taps emotional currents that run as deep as those of the Degas, its achievement seems more an act of consciousness than something to be kept from it. Every element in such a Vermeer suggests the presence of intentionalized awareness—as if the painting were a reflection on itself. Thought seems its very substance. Degas's nudes are variations on an emotional theme that must (and can) be endlessly renewed and reenacted; Vermeer's standing women are facets of a meditated idea that can (and must) at some point be given over. One of the things we instinctively value in Ver-

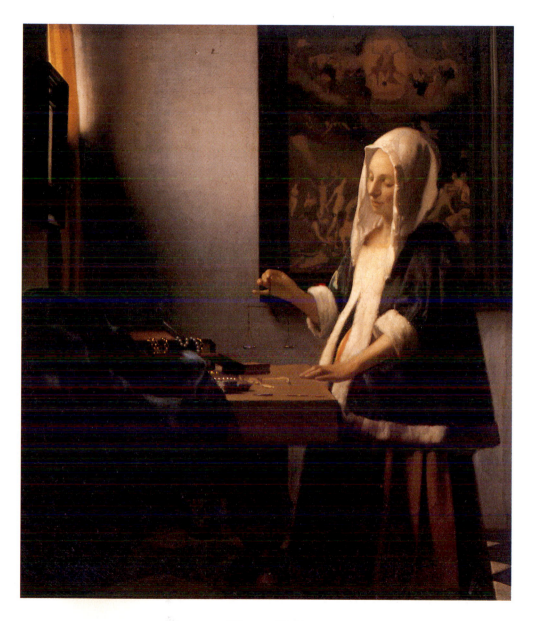

14. Vermeer: *Woman Holding a Balance*.
16½ × 14¾ in. The National Gallery, Washington, D.C. Widener
Collection.

meer is the conviction of a oneness of emotional and reflective experience, the sense of a vision not only undergone but possessed and understood.

Yet one has only to look at Vermeer's early work to realize that his freedom from what disturbs Degas's vision is not something given but achieved. In the beginning the problematic of his own onlooking male-authorial self is perhaps the crucial issue of his work. The first of his many paintings of female solitude is *Diana and Her Companions* [15]. Implicit in the subject is the theme of the artist/onlooker as Actaeon; and the way Vermeer transforms the scene into something so intensely beheld within a hushed and fragile stillness has the effect of activating the theme, making it a facet of the painting's conscious thought.[7] Similarly, the barriers so elaborately built up in the foreground of *Girl Reading a Letter at an Open Window* [23], Vermeer's first painting of a solitary female subject, appear to serve the same defensive purposes as those with which Degas excludes himself from the space of *The Morning Bath*. These paintings tend to isolate rather than release the viewer, and focus rather than transcend his hiddenness. Elements of self-denial and distrust both inhibit and intensify the act of looking. One feels that the open disclosure of artist to subject that characterizes *Woman Holding a Balance* would in these early paintings be as disruptive to him as it would be destructive to his vision.

In many of the early paintings the artist—or at least one part of him—seems to identify negatively with the depicted situation: men paying court to and/or supervising women, waiting on their pleasure and focused on their response—worldly, overshadowing, equivocally motivated visitors who seem encumbered and ill at ease in a space that for the woman tends to be a natural, often aggressively protective habitat. Authorial negativity is especially strong in the three closely related genre scenes, *Woman Drinking with a Gentleman, Gentleman and Girl with Music*, and *Couple with a Glass of Wine*.[8] In these paintings, the attention that man pays to woman—acutely isolated by Gowing as the theme of all Vermeer's work[9]—elicits from the painter a deliberately acid response. All three give the impression of unhappily willed failures, not just immature or bungled attempts at conventional genre scenes.

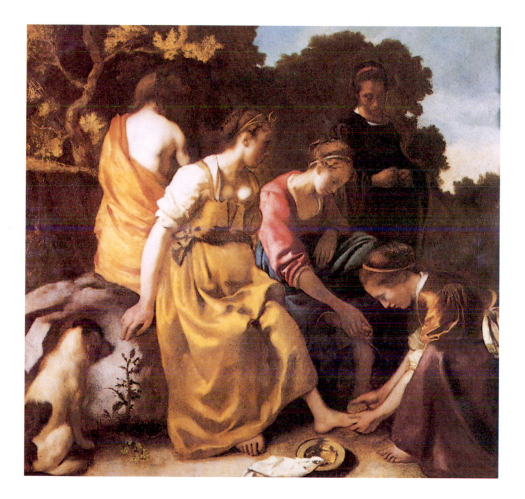

15. Vermeer: *Diana and Her Companions.*
38¾×41⅓ in. Mauritshuis, The Hague.

In *Woman Drinking with a Gentleman* [16], the two perspectives on the woman—that of the man depicted within the scene and that of the artist who renders it—amount to complementary aspects of a single male consciousness. The gentleman's distant consideration of the woman is, even though apparently admiring, vexed by ambiguity: are his feelings romantic, purely aesthetic, basely calculating, or politely deferential? More unsettling is the painter's own bad-humored indifference to the human content of the scene, and especially to that aspect of it that so absorbs his counterpart within the painting. Vermeer's unflattering depiction of the woman who has captured the gentleman's attention seems willfully misogynistic—as if it were a negative overreaction to the spectacle of his own masculine/artistic preoccupation with woman. Her slumping posture and the decorative trim of her dress combine to give the impression of one of the least secure or containing laps imaginable (anything placed on it would slide immediately off onto the floor). To grasp the full negative impact of this image within the context of Vermeer's work, one should compare it to the suggestions of stability and generative potential evoked by or metonymically associated with the laps of women in *Woman Pouring Milk* [5], *Woman Holding a Balance* [14], *Girl Asleep at a Table* [25], *The Procuress* [31], *Soldier and Young Girl Smiling* [37], and *Christ in the House of Martha and Mary* [54].

The flattening of the woman's bodice in *Woman Drinking with a Gentleman* feels similarly perverse. The trim on her bodice merges with that on her left arm to bind her to the chair and make her whole upper body resemble padded upholstery. Her lower body fares even worse. The skirt seems to levitate her above the chair and push her too far forward, while its stiff billows and smooth trim make it difficult to believe in anything at all underneath, much less a body continuous with her upper half. Worst of all is the disastrous effect (which gives every indication of having been exactly calculated by Vermeer) of the wine glass she tilts against her face—as if stoppering herself, or drinking emptiness.

The gentleman fares scarcely better at the painter's hands. His black hat (a motif, as we shall see, regularly associated in Vermeer with a negative male consciousness) seems inimical to images: it cuts into the frame of the

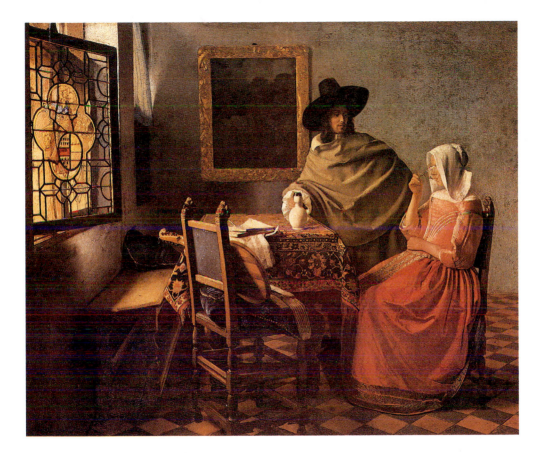

16. Vermeer: *Woman Drinking with a Gentleman*.
25½ × 30¼ in. Staatliche Gemäldegalerie, Berlin-Dahlem.

picture on the back wall, and appears from a distance to slice a hole in Vermeer's own canvas. Its opposite is the half-open leaded-glass window, which facets its area of the canvas into a rich mosaic, and defines the plane it encloses as something that receives, absorbs, depicts, and transmits all at once. The man's gray cloak is wrapped around him like a straitjacket. It deprives him of any interiority or embodied presence—and virtually denies the existence of a left arm and hand with which he might reach out toward the object of his attention. (Whatever motives may lurk on this sinister side are channeled into his right-handed grasp of the jug.) The woman's right hand appears exactly where we might expect the gentleman's left to emerge from under his cloak. In a different mood this detail might suggest the existence of a secret link (as does the continuous line from the woman's right hand to the man's left in *The Concert* [39]); but here it reinforces the sense of deliberate, sardonic ineptness in the handling of the scene.

Hat and cloak work together to reduce their wearer to one reaching hand and a distant, hovering regard. The distance measured by this masculine gaze is one of the most negatively rendered in Vermeer. (The cloak forms a bridge from eyes to hand that seems calculated to offend perception.) Regardless of what motivates it, it is depicted as something that objectifies, condescends, and demeans. The gentleman's lip curls upward into an expression bordering on distaste or amused contempt instead of admiration [17]—as if the misogynism in the painter's treatment were latent in the gentleman's regard. Contemplating this male attendance on woman has led Vermeer to paint a relationship that, in contrast to the similarly inhibited but extraordinarily moving *Soldier and Young Girl Smiling* [37], contains not even the potential for responsiveness or mutuality. Human presence here is an encumberment, an intrusion of negativity and tension into the composed realm of still life. The world of objects—usually so supportive in Vermeer—seems not only indifferent to the man and woman who share the scene but actively hostile to them, as if the painter's animus had found embodiment there: the lion's-head finials stare angrily at the couple, while the glass with its two reflected gleams can seem either to hold in the woman's darts of desire or stab violently at her eyes.

42

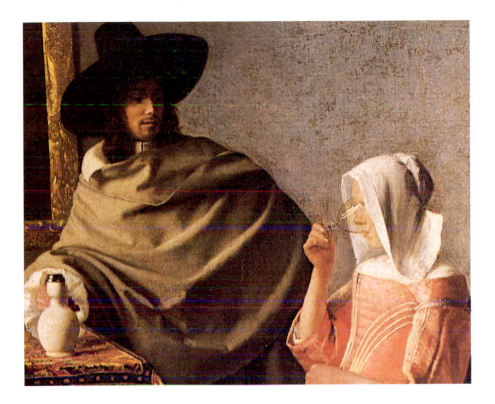

17. Vermeer: *Woman Drinking with a Gentleman* (detail).

Gentleman and Girl with Music [18] in many ways resolves the discordances of *Woman Drinking with a Gentleman*.[10] Here the relation comes forward into a warmer, more sympathetic light, as if indicating the artist's newly enkindled desire to participate in what he depicts. And the still life of the room no longer seems to resent the intrusion of the human element: it clusters around it like a nest, actively empathizing. Descargues calls the painting a "symphony in blue";[11] equally notable is the counterpoint between the red of the woman's blouse and the calm wine in the once empty, antagonistic wine glass.

The motif of benign encompassment extends to the treatment of the human figures. The restrictive garments of *Woman Drinking with a Gentleman* are loosened to convey a more relaxed, less repressive sense of security. The man's left hand emerges to bridge the gap his counterpart's gray wrap awkwardly maintains. The cloak here, in addition to providing a more richly interiorized space for its wearer, outlines the woman against a background of male attention that shields her from the Cupid on the wall behind her. The continuous rendering of the man's cloak and the woman's skirt reinforces the impression of two people blending together into a single figure of relation. Whether the man is a teacher or a suitor, the question of ulterior motives is kept at bay. The musical occasion relieves self-consciousness and distrust, brings the couple close, and deflects their attention from each other to a common object, where hands almost touch—and perhaps do, underneath the sheet of music. The painting appears to depict, even perhaps to achieve, an aesthetic sublimation of the sexual tensions that inhibit *Woman Drinking with a Gentleman*.[12] As such we might expect to find in it a newly acquired good conscience on the part of the artist himself.

Yet things are not so simple. For all its benign difference from *Woman Drinking with a Gentleman, Gentleman and Girl with Music* elaborates rather than resolves the former work's difficulties. The trouble, of course, is with the woman's look [19]. Besides the discomfiture of being looked back at by a painting whose fiction would seem to require our unseenness, there is the disconcertingly neutral quality of the gaze itself: neither warm nor cold,

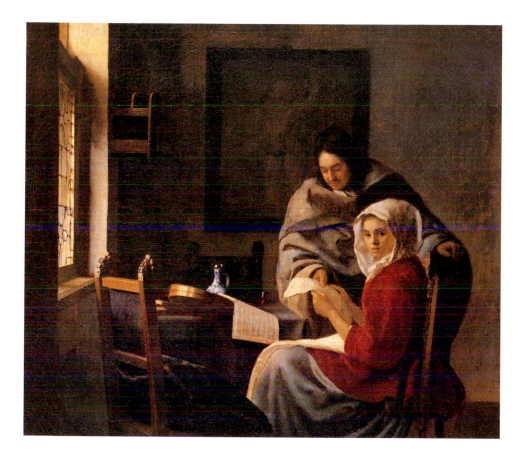

18. Vermeer: *Gentleman and Girl with Music*.
14½ × 16½ in. Copyright The Frick Collection, New York.

hostile nor inviting, curious nor disinterested, fixed on an object it seems to find neither familiar nor strange, registering an intrusion it neither welcomes nor resents.[13] The distancing effect, though not dramatic, is thorough and complex—one is almost reminded of Manet's *Olympia*. The place of viewing is again burdened by an uneasiness, but one that has more to do with our own onlooking presence than with unresolved tensions within the scene. At the same time, that viewing place is undermined ontologically, since we can infer only our visibility, not our identity or relation, from the woman's noncommittal gaze. The painting acknowledges us only the better to neutralize us and define us as extraneous and intrusive. It anticipates our look and flattens it, de-energizes it. We experience our viewing presence as radically nonconstitutive of what we behold—a negation not only of the mode of involvement that *Head of a Young Girl* demands from us, but also of the closeness offered by paintings as different as *Diana and Her Companions* and *Woman Holding a Balance*, which, though free of us, still acknowledge or exist within our gaze.

The painting thus articulates, more consciously and directly than *Woman Drinking with a Gentleman*, a split within the artist over the issue of woman and his attention to her. The man within the painting is an idealized, domesticated image of both a man's relationship with a woman and a painter's with his model: at once intimate and paternal, deferential yet in control, shielding the object of his attention from Eros and oblivious to it himself, innocently absorbed in his aesthetic collaboration with her. But the direct gaze of the woman enforces the distance between the artist and this idealized self-image—to the degree that identification does occur, the woman's look will read as a displaced response to the man who bends over her (hence the popular title, *Girl Interrupted at Her Music*) and the intimacy of the situation will be disrupted from within.[14]

The artist/viewer is thus relegated by the woman's gaze to a periphery he must share with the empty chair, the bird cage, and the hanging Cupid. These three objects represent a perspective inimical to the idyllic relationship they surround. The Cupid, barely visible in the far background, signals openly to the artist/viewer, flaunting the erotic issue so artfully contained by

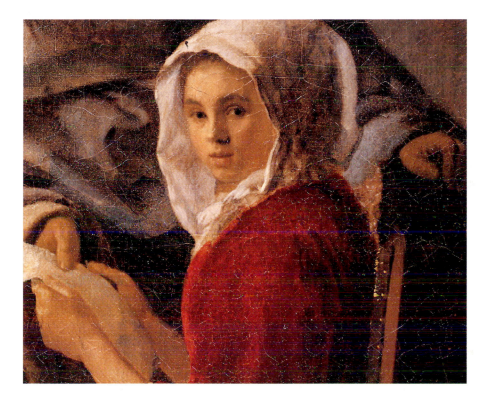

19. Vermeer: *Gentleman and Girl with Music* (detail).

the relationship itself. The bird cage, again outside the couple's ken but prominently within the artist's view, threatens to recast the intimacy of the central couple in terms of subjugation and confinement.[15] And the lion's-head finials, even though they pull back toward us (as we draw closer) and grow transfixed, remain the surrogates of an onlooking animus that has only been partially banished from the painting.[16] Together they adumbrate aspects of the artist's consciousness that exclude him from the solution his own work proposes.

The issues of *Gentleman and Girl with Music* are redressed in a painting from Vermeer's last phase, *Woman Standing at a Virginal* [20]. The Cupid reappears on the back wall of this painting, now blatantly visible. Indeed, he looks a bit ridiculously cross-eyed and bewigged now that his presence is so openly declared. Vermeer's light, instead of making its usual distinctions, gives equal value to foreground and background, and in doing so superimposes the Cupid on the woman's presence (note his planted bow). Despite the obvious contrast between his flagrant sexuality and her perfectly composed uprightness (she is a most unlikely Venus), there is a certain dead-pan humor—only superficially at her expense—insisting that she belongs to his realm and that his gaze and hers are the same. Her somewhat intimidating expression may appear to replicate the female gaze that undermines the place of the viewer in *Gentleman and Girl with Music*; but here, near the end of the artist's career, there is an overriding familiarity about it. She clearly knows the artist, as she both takes for granted and insists on the understanding that exists between them. No metaphysical boundaries are transgressed this time as she looks back at us from within the frame. Her habitat is not art but life—she is not playing the virginal but posing, just a bit impatiently, for a painting. She is the most formidable and at the same time least mystifiable other, as she stands there not just as the subject of the artist's fantasies but as a potent resistance to them.

The third in this trio of genre pieces, *Couple with a Glass of Wine* [21], gives almost schematic representation to the conflicts embodied in the two other paintings. Its two male figures are made to seem contrasting aspects of a single individual. And the splitting is again precipitated by the spectacle

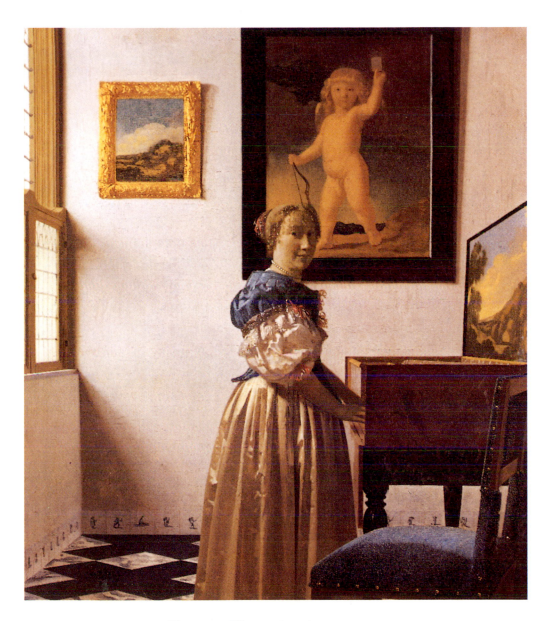

20. Vermeer: *Woman Standing at a Virginal*.
20 × 18 in. The National Gallery, London.

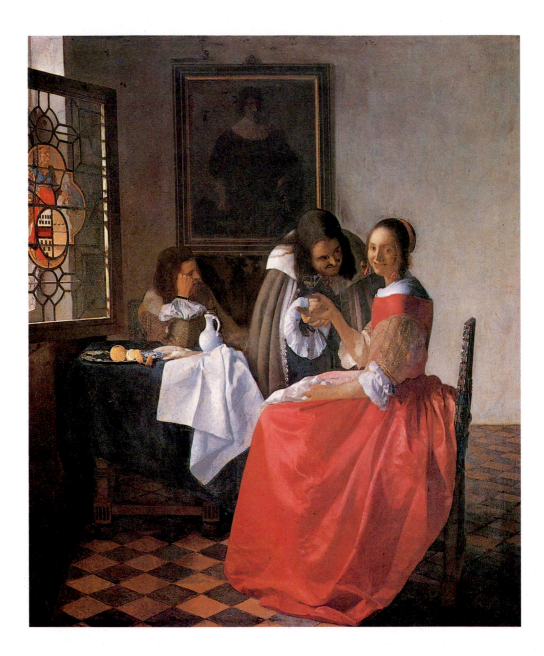

21. Vermeer: *Couple with a Glass of Wine*.
30¾×26½ in. Herzog Anton Ulrich-Museum, Brunswick.

22. Vermeer: *Couple with a Glass of Wine* (detail).

of woman as the object of man's attention. The two oranges [22] deftly counterpoint the issue and make its applicability to the painter more apparent: the one untouched and whole, an aesthetic object; the other peeled and ready to eat. The mood of the painting is such that neither male aspect has much force. The posture of the withdrawn figure in the background recalls that of the solitary woman in *Girl Asleep at a Table* [25]. But his reverie, instead of opening (or half opening) onto some luminous further realm, is boxed into a shallow, closed space, where it tends to read negatively as boredom and passive, isolated disengagement. The active, sexually ag-

gressive figure, meanwhile, comes forward into an embarrassingly contemptuous light, where he becomes an image of both petty, calculating villainy and egregiously condescending attendance.[17]

Linking the two figures, and opposed to both, is an old-fashioned portrait of male uprightness—the objective correlative of the artist's conscience, an obsolescent ego-ideal that seems ineffectual and a bit stuffy as it overlooks the current scene. And as if to prevent identification with this image of virtuous aloofness, or even with the figure of detachment in the background, the woman looks directly at the artist, in response to the advances of her active suitor. Vermeer's rendering of this central couple depends for its full negative impact on a half-subliminal perception: the man is not merely a calculating suitor but an artist explaining to his model how he wants her to pose for him, and the woman's response is not so much that of a coquette as of someone flattered and embarrassed to find herself the object of an artist's attention. The artist responds to her in turn with an animus rooted in his own negative identification with the suitor hovering so absurdly at her side.

Even the virtuoso display of painterly skill seems more calculated to exacerbate conflict than to give pleasure for its own sake. The woman's dress is richly colored and finely detailed, but one can appreciate its textures only by ignoring its bizarre representation of the woman herself. It seems impossible that she could really be sitting on the chair, which is too small for her skirt and positioned too far behind her. What her skirt appears to cover, in fact, is not a lower body at all but another table like the one in the background covered in blue. The pointed resemblance between table and lap places them in a diagonal, opposing relationship—the one (with its still life) welcoming contemplation, the other (with its human form) alienating sexuality. Any fidelity to what a seated woman might actually look like is clumsily sacrificed to this thematic counterpoint. The still life resting on the table is exquisitely realized and competes for our attention with the woman's gaze. But we can never really get past that gaze or banish it from the periphery of our attention. Likewise the beautiful leaded-glass window. The red and blue garment of its depicted figure combines the separate colors of

the table and the lap. At the same time it explicitly connects this heraldic figure with her red-skirted counterpart. The former is tall and upright, capable and regal in her bearing, and holds in her hand what may either be the reins of rhetoric or two serpents wound several times about themselves.[18] She is a more formidable version of the gentlemanly figure in the portrait—the residue of a remote heraldic fiction, not an elder but a virtue, a strong controller whose difference from the woman who responds so mawkishly to her seducer's serpentine persuasions could scarcely be more ironic.[19] Yet this cut-glass figure is barred by the window's mullions, and its angled gaze, wistful and almost pitying as it observes the central couple, is like a rebuke to the entire scene.

It is only when men vanish from the space of representation that the troubled conscience of these early paintings disappears. A rapt study of solitary female figures gradually replaces a tangled spectatorial involvement in the depiction of the sexes. But it would be a mistake to view this development as merely an escape into aesthetic contemplation. The paintings of single female subjects impress one, in fact, as somehow directly engaged with what is being kept at a distance in the genre scenes. When one turns from *Couple with a Glass of Wine* to *Girl Reading a Letter at an Open Window* or *Girl Asleep at a Table*, certain representational defenses seem to fall away. There is something like acknowledgment or disclosure on the artist's part, a willingness to make himself vulnerable to what in the genre scenes he ironically depicts.[20]

From this point of view, the disappearance of men from the scene of representation signifies an acceptance rather than a retreat from the sexual theme. Its complexities are directly entered into instead of being observed from a distance through negatively depicted surrogates. The paintings themselves come to embody, in the relationship between viewer and subject, the erotic issues they once pretended only to represent. As this shift occurs, sexuality ceases to be a threat, a negative force for the artist, even if it remains his central theme. The tensions that intrude into the aesthetic realm in the genre scenes are in *Girl Reading a Letter at an Open Window* also, but they energize as well as complicate its atmosphere. Eros here seems a res-

ervoir of charged ambivalence from which the artist's images might draw.

Girl Reading a Letter at an Open Window [23] teems, in fact, with unresolved energies, disguised as they are in the almost forced stillness of the moment. For the first time in Vermeer's oeuvre, space itself grows tenuous and alive. No object seems resigned as yet to a stable equilibrium. The inert red curtain stretched into the background drapes uneasily, turning the casually open window into a precarious hinge. The foreground curtain with its acrid hue seems to stand stiffly rather than fall, and is energized by contraries of its own. It bunches at the top and billows at the bottom, as if simultaneously pulling toward and recoiling from the facing light. The light, in turn, can appear both to enter forcefully—thrusting the foreground curtain back, throwing the window open, extending a rectangular shadow out to claim the girl, brightening lavishly on the wall behind her—and to pull things toward it from outside—drawing the green curtain leftward, tugging at the letter, extracting onto the panes an image from the young girl and threatening to swing the window closed.

The foreground tapestry participates in this uneasy push and pull. Its left portion bunches up and in toward the painting's center, refusing either to fall outside the frame or to spread and flatten on the table. In the process a ceramic bowl is tilted up and to the right, causing its pyramid of fruit to tumble out onto the table. And the fruit reacts with opposing impulses: spilling out and dispersing, but also resisting that movement—bunching, braking, even trying to climb back into the bowl and maintain itself against the force of gravity.

All this activity imparts a strange disquiet to the space in which the young girl reads. Feelings of placidity, tense expectation, and a sense almost of dread or doom vie as the young girl nears the letter's end, her own expression still a cipher. (Why is it so hard to imagine that the news is good?) Protective barriers crowd in all around her, suspending her in a narrow cylinder of space (neither floor nor ceiling are in evidence) and making her seem exposed and vulnerable within the scene. The area where she reads is crowded with onlookers and eavesdroppers. The reflection in the window, the lion's-head finials, and the entering light all seem to be reading her letter,

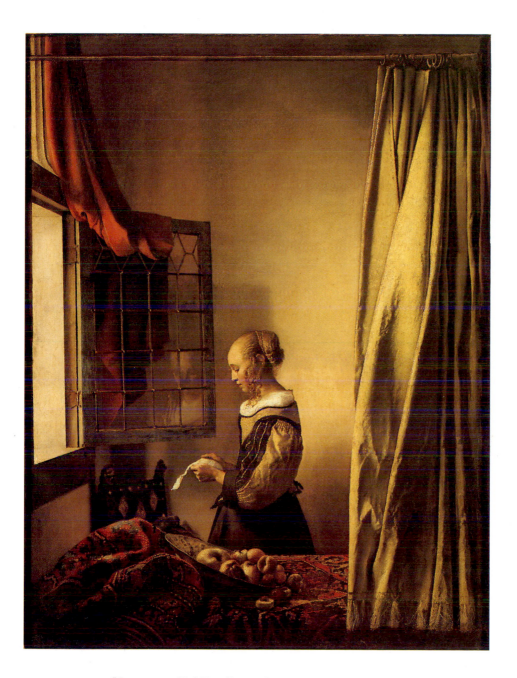

23. Vermeer: *Girl Reading a Letter at an Open Window*.
32¾ × 25⅜ in. Staatliche Gemäldegalerie, Dresden.

24. Vermeer: *Girl Reading a Letter at an Open Window* (detail).

more closely and intently than she; the chair-back points its pattern toward her like a watchful visage. Even the sheet of paper condenses mixed feelings. Its top portion (the part open to the onlookers) brightens in the light, and the crumples seem to float and ripple rather than to fall; but the section the young girl reads is stretched taut and creaseless, and the message's conclusion grows dark as it descends into the V-shaped private space from which her feelings have yet to rise.

Especially haunting is the image in the window, so different from the young girl it reflects [24]. The detail is practically all suggestion, a visual idea whose aspects gestate separately. A barred image, imprisoned in the virtual. A screen through which confessions might be whispered. A glass for detecting specters of otherness. An intimation of the hold death has on life. (The girl's bright cascading curls become, in the window's image, a skeletal hand resting on her shoulder.) Even an alter ego with a range of fates, in contrast to her counterpart's real presence, whose paintedness seems so unalterable. She will flit out the window as it closes. She will fade with the sun. She will drift back to the rear wall, where the rectangular shadow (from which the panes have temporarily stolen her) creates her frame. Or she will grow into the light, uniting perhaps with her twin to achieve the reality and full sexuality of *Woman in Blue Reading a Letter*.

Girl Asleep at a Table [25] maps complexities between viewer and subject, space and psyche, the image and its other, that *Girl Reading a Letter at an Open Window* more intuitively explores. The lion's-head finials, more conspicuous here than in *Girl Reading* or even *Woman Drinking with a Gentleman*, are pushed forward and turned away from the girl, to become sentinels of her space rather than secret or menacing onlookers. So positioned, they indicate a presence somewhere in the painting's offspace, as they fiercely refuse entrance to the very threat they represent. But here the place indicated does not coincide with that of the artist/viewer: the barrier is pushed aside, allowing qualified access to both the girl and the mysterious realm upon which the door behind her partially opens.

And as the painting distinguishes between the viewer and the offspace presence that alerts the lions, it becomes possible to regard that presence as

something positive, even generated by the girl herself: the diagonal that slopes down from the picture of the unmasked Cupid through the slant of the dreaming girl to the forward-straining lions' heads and out beyond the frame transforms the finials from guardians of her self-absorption to vectors of her desire. The sense of male absence that is so strong in this painting—the tense finials, the unmasked Cupid, the open door, the cloak (?) hanging on the wall, the walking stick (?) and the overturned roemer (?) lying on the table all obliquely indicate it—is as rich with mystery as male presence in the genre scenes is stultifying. Has something taken leave, does it approach, or is it already *there* in some uncanny way? Rooms seem to contain ghostly presences; successive thresholds feel charged. Objects, light effects, space itself create a kind of phantasmagoria and take on the quality of things vivid and alive inside the mind. And a depicted woman occupies the space of this potential, if not yet with the power to unify and make real, then with a reverie in which the fulfilled image waits.

Whatever haunts the girl asleep thus haunts us as well. It is not clear whose mind is at work in this painting, creating phantoms of feeling, vectors and precipitates of desire. Across the once firm barrier between viewer and subject there is a strange osmosis of imaginative states. (As we watch her, does she dream us?) Even the symbolic-looking elements of the painting refer as plausibly to the viewer as to the gazed-on subject.[21] The mask at the foot of the Cupid above the girl's head, for instance, may hint at the content of her dreams ("Sleep is revealed as the dropping of a mask, uncovering the fantasy which is the sleeper's secret, a fantasy, we may guess, of Love"),[22] but it can also suggest the artist's own discarded mask, as he admits to both his own motives and the image's erotic hold on him.

The opening in the background of the painting [26] can likewise be read as an extension of the girl's reverie, a metaphor for her half-openness, or the destination toward which our own projected viewing tends. The private significance for the viewer of this threshold and the room beyond is stressed in several ways. The chair and foreground tapestry, which at first glance seem deployed to keep our attention at a distance (in the manner of *Girl Reading a Letter at an Open Window*), work more subtly to channel our eye

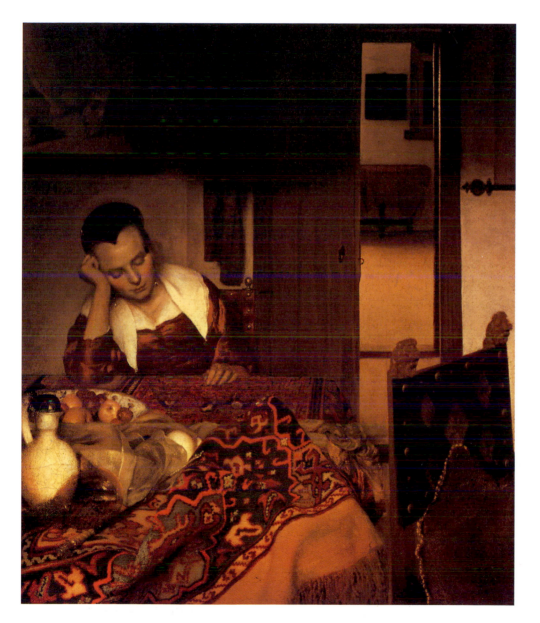

25. Vermeer: *Girl Asleep at a Table*.
34⅛ × 30⅛ in. The Metropolitan Museum of Art, New York.
Bequest of Benjamin Altman, 1913.

26. Vermeer: *Girl Asleep at a Table* (detail).

through the background opening. And the focal point of the painting is not the girl but the square shape on the far wall of the room behind the door.[23] This distant object, the only uncropped geometrical shape in the painting, proves on closer inspection to be a mirror.[24]

A dialectic is thus established within our vision between an erotic attraction that draws us to the sleeping girl and a narcissistic pull that draws us deeper into the image (the mirror in the background does not reflect us, it stands as destination), toward a realm that is open and sparsely furnished,

60

bathed in light and ruled by absence. The two edges of the right angle formed by the section of tapestry pushed up into the foreground precisely indicate these two vectors—the one pointing toward the young woman, the other through the door. The viewer's interest is admitted here, even solicited, but then gently deflected, channeled past its ostensible female object toward a purely imaginative (and scarcely humanized) space that opens behind her.

In a sense the subject of the painting is the process we call "sublimation." But if we think of sublimation merely in terms of substitute satisfactions, we will miss the full complexity of Vermeer's vision. True, the imagination is colored by a certain grief or disappointment as it passes by the young woman on its way through the doorway into the near-emptiness beyond—in this, as in so many ways, the painting anticipates *Head of a Young Girl*. Yet the feeling is equally strong that the girl and her reverie exist to materialize that threshold, and that it addresses the viewer's desire at a more primordial level than she does. And the composition as a whole leaves deliberately unresolved whether the door is the background of grief or of desire, whether it opens on a renunciation of sexuality or as its promise, its "beyond." The question animates the whole of Vermeer's oeuvre. We will return to it when we come to two of his most self-reflexive paintings, *Couple Standing at a Virginal* [44] and *Artist in His Studio* [49].

In the series of single female subjects inaugurated by *Young Woman at a Window with a Pitcher* [62], the two realms still kept separate in *Girl Asleep at a Table* and *Girl Reading a Letter at an Open Window* are fused. Here, where self-sufficient women bask in the light of the viewer's attention, uncannily alive within the frame, the erotic and the imaginative, the real and the virtual, seem one. Although the nostalgia about male absence that colors *Girl Asleep at a Table* has disappeared from these paintings, they preserve a relation with the artist/viewer, and their realism holds its oneiric charge. The pregnancy in *Woman Holding a Balance* [28] ostensibly implies some absent male, but it signifies more powerfully the woman's own capable, almost parthenogenic singularity—an ontologically enriched presence that

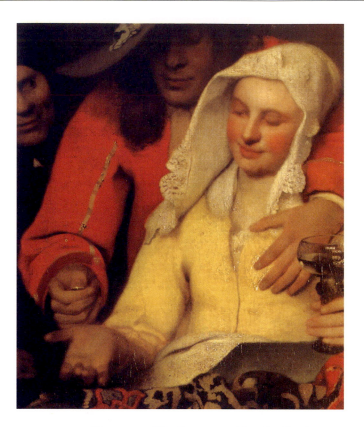

27. Vermeer: *The Procuress* (detail of 31).

communicates itself beyond the frame. Her serenity is a refinement—but not a repudiation—of the look of sexual happiness her counterpart displays in *The Procuress* [27]: the thin gold coins and the gap between the third and fourth fingers of both right hands stress the link. Both women weigh with their eyes a transaction, the emblem of a relationship, focused at a suspended and utterly confident right hand. But in *Woman Holding a Balance* "space" as we uniquely know it in Vermeer—loving, erotic, magically supportive—takes the place of the amorous cavalier, while the artist/viewer enters into angled complicity with her look.

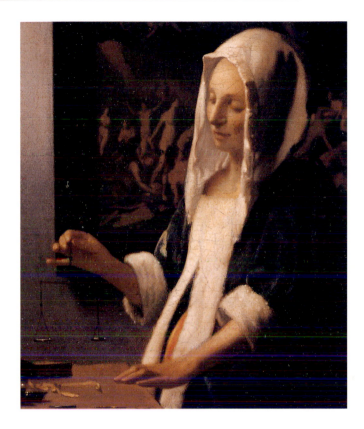

28. Vermeer: *Woman Holding a Balance* (detail of 14).

In the same way, the gesture of the woman in *Woman Pouring Milk* [30] becomes an elaborated version of the offering made by the standing woman in *Christ in the House of Martha and Mary* [29]. As the central male disappears, the two poles of femaleness that gravitate around him (in full-face and profile) merge in the figure of the pensive milkmaid. The line that slopes from the absorbed expression on the woman's face, down across her tightly laced bodice, through the jug held open in her hands, to the basin into which the milk trickles (up and over the jug's lip, as if of its own accord), suggests ontological continuity, even generative flow—as if the bread,

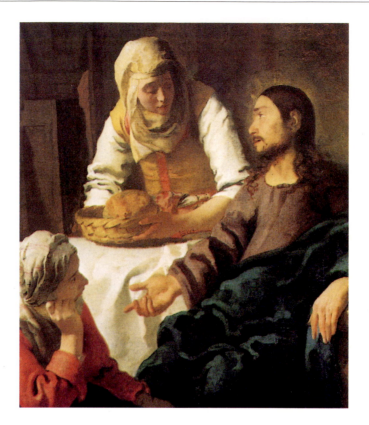

29. Vermeer: *Christ in the House of Martha and Mary* (detail of 54).

milk, and open vessels were extensions of the woman herself and issued metaphorically in a relation with the viewer. All the painting's vectors seem to meet at the open jug, where opposing aspects again seem reconciled: the woman cradles it with maternal tenderness (we take its place, we feel what it is like to be held like this, to have our heaviness made light), yet holds its dark interior open to our gaze (almost as if pouring were a pretext for doing so). While the artist/viewer of *Diana and Her Companions* observes women from a place of hiddenness, here his presence is matter-of-factly assumed.

64

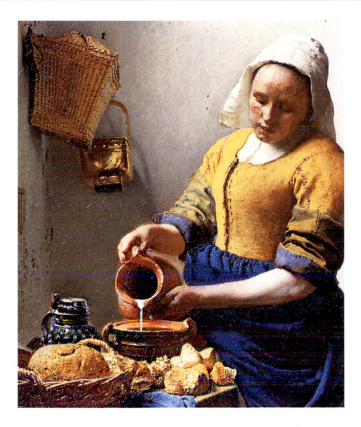

30. Vermeer: *Woman Pouring Milk* (detail of 5).

The realm of femaleness is discovered unconcealed—and impervious to interruption—at the heart of an ongoing and familiar world. One is tempted to seek an explanation for such a development in the particulars of Vermeer's life; hence the impulse to identify the women in his paintings as his wife and daughters. But the paintings keep pulling us back into the aesthetic sphere, insisting that such grace is accomplished entirely within art, and that such art in turn makes life possible.

II

TWO EARLY PAINTINGS

IT MIGHT SEEM from the preceding discussion that Vermeer's oeuvre moves toward *Woman Pouring Milk* and *Woman Holding a Balance* as an affliction toward its cure. But evolution is never so simple in Vermeer. Consider *The Procuress* and *Soldier and Young Girl Smiling*. Although these two early paintings almost certainly precede the three troubled genre scenes [16, 18, 21], they contain the crucial elements of Vermeer's later equanimity, not merely latent but consciously articulated. Issues involving sexuality and the distance between the sexes do inform the two paintings—indeed, the tensions of the genre scenes receive their most complex embodiment in them—but here, at the very beginning, those issues seem to have been confronted and understood. In spite of the discrepancies both paintings visualize, they yield configurations of relatedness that are among the most moving aspects of Vermeer. It could even be said that Vermeer never surpasses the achievements of these first works, and manages to return to them only by way of a strange renunciation.

Consider first *The Procuress* [31]. An initial glance confirms the impression of an artist more open to the problems than to the possibilities of the sexual theme. The tonal values are much darker than anywhere else in Vermeer, and the color scheme is marked by a predominance of black. The setting (insofar as it can be determined) is a brothel, and the two figures on the left materialize an atmosphere of venality and concupiscence. There is an interior, mental quality about these figures: they mirror facets of the viewer's psyche and the painting's subject, and in doing so indicate elements of bad conscience and sexual unease within both the painting and the scene of looking. One might conclude that *The Procuress* transcends typical Dutch brothel scenes—such as the Van Baburen *Procuress* [40] that Vermeer depicts in two of his later paintings[1]—only by virtue of a neurotic intensity.

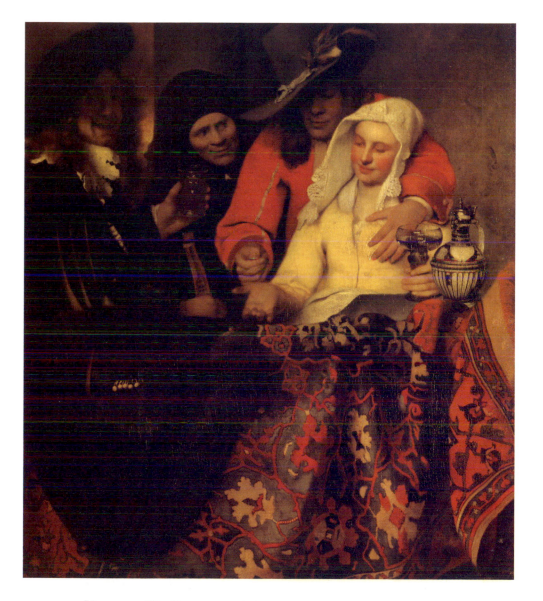

31. Verméer: *The Procuress*. 56¼ × 51¼ in. Staatliche Gemäldegalerie, Dresden.

67

And yet as one's first glance deepens into an extended viewing, everything begins to change. All that is satisfying—visually, emotionally, viscerally—about the exchange between the man and woman on the right begins to assert itself and draw us deep within it, on its own complex terms. As we move closer we can feel the two alienated figures in black being left behind, trapped in their frozen postures of voyeuristic remove. One becomes struck by how unaffected the couple on the right seem, by either their setting or the dark figures (ourselves included?) who crowd around them. Within the configuration they share, the man and woman seem invulnerable to either the voyeuristic or the moralistic gaze—hence the surprising power of the detail that isolates them [32]. And all these impressions are visually immediate sensations: the image achieves what feels like uninhibited access to the experience the couple share, in spite of the dark themes that surround it. The artist may identify with the self-conscious cavalier on the left, and insist on our complicity with him, but the painting finds an unabashed sensuality in the two figures on the right. The force of the woman's presence, especially, transforms even the structure of the painting: against the left-to-right movement that arrives at her as a compliant object of vicarious fantasy and sexual desire, she becomes a radiant subject about which other figures gravitate in increasingly dark and frigid orbits. And for the only time in Vermeer, a man finds himself included in this richly female sphere. Unlikely as it may at first seem, there exists in this painting, as if on the other side of moral prejudice and sexual restraint, one of the most unsentimental and guilt-free celebrations of shared erotic experience in all of art.

No painting, in fact, suffers more from the necessity of attaching a name to it than *The Procuress*. The conventional title falsely stresses the theme of venality and misleadingly refers to a narrative dimension that has been all but eliminated in Vermeer's treatment of the subject. If we identify the woman on the right as the procuress of the title, and then invent an anecdote to explain the exchange that passes between her and the man who leans over her (perhaps he flips a coin into her palm with a knowing, half-insolent squeeze as he goes off to take his pleasure with one of her charges), we will miss the sense of fit between them, the depth of the erotic bond that unites

32. Vermeer: *The Procuress* (detail).

69

them, and the immediacy with which both are conveyed. Vermeer, in fact, seems less interested in depicting a visit to a brothel than sexuality itself—not so much how it looks as how it feels, how it is when things are right—as well as what threatens to darken it, both from without and within.

Even a neutrally descriptive title like "Man and Woman Exchanging a Coin in the Presence of Two Onlookers" would remain too external, too exclusively visual, to suggest the endopsychic level at which Vermeer's image registers. The complicity between this couple goes deep, despite the air of casualness it projects. And the mood that envelops them is one of consummation rather than anticipation, pleasure in the present moment rather than desire for what lies in wait, however an anecdotal reading might have it.

Indeed, that Vermeer situates so positive an image of erotic fulfillment within the context of venal love may indicate not ambivalence on his part so much as a desire to celebrate what is bestowed by actual (one might almost say impersonal) sexual experience, apart from any morally respectable relationship that might contain it. Rembrandt's *The Jewish Bride* [33] provides an instructive contrast. Rembrandt too wants to celebrate sexuality and invest it with ethical resonance. But he is careful to do so by subordinating it to marriage, so that the love of husband for wife (and vice versa) sanctions the erotic touch. One can feel the awkwardness and constraint with which Rembrandt seems to will both the husband's gesture of tenderness and the wife's receiving it as such. Hence, perhaps, the sense of distantness within each participant, and the odd melancholy of the work itself. Both figures are envisioned from the outside, and their relationship is still blocked in terms of the inherited imagery of venal love [34] that the painting wishes to redeem. Vermeer, on the other hand, concerned with how good things fall in place, and with how felt values inhere in sexuality itself, revises the old configurations to take us all the way inside.

Yet at the same time Vermeer goes out of his way to evoke the ways of seeing that his own image transcends. Consider his treatment of the pitcher that stands at the far right, beside the woman's glass [35]. It has been placed in the most precarious position imaginable, at the very edge of the table,

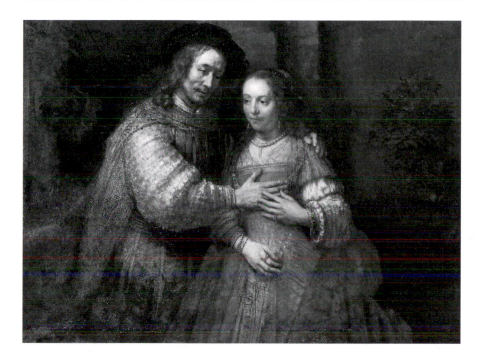

33. Rembrandt: *The Jewish Bride*. 47¾ × 65½ in.
Rijksmuseum, Amsterdam.

almost touching the back of the hand that absentmindedly grasps the wine glass. At first glance disaster seems imminent, especially in the context of such relaxed abandon. The very composition of the painting—the flow of attention from left to right, the sequence of overlapping hands and glass crowding into the pitcher's space—seems to conspire with the viewer's imagination to topple it over onto the floor. Even the pull of the bunched-up portion of the tapestry contributes to this effect. The temptation is to find in this detail a warning, even the key to a full-fledged moral allegory, and many drinking scenes by Vermeer's contemporaries could be marshaled in support of such a reading.[2]

34. Urs Graf: *Venal Love*. Woodcut.

But again, as one continues to look, the pitcher continues to stand in place, with the same centered, imperturbable calm that similarly begins to characterize the woman's presence. Her certainty of self and gesture gradually disarms the anxiety located by the pitcher and her nearness to it, and allows a more benign counterpoint to grow between them. As her centeredness arrests the flow of attention toward her, things even begin to pull in toward the left: the press of the man's hand on the woman's breast and the curl of her fingers around the glass's stem (the first of many such steadying

72

35. Vermeer: *The Procuress* (detail).

gestures in Vermeer) make extra room for the pitcher and keep it, as if by attraction, anchored on the table. Indeed, the pitcher's intactness and calm uprightness in the midst of a sexual exchange may well signify an argument against conventional morality. Erotic experience here, at least insofar as the woman is its focus, has to do not with loss of virtue but with centeredness and self-possession.[3] That pitcher will never fall, one feels certain, persuaded by the woman's steady presence, any more than the ribbon of milk will ever break in *Woman Pouring Milk* or the scales ever tremble in *Woman Holding*

a Balance. All in all, the placement of the pitcher seems less the calculation of a moralist than of an artist confident in the capacity of his vision to triumph over conventional attitudes and his own inner demons.

The Procuress is organized around the ambiguities of participating in or being absorbed into someone else's experience. (It seems characteristic of Vermeer to see the sexual issue in such terms.) This organization is especially evident in the left-to-right movement of the painting. The four depicted figures form a spectrum that leads simultaneously from vicariousness to self-absorption and from isolation to relatedness. (That the woman can serve as an extreme of both self-absorption and relatedness suggests the resolution in her of a fundamental paradox.) And at the level of our own engagement with the painting, this spectrum involves a passage from bad to good conscience—with uneasy specular identification at one extreme and erotic investment in (and access to) experience radically other than our own at the other. The stages of this passage suggest both a continuum—note the subtle progression of lips, as well as the gradual centering of attention on the woman—and a division into unbridgeable worlds of darkness and light, spectral lack and sensually embodied plentitude.

The bottom half of the painting stresses the division. The black cloak draped over the table's edge blots out the bright, richly patterned tapestry, and its curve encloses the two figures on the left in a dark ovoid shell. Its heaviness also pulls them downward and roots them in a dark "below" that is static and inert. How different the upward sweep of the tapestry on the right: its restless movement is full of light and energy, and it seems to channel itself into the two figures who flower just above it. They manifest and calm its reds and yellows, just as they absorb and stabilize its upward surge.

The two dark figures on the left not only attach to the central relationship but confront us with negative images of the authorial and spectatorial aspects of our own presence to the painting. The cavalier at the far left wears almost the same costume as the artist in Vermeer's later, more openly self-conscious *Artist in His Studio* [49], and has been identified by several commentators (largely on the basis of this internal resemblance) as a self-

portrait. Tenuous as the autobiographical inference may be (why, for that matter, should we think that the artist in the later painting is Vermeer?), certain details—the lute he holds in his right hand, his sense of himself as in direct complicity with the painting's audience, his self-appointed role as celebrator of its revels, even his resemblance to several of Rembrandt's self-portraits—do suggest a mirroring of the artist qua artist.[4] This figure would obviously like nothing more than to feel himself at home in a typical Dutch "Merry Company" scene—indeed, he seems to understand himself as belonging to just such a group. But in the context Vermeer has placed him, his merriment has a hollow ring. He comes across as a superficial, isolated figure, cut off from the man and woman whose experience he thinks he shares with us.[5] The slightly forced, tentative quality of the libertine pose he strikes undermines its intended effect and betrays an insecurity and embarrassment beneath it. His overeagerness to be a part of what is going on and his sense of himself as in contact with an audience external to the scene become symptoms of his alienation, perhaps even defenses against the experience of deep sexuality to which he is vicariously drawn. Even the objects he holds in either hand, which should be emblems of participation, only further isolate him from the possibility of real human contact: note the contrast with the beautiful interweaving of hands between the couple on the right, and the narrow strip of negative space that separates his hands from theirs like a chasm he cannot hope to cross.

A dim view, then, is taken of the artist's claim to be "in the know" (here especially the painting might be taken as a critique of the Rembrandtesque), and even of the vicarious, compensatory claims of art. The artist is portrayed, especially in comparison to his more worldly, self-assured counterpart, as something of a permanently arrested adolescent—whose art, if we are to judge from the way his hand grasps the emblematical lute handle, has strong masturbatory connotations. The ultimate paradox, which Vermeer makes no attempt to resolve, is that the painting which presents this skeptical view of the artist's relationship to erotic experience is itself deeply in touch with that experience. Indeed, the life that evades the artist takes on

such resonance largely because we come upon it within art, and feel it to be an aesthetic achievement.

If the cavalier on the left mirrors the artist's negative sense of himself, the dark figure next to him functions similarly with respect to the viewer. The black in which Vermeer has shrouded her (?)[6] negates any sense of bodily presence and reduces her to nothing more than pure face, a hovering, voyeuristic regard. We see eyes greedy for, and jealous of, what only hands can feel. There is something similarly sinister about the sexual ambiguity of the figure, who both couples with the toasting cavalier and mediates between the two male figures. The ambiguity underscores, by way of contrast, assurances embodied in the couple on the right (the absence of hands functions similarly): in their case, both a stable, brightly contoured difference between male and female, and a pleasurable sensation of how the sexes fit together and interweave.

The handless figure also occupies an uncertain place in the structure of the painting. She definitely belongs to the dark half of the composition; the black cloak pairs her with the toasting cavalier, and her link with him is reinforced by one's tendency (obviously calculated by Vermeer) to attribute the hand holding the lute to her rather than him, a perception that makes the sexual connotations of the detail even more disturbing. The upper background, however, isolates her from the cavalier and stresses a progression that links her with the couple on the right. This relationship with the couple may be less apparent, but it is equally compelling, and at least two ways of reading it come to mind.

First, it allows us to see the two figures on the left as dual aspects of a single bad (male) viewing conscience, corresponding to the splitting of male presence within the painting. The cavalier on the left, that is, would embody a compulsively narcissistic ego, visually alienated in mirror-relationships; while the shrouded figure next to him would manifest both an insecurity about sexual identity and a deeper, id-like viewing presence, hovering pruriently over the shoulder of the active self, even when it seems most pleasurably absorbed in sexuality. A particularly dark perception might see the

76

disembodied figure's left shoulder reaching back behind the man in red to emerge as (or merge with) his extended left arm, so that the two appropriated hands of this leering visage would bridge the lute handle and the woman's breast.

Second, the arrangement emphasizes the asymmetry of the relation between the amorous couple by inscribing it within a continuum of vicarious desire leading from the shrouded figure toward the woman on the right— and pointedly excluding the cavalier at the far left. For even as a happy image of sexual relation, the couple on the right configure dissimilarities of male and female pleasure and desire. Indeed, the sense of differences preserved, of individualities shared but not subsumed, is part of the image's delight.

These differences hinge on the issue of vicariousness, a dark theme that brightens in the relationship on the right. Both the man and the woman incorporate an imagined or intuited awareness of the other's presence into their own sense of themselves within the relationship. (The circumvention of direct eye contact allows Vermeer to give full weight to these interiorized, nonvisual aspects.) Yet the ways of access to this otherness, and the modes of relating to or absorbing it, are very different. Her experience is primarily of herself, securely in place at the center of things (despite her position at the far right), a sensation eloquently underscored by her easy grasp of the androgynous wine glass. The man seems present to her almost autoerotically, a kind of surrounding yet at the same time immanent, imaginatively engendered erotic spirit. Even his obtrusive left hand seems under her control. Note how her wine glass, which bridges the interval between her left hand and the man's, facets a portion of the latter, otherwise so solidly present on the curves and fullness of her breast. The effect, metaphorically at least, is to displace it to her own grasp of things and channel it in to her, a function of her own private feeling and the wine's effect. Vermeer's reworking of the man's hand—it appears to have once been even larger— creates a similarly metaphoric effect. The area where his first two fingers make contact with her breast ripples with rough, thickly laid paint, almost

77

as if he were touching a pool or an illusion—or conversely as if their surfaces and the boundaries between them had not hardened, and his hand were sinking in at the point of maximum cathexis.

For he, too, experiences the woman almost autoerotically, incorporating her presence to him almost as if it were an element of his own absorption in himself. The nearby pitcher, a tactful displacement, seems more a psychic than a sensual index of what he feels in contact with her breast. But he is also more vicariously centered on her than she on him. In this he works as a transitional figure: mediating between the shrouded figure and the woman, bridging the regions of darkness and light, crossing over from the world of his companions, his face still half-shadowed, to enjoy her bright presence, not an invader but a protective barrier to the dark interest in her he continues. She is still an object for him, though not in any visual sense, and he seems conscious both of her experience of him (or at least of what he imagines it to be), and of himself as evoking it in her. She, by contrast, does not seem to consider—at least in any observable way—his of her. She seems content to remain all the way inside her experience, anchoring the reality that emanates from her pleasure. We can thus read the linear organization of the four figures in yet another way, with one pair bracketing another: the suitor in red providing a benign counterpart to the vicariousness of the shrouded figure next to him, and the woman balancing in her open self-absorption the closed narcissism of the toasting cavalier. Notice how the movement of hands across the painting, with its orchestration of closed and open, active and passive, secured and suspended gestures, stresses the counterpoint between these latter two: the cavalier's undistinguished glass of muddy red wine, held up high; the woman's crystalline wine in its beautifully stemmed chalice, fingers curled lightly around it where it stands in place; his too-eager toast, her restful hold; his self-isolating grasp of the lute handle so close to where her unhurried palm waits for the coin to fall.

The experiences of the man and woman mesh in such a way that ideals of union and separateness reinforce rather than contradict each other. She leans back against his arm just enough to communicate her responsiveness and casual trust in his presence, yet not so much as to disturb her own inner

equilibrium. He leans forward to surround her and reach out toward her open palm, yet without encumbering her or encroaching on her privacy, and equally without jeopardizing his own center of gravity. As subjects in complicity they seem far in the background of the transaction happening at their hands, and from their vantage they observe that transaction serenely and a bit enigmatically, as if relishing in it a meaning that escapes the external view. Even their smiles seem to emerge gently from within, in contrast to the directed, outwardly focused grins of the figures on the left.

How we view the man's grip of the coin [36] will influence how we feel about him and the moment as a whole. If we see the coin balanced on his forefinger, the tip of his thumb lightly under it and ready to flip, we will probably feel the rakish insouciance that his smile and the angle of his hat also can convey. It seems the gesture of a man involved in casual sex and relishing an image of himself that goes along with it (much like his counterpart in the Van Baburen *Procuress* [40]). The woman may either be complicit with him in this attitude or completely apart from it in her own spirit of reception.

But the longer one looks, the more unlikely this reading becomes. As the moment deepens and the bonds begin to take hold, one finds oneself seeing him *pressing* that single coin between forefinger and tip of thumb, holding it there in the moment before something is made complete. The suspendedness of things takes on a greater charge, and his rakishness softens to an almost caring, contemplative tenderness he offers her along with the coin. (Note how the gleaming stripe on his sleeve channels his attention down his arm into the piece of gold.) Now he can seem, while reaching forward, also to draw back into himself. To complete the gesture, to let go, he will have to reach his whole hand forward into hers; and, caught in the pleasure of the present, he seems hesitant to do so, to disturb the moment in any way. She too seems to savor—perhaps even more than he—the interval marked by their exchange, the experience not of anticipation but of the present moment sinking in. Her hand can even seem to be outstretched in offering rather than waiting to receive, almost as if her suitor had just taken from her something she happily extends. A secret reciprocity asserts

36. Vermeer: *The Procuress* (detail).

itself, the idea of an exchange in which neither partner is left bereft. It is an idea that will persist in Vermeer's later, more visionary work: the interval between the two hands reappears, invested with similar feeling, in *Woman Pouring Milk*, where the jug the woman holds tenderly (at almost the same angle as the coin's tilt) sends a trickle of milk down into the basin waiting open beneath it, while she looks on with happy pensiveness and with similar detachment, angled back and far inside.

A final word needs to be said about the hand on the woman's breast. It is an openly erotic gesture, no doubt intended by the man and received by her as such. The hand is not at all subtle: Vermeer has rendered it almost without "personality," in contrast to its nuanced, finely articulated counterpart involved in the coin's exchange. Yet there *is* something infinitely subtle about the way it seems to reach its destination with as little will, and as little attention to ends, as possible. One of the things that makes the gesture so moving, in fact, is the sense of fortuitousness about it. It is as if in putting his arm around her, his hand just happened to fall upon her breast—as if it were not a gesture at all but simply a matter of the fit between them. At stake in this fiction is not just tact and touch but a new sense of the real. *The Procuress* relieves sexual experience of the burden of will and inscribes it in an order (the steady wine glass, the poised coin, the woman's own happy calm attest to it) where things suspend themselves and fall by chance into natural resting places. Its loving couple presents us with an image of what it feels like to be in the world, and be assured of it.

With *Soldier and Young Girl Smiling* [37] we move closer to the focus of the problematical genre scenes. Whereas the couple of *The Procuress* describe "the lineaments of gratified desire," the man and woman here remain apart, suspended in a complicated atmosphere of anticipation and restraint. Yet the tension of *Soldier and Young Girl Smiling* is predicated on a structure of male and female aspects as complex, and as poignantly observed, as anything in the later paintings. Even if the vision of the whole remains that of a man hesitating on the threshold of his desire, drawn back into a shadow

he casts upon himself, the equilibrium that assimilates his presence feels as assured as anything in Vermeer.

Soldier and Young Girl Smiling creates, like *The Procuress*, two distinct impressions, the second of which contradicts and revises the first. Its composition tends initially to force both partial identification with and apprehension about the soldier—even if our attention is drawn to the young woman, it is channeled through his presence to her, which we tend to read in terms of her vulnerability. He appears to be projected backwards, flattened against the inside of the surface of the canvas, as if to position him just inside the threshold between the viewer's realm and the space the woman occupies.[7] His black hat, especially, tends to lie flat on the canvas rather than fill volume within the image. Slicing through foreground, background, and middle ground indiscriminately, it seems at odds with the illusion of representational depth that the rest of the painting wishes to maintain.

Closely tied to this male figure as viewers, we do not so much enter his perspective as crowd up behind it (much like the shrouded visage of *The Procuress*), obstructed as much as enlightened in an off-center, over-the-shoulder identification with him. It is as if we were in the place of that "other" consciousness that haunts the experience of sexuality—as if our point of view were that of the self secretly reflecting on itself, looking at itself looking at its object. The lion's-head finials serve as objective correlatives for both this hidden, inhibiting self-consciousness and its guarded inner object—they figure as both superego and id at once. As such they encapsulate an overdetermined male psychology: at once a concealed threat to her, a repressed desire within him, and an aspect of him that needs to protect her from both, by warning him off, keeping him at a distance.[8]

The emphasis on this viewing position creates a strong perspective divergence, and its distortions in turn affect the way we see the relationship.[9] The woman and the space she occupies appear to recede from the soldier, while he in turn becomes a dark, looming presence, alien and ominous in his place opposite her. From where we look we can see a side of him that is hidden from her (the lion's-head finials and the hand beneath the table

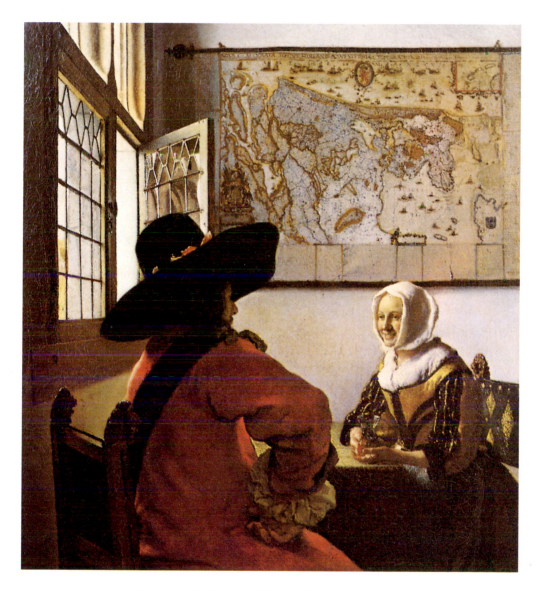

37. Vermeer: *Soldier and Young Girl Smiling*. 19 × 17 in.
Copyright The Frick Collection, New York.

are cues here); at the same time we are aware of a view of him that is un-
available to us. We tend to project these apprehensions into the scene, feeling
him as "threatening" and her—since she clearly sees nothing sinister about
him—as "unsuspecting." But there is no reason to privilege our perspective
over her own, and the possibility remains that our dark impressions are a
function of our own regard.

The identification with the soldier encouraged by this perspective yields
anything but self-transparency: we receive only vague hints of the expres-
sion on his face, and are blocked by the protruding arm from the space
where his exchange with the young woman takes place. His left arm, es-
pecially, which must be where he is closest to her, remains a mystery to us.
What we have access to instead is the other side of the worldly pose he
strikes opposite the woman, and our impressions here tend to contradict the
careless air it is meant to affect. There is, from where we look, a cramped,
defensive uneasiness about his posture, and an indrawn, evasive quality
about his gaze. It is as if he fused the two male figures of *The Procuress*,
outwardly resembling the one and inwardly concealing the other.

The gesture of the bent arm and hand, especially, seems awkward,
forced, and psychologically ambivalent. The gesture itself is a perfectly con-
ventional feature of contemporary Dutch genre scenes: it is an especially
brilliant instance of Vermeer's psychologizing of the standard repertoire,
deepening the human situation and bringing out what is latent and denied
in the conventions.[10] Here the gesture appears both to turn toward and pull
away from the young woman, and either movement can be read as an at-
tempt by the soldier either to open or close himself to her presence. The
suggestion of inner conflict in his posture contrasts markedly with her un-
guarded openness to him, while his inwardly preoccupied gaze is similarly
opposed by her undivided, brightly focused attention. He even appears to
draw back slightly (in opposition to the forward arc of the lions' heads) as
she leans toward him. The palm of his hand turns away from her, an un-
conscious refusal of the gesture she openly (and just as unconsciously) makes
to him with hers. And yet it also seems to mimic hers, and match it perfectly:
his hand is gently, softly open, just as hers is, and one senses how easily they

might meet if the artificially maintained, conventionally male posture of the arm were to unwind. But all the weight of that posture—especially with the left arm on which he must be leaning blocked from us—bears down upon the hand bent backward. The black sash pulls the soldier down into his chair and keeps him there (even while it, like the finials, arcs toward the woman), and the black hat and mass of hair refuse to let the sliver of his almost readable visage (its profile like that of the onlooking lions' heads) emerge.

If this over-the-shoulder perspective were the extent of our access to the painting, its mood would probably be determined, as in the three genre scenes, by those negative, conscience-ridden gestalts that maleness so often generates when it visualizes its presence before woman. Yet where the interiors of *Woman Drinking with a Gentleman* and *Couple with a Glass of Wine* are closed and sullen, that of *Soldier and Young Girl Smiling* is open and radiant. Its discordant elements are contained within a visionary elation.

The deciding factor, of course, is the young woman [38]. Although she is presented in the context of the soldier's attention, his presence casts no shadow on her, and once arrived at she takes on an existence of her own, independent of his gaze and the nostalgia attached to it. Through her we enter the painting and find embodiment there, freed from the projective identification with the soldier that initially keeps us at a distance. There is thus a left-to-right movement similar to that in *The Procuress*: on the one side, self-consciousness and its distancing, projective mechanisms; on the other, access to a woman's feelings, to otherness, to embodiment and the object-world. Vermeer's handling of paint underscores this difference: flat, smooth pigment for the projected soldier; "grainy, finely scumbled, light-catching paint"[11] for the woman's dress and the objects close to her.

The young girl's warmth and openness seem to emanate from her, keeping the space between her and the soldier bright and sharply contoured and causing whatever might be dark or invasive in his presence to be cast backward toward the viewer. Remote and diminished when seen through the soldier's gaze, she seems to move nearer, both to us and to him, as she comes into her own. As she does so, she counteracts the tendency of the soldier's

counterclockwise torque to fix their relationship along the lines of a sharply divergent perspective. The very force of her response seems almost enough to make them equally present to each other and establish their relationship along a lateral rather than a receding line. There are even structural cues for these antithetical tendencies within the image. The soldier's gaze is aligned with the sharply receding orthogonals of the window, whose invisible extensions converge in the empty space halfway between their gazes, as if subliminally to reinforce a feeling of how far she lies beyond him. The girl's, on the contrary, is associated with the map's strong horizontal, which starts with her and leads straight across to him. To the degree that she becomes our focal point, the distance between them seems filled no longer by pathos but by a sense of the unshadowed and imminently possible.

As the young woman becomes an interpretive center in her own right, she returns to us a triangulated image of that side of the soldier which our over-the-shoulder or behind-the-back relationship to him denies us. An irreversible diagonal of self and other, male and female, subject and object, is opened (as if by the light that comes through the window at an apex) to reveal an exchange of aspects. This process, and the way it alters our apprehension of the scene, is beautifully described by Berger:

> We read his intentions only in terms of her visible response—the receptive smile and half-open hand, gestures instinctively subdued yet warming to an attentiveness, sympathy, or delight, which is more personal than physical. So mirrored, the officer's motives are, at least for the suspended moment of the painting, purified of their conventional associations.[12]

Mediated through the young woman's response to him, the soldier no longer seems to loom over her, and his inwardness takes on a quality more rapt than defensive—almost as if he were fixing this image in his mind. The light, which he at first seems merely to obstruct, becomes associated with the attention he pays her and with her response to his presence. A regressive and self-obscuring mode of consciousness is modified, if not altogether supplanted, by another experience of the self, "seen from without, such as an-

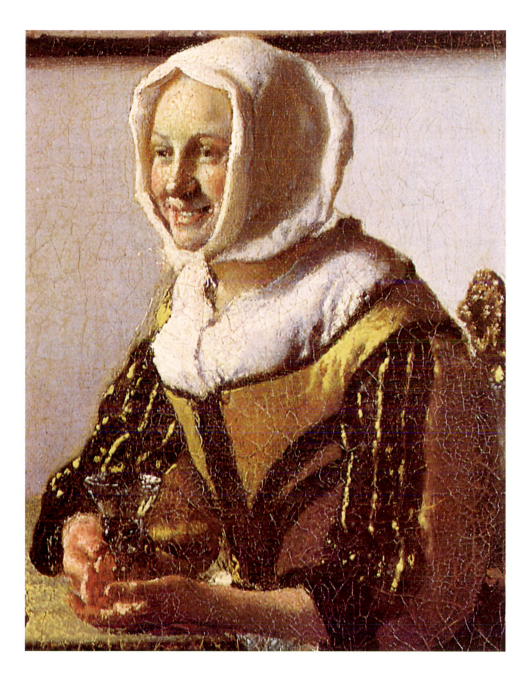

38. Vermeer: *Soldier and Young Girl Smiling* (detail).

other would see [it], installed in the midst of the visible, occupied in considering it from a certain spot."[13] And this in turn is like self-acceptance, a liberation from the elements of self-mistrust that tend to attach to a man's sense of his own sexual presence (before women, before art).

And yet the distances remain. The space Vermeer discovers in *Soldier and Young Girl Smiling* seems made for solitude. And comparing the painting to *The Procuress*—so much simpler and less poignant in conception—one can scarcely help but measure losses. The hand of the soldier, especially, seems limp and furtive in comparison to those of his earlier counterpart. It may be the kind of hand to receive or give some secret token, but it will never "sink in" or savor at confident fingertips an exchange that is openly sensual and shared. The girl's hands are much closer to her predecessor's: one reaches out to give or to receive, openly articulating; the other folds in around yet another transparent carafe, which seems here almost to rise out of the space she makes for it. But instead of spanning open like her counterpart's, they enclose her in a small triangle that echoes that of the soldier's huge blocked arm. They do extend, but only far enough to define, from her side, the negative shape that divides her from him on the canvas like a gulf. (It is similar in contour to the one that separates the isolated cavalier from the embracing couple in *The Procuress*.) However subtle the unconscious body language that their hands express, there is loss here too when one remembers the way hands, eyes, and minds are so eloquently conscious and in contact in the earlier couple. Even the direct eye contact that the young woman seems to initiate and uphold via the map's horizontal border winds up measuring the gulf between them at its widest point and—for all the promise with which it starts with her—vanishes into his black hat before it reaches him. Despite the depth of sympathy the painting generates for their relationship, no act of the imagination can make them fit.

Soldier and Young Girl Smiling is also a meditation on male and female horizons, and its vision here anticipates both the ironic focus of the genre scenes and the metaphysical viewpoint of the later paintings. The woman is boxed into her narrow domestic space (the space the painting seeks to capture) by the map, the window, and the soldier-spectator, all representa-

tives of the life of transcendence that is denied her. Yet fixed within her confines she manifests a unity, a concentration of being, a capacity to exist at the center of the present moment. She more than he seems open to horizons.

The soldier, by contrast, seems peripheral and transitory in this context, gazing somewhat timidly across a threshold that some inner conflict makes him hesitant to cross. The superimposition of window, map, and picture plane at his hat indicate his access to the outer realms that close the young woman in;[14] yet the visual effect is curiously negative. The mass and angle of the hat are at cross purposes with the open window, and the flat, uniform black pigment is at odds with both the painting's and the map's attempts to represent.[15] The awareness of external horizons is an inhibiting factor here, a point of resistance to the mood of openness and possibility that is otherwise so strong.

Vermeer concentrates these paradoxes by positioning a map directly over the young woman's head. It is the exact replica of an actual map of Holland: all Vermeer has changed is the relation between the two colors, so that blue represents land and brown the sea.[16] The reversal—so in keeping with Vermeer's treatment of the relationship between the man and woman—is oddly disorienting: familiar boundaries, without changing shape, take on a different look, and strange new territories momentarily appear. Goldscheider interprets the positioning of the map as signifying that "the country, the whole world is open to her."[17] Berger, on the other hand, finds in it a reminder of the reality that is "conspicuously excluded" from the young woman's world.[18] Berger's reading makes more sense of the painting's composition: the map hangs at the back of her head, not before her eyes, and it serves to diminish and lock her more tightly into the space that can properly be called her own. Yet there remains a certain rightness about Goldscheider's response. The map, without ceasing to restrict her, becomes metaphorically attached to her (perhaps *her* background consciousness, its expansiveness and open visibility so different from the cramped hiddenness of the soldier's)—a suggestion of what she sees in the soldier, perhaps, or an objective correlative (in so many possible ways) of her response to him.

Seen as the background of the soldier's regard, however, the map becomes ambiguous in a different sense. Gowing suggests that "the broad lines of the map . . . [might] add something to our impression of the soldier's bold plan of campaign";[19] yet it can just as easily be taken as an image of his apprehension as he surveys the unknown world of woman, where all the familiar lines he travels by are somehow in reverse. In addition, as an image of the world of masculine transcendence ("Politics, warfare, trade—the life of risk and action, the outer world containing the room that contains the map"),[20] it is juxtaposed with the woman in his eyes, as if to suggest the nature of the inner division that makes him hesitate before her.

All the map's disparate connotations receive equal weight in the painting. The same holds true of our multifaceted relationship to the couple. An initial experience of having an uncomfortably close involvement in their exchange forced on us by the male participant gives way to a more distant, sympathetic consideration enfolding both their points of view (just as the hexagonal shape of the pictorial space counteracts the strong perspective divergence). And the remarkable thing about the painting is that all its aspects cohere in a single act of vision. "Maturity" scarcely does justice to the depth of insight in *Soldier and Young Girl Smiling*. It has the feeling more of a last than a first work. Indeed, Vermeer's subsequent development would suggest a compulsion to lose everything that is discovered in this painting, so that eventually it might be found again, transformed. The reappearance of its central relationship and the charged feelings that surround it, first in the receding background of *Couple Standing at a Virginal*, then in the stable middle distance of *Artist in His Studio*, brought closer and assimilated to the act of painting, constitutes one of the most elusive passages in Vermeer. It will be the subject of the next section.

III

THE ENIGMA OF THE IMAGE

OF THE SOME TWENTY-FIVE PAINTINGS that follow the three genre scenes, only *The Concert, Couple Standing at a Virginal*, and *Artist in His Studio* continue to depict the interaction between the sexes. These paintings are among the most important in Vermeer: they chart the survival of the early concerns into the later work, and at the same time trace the development that leads away from them. Vermeer's subject—women in the light of men's attention—remains the same, but there is a gradual refocusing, so that first the image itself, then the act of representation come into view, along with the metaphysical issues that impinge on them. Together these three paintings set out the space of the artist's enterprise; they are like reflections on the matrix within which his solitary women take shape.

The setting of *The Concert* and *Couple Standing at a Virginal* is still basically that of the three genre scenes, but the unresolved tensions that complicate the earlier paintings have disappeared. Suddenly everything is calmed, watched over, protectively enclosed. The solution seems simple enough: the human content is pushed back to the far recesses of the room (as if life now took place where the solitary cavalier of *Couple with a Glass of Wine* sits brooding), beyond the range of irony. Yet one result is a new mood of intimacy, even a sense of access to that from which our nearness blocked us in the three genre scenes. Suspended tenderly at the end of the gaze instead of invaded by it, the human moment suddenly coheres, in spite of the internal distances that structure it. And it is situated in a space that seems more transcendental than spectatorial. We seem to have (just) crossed the threshold that beckons to us from the background of *Girl Asleep at a Table*.

The Concert [39] is the more modest of the two paintings. The realism of the scene can still be more or less taken for granted.[1] Its self-consciousness, as in the three genre paintings, is limited to thematic issues: questions con-

tinue to arise about the motives of art (hidden and admitted) and about both its linking and sublimating powers. The painting's human concerns, too, are in general those of the earlier works; it differs primarily in establishing a more congenial space in which to contemplate them. The two pictures on the wall pose the central relationship even more directly between the erotic and the aesthetic: the landscape is to the brothel scene as background is to foreground in *Couple with a Glass of Wine* and *Girl Asleep*, or as inner circle is to outer circle in *Gentleman and Girl with Music*. Yet the impression now is more of balance than of tension. Indeed, the two poles are bridged by an elaborate overlapping of forms that places the three human figures in intricate relation.

The counterpoint between the painting's three figures and the Van Baburen *Procuress* [40] that hangs behind them is especially subdued. Given the ironies of the genre pieces, one might expect a sly comment on the bourgeois proprieties so strictly observed within *The Concert*, or on the hidden erotic motives they both sanction and suppress.[2] And inhibition, or at least a sense of energies held in abeyance, does seem one element of *The Concert*'s mood. Yet the overall atmosphere is good-humored and benign. The immobile, introverted quality of the scene rules out any open declaration or direct physical contact (we have left the world of *The Procuress* far behind); yet it also creates an imaginatively intensified atmosphere that seems to issue from the hushed landscape, and makes the uninhibitedness of the Van Baburen seem crass and raucous by comparison.

The change in mood is perhaps most evident in the curious treatment of the male figure. He is still a visitor in an interior realm that obviously favors female presence. And he retains the capacity to stand out or intrude. The landscapes function as the map does in *Soldier and Young Girl Smiling*, framing the male figure's head against representations of the outer world, while enclosing the seated woman even more rigorously within the room's geometry. But now the relationship between inside and outside grows problematical, as everything (including the painting) tends toward image: the left wall and ceiling of the room disappear, the map and open window are replaced by two painted scenes (one a rugged vista, the other a gentler pastoral

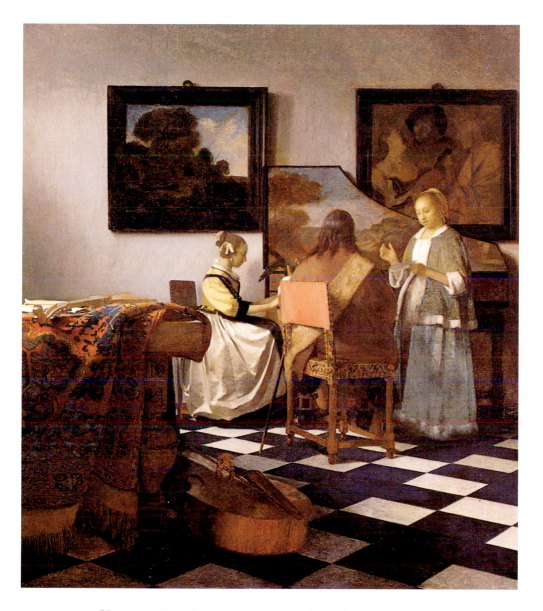

39. Vermeer: *The Concert*. 28 × 24¾ in. Isabella Stewart Gardner
Museum, Boston.

40. Dirck van Baburen: *The Procuress*. 40⅛ × 42⅛ in.
Museum of Fine Arts, Boston.

view), and the distant horizon that cuts through the man's hidden line of
sight is something that appears only when a virginal's lid is raised.

Even the man's intrusive aspect is absorbed and rendered as innocuous
as possible [41]. The ubiquitous lion's-head finials are conspicuously re-
moved. The man's sash, instead of straining forward, lies inertly on his
shoulder, dividing him in two. It comes alive only at its lower end, where
it seems to hold on tightly to the chair. The lower part of his body practically
disappears into the ill-defined area beneath the virginal. The seat of his

94

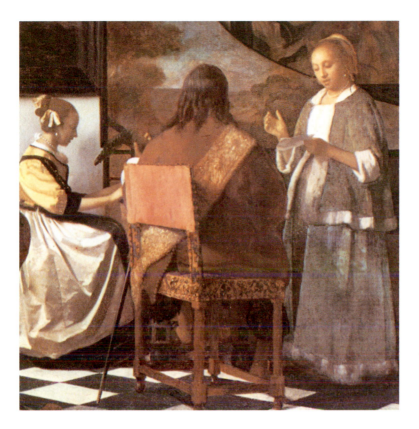

41. Vermeer: *The Concert* (detail).

chair appears almost empty, and his legs and feet (which can be found propped on the horizontal bar of the virginal's support, almost touchingly unselfconscious and at ease) are effectively replaced by the stolid legs of the support itself. Even his head—whose black hair rhymes with the black hat of Van Baburen's lusty cavalier—seems like some strange piece of vegetation that has migrated down from the landscape into the virginal's pastoral scene. Vectors, in fact, lead both left and right. The line of the man's sash runs tangent to the standing woman and points up toward Van Baburen's

95

cavalier. But a subtler diagonal slopes down from the thick trees of the landscape to their lightened repetition in the virginal's scene (displaced to the left, as if just entering), and from there to the man's clumped head, which interrupts the latter's horizon much as two dark masses jut out into the landscape's sky.[3]

The intimate placement between two women, one seated, the other standing, recalls Vermeer's first painting, *Christ in the House of Martha and Mary* [54]. But in the light of the present painting, that arrangement (the centrality of Christ, the raptness of the two attendant women) can easily seem just another self-aggrandizing male fantasy not all that unlike the Van Baburen brothel scene. Indeed, the counterpoint between the Van Baburen and the musical moment of *The Concert*, though it may hint at erotic overtones, works more strongly to suggest a discrepancy between popular images and actual feelings. The man in *The Concert*, even if he does remain central, certainly does not preside in this female realm, nor does he seem to want to. His ease, in fact, to the degree that it wins out over a potential discomfort, has to do with the way the scene makes him a focus of attention and then absorbs and effaces him, granting him not dominance and aura but anonymity. Here again, ideas first broached in *The Concert* will be worked deeper in *Artist in His Studio* [49].

The matter of who dominates, and who is in relation to whom, and via what medium or feeling, is a visually complex theme in *The Concert*. While the male figure seems to stare straight ahead, his gaze transfixed by a straight horizon line (as if intent upon the scene before him, yet looking almost like a blind man, complete with cane), the angle of his chair places him in relation to both women equally (this surely is the rationale for so strange a way of sitting): the chair itself faces the standing woman, but its orange back vectors toward the seated player, connecting with her hands. As for the man himself, only the barest indication of a left hand and the guitar it fingers is provided, but that is enough to transform (without entirely effacing) an image of uneasy, frozen spectatorship into one of relaxed, unselfconscious participation.

Still, the cues are mixed. What we can see of the guitar's handle looks strangely oversized and phallic, and its right angle points straight down toward the woman's lap, cutting through the thick protective border of the "sublimating" virginal. But this potentially ironic detail (we might expect it in either of the drinking scenes) is subsumed by the intricate overlappings that link these two figures on the canvas. Just enough of the man's brown sleeve extends beyond the chair's back to reach the woman's half-hidden hands, which rise slightly, as if leading up to and finishing in his. Note also how the descending black trim on her lap and the downward slant of his sash converge, and how the rising line of her skirt's silver edge is continued by the coattail draped over the chair's seat. This dense area of interconnectedness makes the two appear—almost subliminally—a couple, separated from and perhaps even overseen by the woman on the right.

Other near-subliminal aspects also configure the threesome this way— as if they were, again, a transformed version of the Van Baburen above them. The man's sash, for instance, divides him into virtually two separate beings. To its left the head, shoulder, back, and hand cohere (however quirkily) as an upper body, illuminated by the same light that brightens the seated woman. To its right, however, the man's lower body dissolves into a dark brown mass, amorphous and indistinct. The sharp unbroken contour that separates him from the standing woman opposes the intricate overlappings that connect him with the seated player. Though it does meet the woman's skirt at two points, this contour recalls some of Vermeer's most negative divides: the arc of the man's cloak in *Woman Drinking with a Gentleman*, for instance, or the dark vertical space between the two pairs in *The Procuress*.

This arrangement of two and one can be read in different ways. Most benignly, as the man sits down to play, the patronizing, paternalistic, and/ or predatory overtones of his bothersome standing position in the three genre scenes disappear, and he is united with the seated woman in a mood of almost childlike innocence. Correspondingly, the superego now finds female embodiment in the more matronly figure who stands apart at the

right, chaperoning (it would seem) as well as participating in the musical occasion. Logically an inhibiting factor, her presence surprisingly relieves tension, as it ballasts and balances the relationship over which, from one perspective, it presides. Her singing is especially important when we think of her as a stand-in for the superego: instead of subjecting the seated couple to a suspicious, prohibitory gaze—the gaze with which the three genre scenes are permeated, and which their audience must adopt—she unites them in a sonorous auditory envelope.[4] Its boundaries may only reach out so far in this tentative painting—one feels it almost like an island—but it is the prototype for the way space itself encompasses things in Vermeer's greatest works.

The standing woman's raised hand is especially interesting. It echoes the open palm of Van Baburen's procuress, her direct counterpart in the painting just above her. But instead of crassly demanding payment it lifts beautifully into the virginal's landscape, gently cupping, perhaps even figuratively waiting for or holding something (it has affinities with each of the hands of the serene woman of Vermeer's own *Procuress*), but certainly not expecting money. And as the gesture of an overseeing figure, what might almost be an admonition becomes instead a means of keeping time, even a gentle shaping and containing of the invisible song she draws from the transcript in her other hand.[5]

But the standing woman is more than just an adjunct of the seated couple. She is also a counterpart of the other woman, and when the two are seen as such, the man becomes a shadowy mediating presence between them, contained almost womblike beneath their arc. His sash, no longer vectoring toward the brothel scene, leads like a path from the skirt of the harpsichord player to the hand of the singer, creating a sense of progression as well as equilibrium between the two.[6] Indeed, the player on the left seems to belong to the women of Vermeer's earlier paintings,[7] while the singer on the right, with her bell-shaped presence and her ermine-trimmed coat spread slightly open at the waist, suggests the solitary women of the later work—especially *Woman in Blue Reading a Letter* and *Woman Holding a Balance*. Even the positioning of the two suggests emergence: while the

seated woman is confined protectively by the two pastoral scenes, fitted like a mosaic tile in the construction of the painting, the standing woman casually bridges the pastoral/erotic divide (she is the only one of the three figures to do so), and appears almost free to leave the scene.[8]

Vermeer even creates an access to the standing woman that bypasses her two companions. The light which enters on the left sweeps toward the player and illuminates her, strikingly, in contrast to her companions. Yet, more subtly, it seems to reach into the landscape behind them all and draw some of its pastoral color into and over the woman on the right. This infusion combines with an upper-left to lower-right diagonal, which descends gently from the framed landscape with its dark undergrowth and swatch of white-clouded blue sky, down through the more muted green-browns and blues of the virginal's pastoral, to emerge in the bluish-green, white-trimmed dress of the standing woman. The progression of peaceful blues creates a waterfall effect, and the drop of the woman's skirt issues in an open space which seems to widen as the light channels brightly through it.

In contrast, the objects on and around the table accumulate almost like the room's version of the depicted landscape's undergrowth. Their darker, more earthy tones reach toward the seated couple and seem to lighten in them, much as the upper landscape lightens in the pastoral. The saturated colors of the tapestry are even duplicated in the left vertical support of the man's chair-back, as if to stress their potential infusion in that area, before they are diluted in the more inert browns, golds, and pale oranges of the couple's space.

These objects in the left foreground also initiate an extended diagonal—it crosses the more condensed "waterfall" of blue—that subsumes the trio on its way to the shrouded brothel scene at the upper right. But in contrast to the easy flow of blues and greens that culminates in the fall of the standing woman's skirt, there is a wavelike accumulation of potential energy in these dark masses in the lower left. The folds of the tapestry resemble the lines of a cresting wave, while the unused viola and the expanding tile crosses seem drawn toward the foot of the table as if sucked by some shadowy undertow. The obscure carvings on the massive table leg—so different

from the elegant decorations of the thin-legged chair—add to the sense of a dark substratum upholding the tapestry that sparkles at its crest.

The folds of the tapestry rise as if in defiance of gravity and wrap themselves tenaciously around the table's edge, so that they reach toward the seated woman and become part of the intricate mosaic that holds her in her place. Her chair-top pins the tapestry to the table more convincingly than the relatively weightless lute, which lies thinly across the table and juts out toward the viewer, almost puncturing the picture plane with a *trompe l'oeil* effect.

All the potential and inchoate energy in the left foreground, then, is channeled toward the seated woman and her male partner, who seem both close to it and far away. We can feel variously about the relation between the two planes. On the picture's surface, a bridge is formed between areas kept separate in reality, and there is a secret infusion from one to the other. But within the illusionary spatial envelope, a sharp channel of light cuts between these two areas, keeping them separate, preventing chthonic forces from inundating the globe of music within which a fragile human interval is prolonged. (Consider the way the tapestry in *The Procuress* surges up from below to flower in its amorous couple, and how far we have receded now from *that* vision.) The widening tiles at the lower right are the hinge on which these two perceptions turn. Do the two large black crosses, under the influence of the waterfall of blue and the spreading light, sweep straight through and out at the lower right-hand corner? Or do they make a ninety-degree turn at the woman's skirt and the man's chair, and pull us into the shadowy undertow at the lower left? Does Vermeer depict a widening, increasingly unimpeded channel of light or an ambivalent circuit of light and shadow, desire and restraint? Are forces being kept at bay by that envelope of song, or do they already circulate in the music being made?

These questions find counterparts in the man's ambiguous relationship to the two women. The strong diagonal that starts with the dark-toned objects in the lower left sweeps straight through him on its way to the brothel scene, isolating him from the brightly colored female pair. Yet other factors work, as we have seen, to configure him with the two women and absorb him in the pastoral scene. And even as a member of the trio, his connections

with the women differ. Though he is elaborately linked (by position, color, light, and overlapping forms) to the player on his left, his chair turns toward the standing woman on his right; and if the desire to draw near grows strong anywhere in this painting, it is in the space between these latter two. Indeed, the man's immobile gaze, fixed, we must assume, on his guitar, still pulls mysteriously toward the woman on the right (while the horizon line draws *him* even more mysteriously into the painting, detaching him from the "chthonic" diagonal, securing him within the women's plane). In this *The Concert* again anticipates *Artist in His Studio*, where the head of the artist-figure, also viewed cuelessly from behind, seems to pull toward the far-off model on his left, even though his hand is working closely on the canvas at his right [42, 43]. The later painting's powerful and unabashed attraction is still largely held in check in the earlier work. But what if the lute player of *The Concert* were transformed into an artist, canvas before him and brush and maulstick in hand? What would he be painting? A brothel scene? A landscape?[9] A young girl seated at a virginal? Or a solitary standing woman?

With the distancing that *The Concert* performs, the act of vision and the image itself come into focus, but almost inadvertently. In *Couple Standing at a Virginal* [44], however, this new focus seems the essence. Suddenly it is not just depicted moments and relations that are in question but reality itself, especially as it manifests itself in images. Contours, intervals, things that separate, measure, and connect, are strangely intensified. The table and the viola da gamba of *The Concert* are mundane objects subsumed in an elaborate thematic play. But the similar objects of *Couple Standing at a Virginal* are *presences*, imbued with a life that exceeds the logic of verisimilitude. In a like manner, it seems no longer a question of merely depicting desire and its boundaries, or even constructing it as a theme; the image itself is charged with a desire that seems intrinsic to representation, one that finds only partial embodiment in the human moment it pictures. Space itself takes on the quality of the uncanny in this painting—as if it were not so much mimicked on a canvas as carved out of thin air and surrounded, ten-

42. Vermeer: *The Concert* (detail).

uously, by a frame. And it resonates as never before in Vermeer—as if the unheard song of *The Concert* enveloped the entire image and blended with the more elegiac silence of things passing.

In terms of human content, *Couple Standing at a Virginal* both clarifies and complicates the tentatively achieved resolution of *The Concert* by transposing it back into the more tense, erotically charged atmosphere of the

43. Vermeer: *Artist in His Studio* (detail of 49).

earlier paintings. The objects piled up between the viewer and the couple recall the defensive structures erected in the foregrounds of *Girl Asleep at a Table* and *Girl Reading a Letter at an Open Window*; yet here they encourage imaginative involvement, and channel it toward the crucial point of human exchange—here, as so often in Vermeer, a charged interval not directly bridged.

These heaped objects involve us largely by triggering the imagination's anthropomorphizing impulses, and by activating fantasies of crossing over and taking part. There is something, for instance, both sphinxlike and maternal about the portion of the carpeted table that dominates the right foreground [45]. Gowing even identifies its form as that of a seated woman's lap[10]—a highly subjective perception, but one that tends to be borne out by the way carpets serve as imaginative extensions of women's laps in other paintings by Vermeer, most notably *The Procuress* and *Girl Asleep at a Table*. And the resemblance is all but clinched by an element the image conspicuously excludes. A Roman Charity hangs in the upper-right background of *Couple Standing at a Virginal*, cropped so that the viewer can barely make out a kneeling man's arms tied behind his naked back. If Vermeer's frame were to extend rightward to include the whole of this painting, it would reveal—in the upper-body area just above the carpeted "lap"—a bound man nursing at a woman's breast [46].[11]

It is as if the watchful function of *The Concert*'s standing woman—her reassuring presence a haunting absence here—had been taken over by the object-world itself, whose chthonic forms, instead of building up eruptive force, spread out and tranquilly preside, avatars of a more archaic maternal.[12] The white pitcher, a locus of suspicion in *Woman Drinking with a Gentleman* and of aesthetic indifference in *Couple with a Glass of Wine*, now also reassures. It stands on the table like a manifestation of pure presence, and in its role as object it helps to pull the entering light across the frame's cavernous space. (In *Young Woman at a Window with a Pitcher* [62] a standing woman will bridge this gap.) It seems there now for the viewer's grasp—as if it were a still point toward which the mind could reach as it crosses over into the painting's illusionary space. Even the unused viola da gamba (here freed from *The Concert*'s undertow) and the empty chair now indicate a place for *us* in the composition, and virtually invite us to participate in the unstoried space of the exchange.[13]

The accumulation of objects and interlocking forms in the right-hand side of *Couple Standing at a Virginal* balances the sensation of sharply receding space accentuated on the left. The foreshortened orthogonal leading

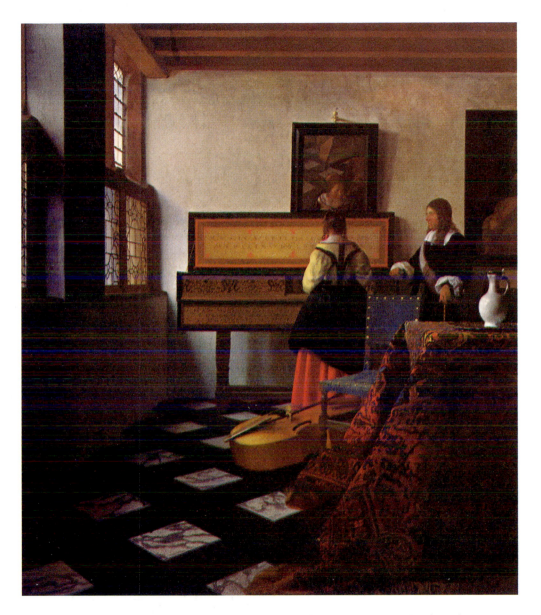

44. Vermeer: *Couple Standing at a Virginal*. 28½ × 24⅝ in. Buckingham
Palace, London. By permission of H. M. the Queen. Copyright reserved.

inward along the edge of the table to the chair's back measures a much shorter distance to the woman than the one indicated by the lines of the wall on the left.[14] It even places us differently. Its near end brightens illogically at the table's corner, whose jutting tapestry seems to push against the painting's surface from inside, an effect heightened by the thick, scumbled paint that represents it there. It is almost as if, standing where we are, we could touch this cathected point within the image. The wall on the left, by contrast, exits the frame in exaggerated perspective: if we were to imagine it (prompted, perhaps, by the way the black crisscross seems to spread beneath our feet) extending outward to include us, we would have to locate it far away and out of reach. The viola da gamba and the edges of the rug work similarly. They cover the tile floor which, if left exposed, would define our relationship to the couple in strongly recessive terms. As it is, it seems but a short distance from the fringe of the rug to the woman's skirt—a distance, however, measured not in depth but vertically, in terms of the mosaic pieces that lie flat, one above another, on the surface of the canvas.

So convincing, in fact, is the impression of spatial integrity conveyed by the broad perspective, that it comes as something of a shock to notice how radically the painting divides into compositionally distinct spaces. The left-hand side might be part of an interior by Saenredam: it gives almost surrealistic emphasis to the deep recessive space of the painting, its existence as "an envelope of quiet air."[15] This emphasis on a third dimension controlled by the viewer's perspective enhances the illusion of a life, a present moment, continuous with ours, accessible to us on our own terms. As Descargues remarks, giving voice to a fantasy deeper than he realizes, "We . . . feel that simply by sitting down on the floor we should find ourselves in the heart of the picture."[16] Yet in the process, life, as in *A View of Delft*, comes to be seen as unapproachably remote: we are made to sense the tenuousness of human presence and to feel the slippage of the moment that holds it in suspension.

This feeling of "slippage" may seem utterly phantasmatic, but it is one of the painting's most precisely calculated effects. The light seems to be changing, and taking things laterally with it (in the case of the virginal's leg,

106

45. Vermeer: *Couple Standing at a Virginal* (detail).

46. Follower of Mattheus Stomer: *Roman Charity*.
Museo del Prado, Madrid.

shadow by shadow by shadow), even as it passes through. Everything, so perfectly arrested, can seem suddenly to be shifting imperceptibly to the right—as if the frame were panning slowly left, toward emptiness. Even the rigorous horizontals tilt infinitesimally down and to the right, while the veins in the marble appear to respond (like paint still wet) by seeping in that direction. The two billowy overhangs of the carpet attempt to hold on to the floor as the table pulls through, while its fringed bottom crawls edgingly

along. The mirror's top falls forward, and its double shadow tilts successively to the right. The woman's reflection seems subject to both these movements, and one wonders how long the thick black frame can hold it. Even the woman herself, a paragon of uprightness, tilts slightly to the right.

The white vase that stands intact at the very edge of the frame takes on added importance as this feeling of slippage registers. Note the way it is played off against the cropped, half-vanished painting just above it: it is like a brake against any further movement to the left, a resistance declaring, like Woolf's Mrs. Ramsay (or like the desire of Vermeer's own image), "Life stand still here!"—and yet, by its very position (again like Mrs. Ramsay), the next presence fated to disappear.

In contrast, the right side calls attention to the painting's existence on the canvas, as "a surface with the absolute embedded flatness of inlay."[17] Here the illusion of depth is minimized; the couple comes toward the surface of the canvas, stabilized within a mosaic of interlocking forms (the woman partially included, the man completely caught). Yet as they do, they acquire (as the life captured in *A Street in Delft* [47]) the remoteness of something that exists only on a painted canvas or in the realm of memory, something already set in the past or fixed in an artifice of eternity. "Space" is all but lost to us: it becomes more difficult (and perhaps less assuring) to imagine that "simply by sitting down on the floor we should find ourselves in the heart of the picture."

Within the intricately measured, temporally complex space of *Couple Standing at a Virginal*, the separateness of the individual figures becomes more pronounced than in *The Concert*, and the aura of aloneness that surrounds them more reflective. Both the costume and the pose of the woman recall the solitary figure of *Girl Reading a Letter at an Open Window*, while the appearance of the man and his proximity (on the surface of the canvas) to the white pitcher that reappears from *Couple with a Glass of Wine* associate him with the introverted, withdrawn figure in the background of that painting. In bringing these two previous instances of moody self-absorption together in an obviously romantic atmosphere (the woman's reflection, whose analogue in *Girl Reading a Letter* reinforces solitude, here

establishes a circuit of desire), it is not clear whether Vermeer means to resolve or deepen the problems of relation with which the earlier paintings are concerned.

The man's attendance likewise becomes subject to the ambiguities that attach to the male figures in *Woman Drinking with a Gentleman* and *Gentleman and Girl with Music*. Is he her suitor, her instructor, or her deferential audience? Is he speaking, about to speak, or just listening, openmouthed, as she plays? And what is going on in his mind as he stares at her? The Roman Charity behind his back seems to haunt his thought. The bound hands visible in the painting counterpoint his own unfettered yet nervously suspended ones. And its unseen portion, in which an imprisoned father sucks abjectly at a daughter's breast, seems equally to color the ambivalent distance across which he stares.

Yet the uneasy aspects of the man's presence, as elaborately counterpointed as they are, no longer seem to implicate the anxiety or bad conscience of the artist, and as a result they are all but overridden by the painting's larger vision—which frames no story—of what holds the couple together. If its world were still that of the genre scenes, we might be tempted to view the scene, with one recent critic, as a nightmare of enthrallment, the intrusive male now held captive in a space controlled by the woman, who slyly casts her spell on her unwitting suitor, a figure of "paralyzing entrapment."[18] But if the painting makes room for such a view, it subsumes it in a vision of two distant people "alone together" in a space moved by forces beyond the ken of either. They seem figments of a transcendental mood. The very matrix around them seems to brood. Even the emotions that charge their space seem to issue as much from the image itself as from their own remote interiors. The expression on the man's face has been described by another critic (in support of the view that "the painting's subject does not matter") as "indifferent,"[19] and an isolated detail [48] might support an even more negative perception. Yet from far away he appears utterly transfixed—whether by the woman or by something in himself we cannot say—and Vermeer's allegiance in this case seems clearly to the distant view.

110

47. Vermeer: *A Street in Delft*. 21¼ × 17¼ in.
Rijksmuseum, Amsterdam.

One of the magical aspects of the painting, in fact, is the sense of intimate access to the human content of the scene, not only in spite of but as a function of the remote perspective that suspends life in images. The woman's "gentle stillness of stature,"[20] especially, with its ambivalent, barely perceptible acknowledgment of the man's presence, is eloquent: the back of her head (it seems in spirit like the neck and earlobe of *Head of a Young Girl*) is as nuanced and involving as the man's in *The Concert* is inert and inexpressive.

Vermeer's preoccupation with thresholds is again evident in his approach to the subject of the painting. The distance that separates the couple is charged with the same mood of anticipation and restraint that colors *Soldier and Young Girl Smiling*. The man brings forward his right hand (the hand his counterpart in *Soldier and Young Girl Smiling* withholds) to bridge his distance from the woman, but in the process he sets up a barrier.[21] Its defensive aspect is reinforced by the way the man's sash sweeps back and down toward his left hand, as if strapping him in place. (Contrast the more charged ambivalence of the earlier painting's sash, which appears both to strain toward and pull back from the young girl.) At the same time the woman's hands, which in *Soldier and Young Girl Smiling* are so openly responsive to the cavalier's presence, become nervously preoccupied with the keyboard of the virginal and disappear from view.

It is the woman, likewise, who now embodies the contradictory torques that in the earlier painting characterized the soldier's presence: her upper body both opening and closing, turning both toward and away from the man at her side (the branching black trim on the back of her dress makes visible the pull in opposite directions), her tucked right arm signaling tensions similar to those *Soldier and Young Girl Smiling* locates at the soldier's jutting elbow. Her companion, meanwhile, now locked into the mosaic she seems half-free to leave, looks at her with the same focused attention that characterizes the young woman of the earlier painting. He, like the young girl smiling, initiates a strong lateral gaze, which is as unwavering and unequivocal as hers, and makes him seem as vulnerable. Unlike the soldier, into whose black-rimmed hat the young girl's gaze disappears before it

48. Vermeer: *Couple Standing at a Virginal* (detail).

reaches his, he is without any defense against the other's look, in spite of the distance he maintains. Were the woman to stop playing and look back at him (in the way, for instance, *Head of a Young Girl* turns itself on us), her gaze would meet his full force.

Yet although the separately gendered aspects of *Soldier and Young Girl Smiling* are more evenly distributed in *Couple Standing at a Virginal*, little of the earlier painting's mood of freshness and imminence—so vibrant, as we have seen, in the seated girl—survives. The gaps that will not close in *Soldier and Young Girl Smiling* have become part of the very architecture of *Couple Standing at a Virginal*. As the man places his hand on the virginal in the later work, it is as if he measures the interval that separates him from the object of his attention precisely and forever. The instrument of art thus mediates and stabilizes, as it does in *The Concert*, but it also absorbs and gives form to the tensions it allays. The inscription on the lid of the virginal reads "*Musica Letitae Co(me)s* [or *Co(nsor)s*]—*Medicina Dolor(is)* [or *Dolor(um)*]": "Music, companion [or consort] of joy, medicine for pain [or grief]," hinting at an allegory of the pleasure and melancholy, not just of love, as Gowing suggests,[22] but of art itself.

But to leave the central relationship here would be to ignore the part played by the mirror, which mediates along with the virginal, and causes the image to portray something different from the pathos of abject or unrequited love. The man may be depicted as isolated in his desire, gazing with feelings he keeps secret at a woman whom he assumes to be his object, and who in turn conspires to seem so, equally isolating herself by keeping her awareness of his gazing to herself. (This is at least a more visual story we can tell.) But the mirror constructs a different relationship. Reflected in it, the woman becomes a *viewer*, gazing unseen across one threshold toward a man who gazes similarly across another threshold toward her real presence. The man's isolated look is thus caught up by the mirror in a chain of gazes that unsuspectingly returns to him. And the way Vermeer depicts this chain, it is the mirror's image that appears—illogically—to initiate it: we see the woman's reflection watching him watching her. The painting thus depicts the space of longing between male and female, subject and object,

but then goes further, grafting onto it a more difficult passage between the real and the virtual. The result is a vision, not so much of the separation between two people, as (again in Gowing's words) "the pure essence of relationship."[23]

Thus a man gazes at a woman playing at a virginal, while she manages, without his knowing, to glance at him in a mirror as he watches. Yet so little does the image in the mirror agree with the woman it reflects, and so haunting is its aura of otherness, that one can scarcely be satisfied with such a literal account of its effect. The image turns much farther toward the man, and looks at him more steadily and directly, than the "real" woman's upper body and poignantly held neck lead us to anticipate. It reads more convincingly as a projection of her inner, otherwise unexpressed aspect—of what she might be thinking, of how she would *like* to gaze—than as a straightforward reflection of her look. The image can even seem to detach itself entirely from the woman. It is as if she were no more aware of its attention to the man at her side than he is. And detached this way, its blurred attention can read many ways—desiring, trying to draw the man's attention, observing him wistfully, furtively, or with cool detachment, perhaps even wishing to redeem him from his predicament.[24] It can also attach itself to the man—an over-the-shoulder consciousness counteracting (yet from so far away) the bound hands that haunt him closely on the other side. The virginal player, as already noted, recalls the solitary figure of *Girl Reading a Letter at an Open Window*; but now it is the man over whose right shoulder her reflected image watches, as if her projection were at the same time his anima, a deeper, more distant second self.

Here Vermeer's experience within the triangle of representation may be a factor. The position of the mirror vis-à-vis the man's attention to the woman is comparable (though the distances are different) to that of the depicted canvas in *Artist in His Studio* [49] vis-à-vis the painter's attention to the model whose half-averted gaze and torqued body his art attempts to bring near. It is notable in this respect that behind/above the head in the mirror of *Couple Standing at a Virginal*, the lower portion of the artist's easel (the device, that is, upon which *this* painting rests) is visible. The mirror

would thus seem to frame a space where the logic of representation is suspended, and the desire of the artist—to be taken into his work, to share the life of what he paints—is fulfilled.[25] In doing so it provides a tentative gloss on the "faintly magical atmosphere"[26] of *Couple Standing at a Virginal* itself, and at the same time prefigures the world of Vermeer's more confident masterpieces: not only *Artist in His Studio*, where both model and painter exist within the painting's space, but the series of single standing women from *Young Woman at a Window with a Pitcher* [62] to *Woman Holding a Balance*, all of which seem to cross the threshold of the mirror realm and grow real as images.

But in *Couple Standing at a Virginal* the achievement of the image is still balanced by a narrowing of the possible. The whole descending apparatus of knob, mirror, image, virginal, and standing woman with converging trim (the mirror's thick verticals, extended to the floor, would ruthlessly contain her) seems to balance on a single shadow, which tilts doubly downward as it emerges from behind the frame. And what appears in the mirror is vague and attenuated. Light does not reign there. The massive table seems to shrink. Certain objects—the chair, the viola—disappear. The sense of slippage to the right and out of sight is even more pronounced than in the image as a whole. And the barest sign of the artist's presence in the mirror involves his absence from the world it reflects. And where exactly *is* this world, whose reality the painting conveys with such hallucinatory force? Is it life itself—that which evades the artist's grasp, and which survives (in) the absence of the viewing self? Or is it the hermetic realm of art, at whose center a ghostly author is installed, busily bringing into being on his empty canvas the reality that contains and confirms his presence?

It is just when art succeeds in capturing life, and not just more art, that life itself becomes uncanny. Looking at *Couple Standing at a Virginal* one feels what Wallace Stevens means by "the world as meditation." The visible world appears doubly encompassed: by a watchful maternal aura, to be sure, but also by an impersonal, disembodied consciousness brooding on vacancy and the slow, imperceptible passing of what seems unchanging. A sense of mortality hangs over the entire scene and a vague sorrow attaches to it. The

virginal might for all the world be a casket (the inscription on the lid, so different from the landscapes that decorate Vermeer's other keyboard instruments, has the look of an epitaph), the woman a mourner looking over into it, and the reflection in the mirror a presence gazing back from the other side of life.[27] (The face lying in state will become visible as the mask resting on the table in *Artist in His Studio* [50].) Yet at the same time, the couple seem to be held tenderly in a space from which all possibility of change or loss has been banished—the giant form in the foreground watches over them as if they were children in a nursery. The sense of a revelation decisive for the artist is in the air, yet its content remains elusive. As with *A View of Delft*, the painting can make us feel, depending on our mood, either that we are in the hands of God or that all passes into oblivion, either that we are weighed down or weightlessly suspended, either that the world is there beneath our feet or that nothing exists beyond the moment of perception.

If *Couple Standing at a Virginal* marks the threshold of metaphysical concern upon which Vermeer's middle period opens, *Artist in His Studio* [49] invokes its closure. Whether we view the later painting as open to its audience (in self-disclosure) or turned meditatively inward (in self-reflection), as lifting the veil of appearances (and discovering there the ongoing act of representation) or as stepping back in order to restore painting to the ordinary world (and in the process turning reality into the scene of art), it gives the impression of a summing up, a statement of value that draws on all the depictions that have preceded it.

Less immediately apparent, though perhaps ultimately more revealing, is the intricate network of references to Vermeer's previous scenes of erotically unresolved interaction between men and women. The figure of the artist seems a culmination of all Vermeer's previous images of male restraint and discomfiture. His hat and his costume refer all the way back to the excluded, self-conscious "artist-figure" of *The Procuress*, who is transformed here into an actual painter unaware of any audience, anonymously absorbed in his work, involved almost without his knowing in the exchange of erotic

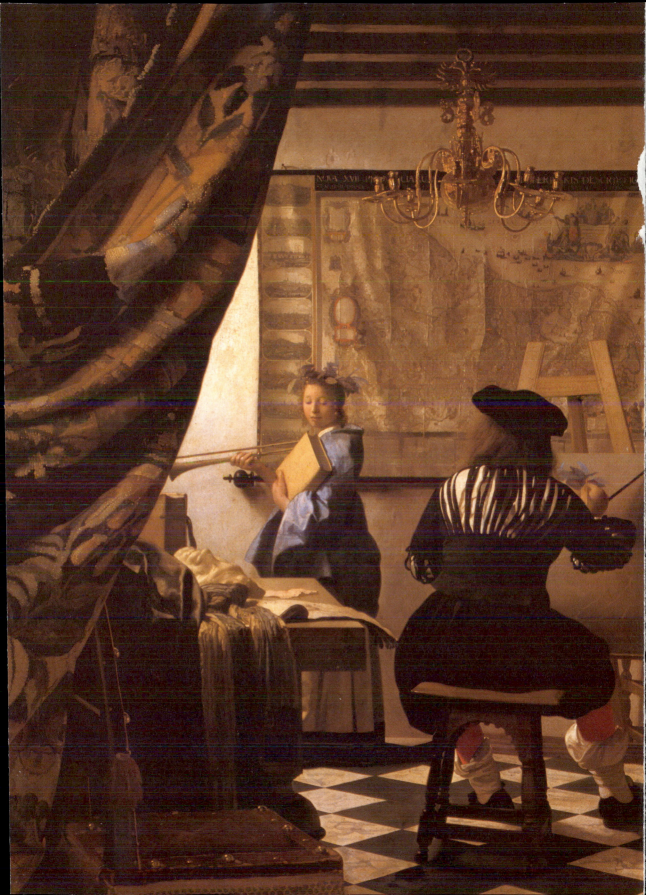

49. Vermeer: *Artist in His Studio.* 51½ × 43¼ in.
Kunsthistorisches Museum, Vienna.

energy from which artistic consciousness is set apart in the earlier painting. His posture, and especially the back of his head, recall, as we have already seen, the seated figure of *The Concert*, only now not so much has to be hidden, erased, or held in check to preserve an image of good conscience. (For the first time in Vermeer since *Christ in the House of Martha and Mary* [54], the lower part of a man's body becomes plainly visible.) The slight turn of the artist's head in the direction of his model now becomes an irresistible perception, and strangely moving. Vermeer provides only the barest of cues: the tilt of the hat toward the woman and the thick black line of the map— so opposite in effect from the thin transfixing horizon of *The Concert*— leading the artist's unseen eyes across toward the model. (Vermeer has placed his signature in this line of sight.) One can thus still *will* a perception of the artist concentrating on his canvas—an even thicker horizontal leads back from model to brush—but only by resisting powerful forces pulling his gaze away from his canvas and to the left. This slight trace of a gesture, felt from behind rather than seen to transpire, seems more expressive of the force that draws man to woman—and keeps him apart from her—than anything one might view directly on a face. On the other side of that cloud of brown hair may be only the "neutral, unimpassioned"[28] gaze of an artist painting what he sees; yet it reads as an expression of love, even if that love has no existence outside the act of representation. We seem back to the paradoxes of Degas's nudes, now meditated on by the work of art in which they appear.

Given the situation as Vermeer has depicted it, one may come to feel that the deepest function of the painter's art is to sanction and prolong his gaze. What seems to count most is the feeling the painter betrays for his model, and the magical atmosphere that holds for the duration of the painting. One wonders by what process, if at all, either of these imponderables will leave their trace on the finished canvas, especially since the painter is in the process of portraying his model as Clio, the Muse of History, in an allegory of Fame—a project that could scarcely be more at odds with either the sense of time or the spirit of place that prevails in the painting.[29]

Yet at the same time, what *Artist in His Studio* tends to communicate to its audience before all else—the painter's lingering over the model's laurel

wreath and Vermeer's own loving depiction of the map and tapestry bear witness to it—is the sheer pleasure of representation, which in some important sense preempts the ends it serves. It may seem that the act of painting is only a pretext for the relationship it sanctions between the painter and his model, but it seems equally the case that the painter's subject (allegorical, feminine) is only a pretext for the act of painting.

The underlying paradox finds its focal point in the leaves of the laurel wreath. Does the painter's concern with copying exactly their intricate pattern (the least virtuosic of painters, he employs a maulstick at this early phase of his project) and his intent on painting them as blue as they appear on the model's head indicate a single-minded absorption in the business of painting? Is it an aspect of Vermeer's gentle irony that this painter, immersed in a privileged moment of being, confronted by the light that streams into his studio and the radiant female presence that stands before him, remains oblivious to everything except the details of an allegorical prop and the task of transferring them onto his canvas? Or does his brush temporize more poignantly at the verge of a critical threshold, while he takes his last free look at the face of his model before having to confront it at the level of representation, where all the feelings that look back at the artist from the canvas of *Head of a Young Girl* come into play?

The painting makes room for both perceptions, and one of its most subtle details applies to either: as the painter's brush concentrates on the leaves of the wreath, his bulbous hand fills the place that will eventually be taken by the image of the model's face and head—as if it were the raw material out of which her features are to be modeled. A narrow strip of white sleeve is even visible at his wrist, just where the strip of white collar appears at the base of the model's neck. And both the blousy part of his sleeve and the right contour of his body trace equivalents on his canvas of her bell-shaped shawl. For just this moment (so the fantasy would go) there is bulk and volume, real flesh, where eventually there will only be an image. And it is the flesh of the artist's hand, given to, and one with, what it paints. It seems fitting that the laurel wreath over which he labors should crown not the artist's head but the hand that paints, subdued almost to what it works in.[30]

The laurel wreath brings into question both the act of representation and the play of light and paint, in such a manner as to suggest an oblique triangularity subsuming the more straightforward polarity of object and image. To begin with, what are we to make of the wreath's *blue* leaves, which seem to proliferate, intensify, and grow abstract on the artist's canvas? Are they really *in* the model's headdress? And if so, why? Cesare Ripa's *Iconologia*, a virtual handbook for Renaissance allegorists, stresses the lasting *greenness* of Clio's wreath: "The laurel crown expresses that like the laurel which is always green and maintains its greenness for a long time, that also therefore through History the past as well as the present lives eternally."[31] As departures from the allegorical formula, the blue leaves tend to pose the issue of historical versus fictive permanence. For green (as both Vermeer and his surrogate must know) is the least stable pigment, and, over time, as the yellow in it loses power, it evolves toward blue—the color of eternity in a more venerable iconography.[32] This evolution would make an apt emblem for the more equivocal lastingness of images—in which, as paint cracks, fades, and deepens, the captured present (already displaced) takes on an aura of both the everlasting sacred and the ephemeral profane. Note how the two pigments—the yellow of the model's book and the blue of her shawl—are juxtaposed below the equivocally colored leaves in a surprisingly intense embrace. If allowed to intermix (by a trick of the eye, a slight blur of technique), they would produce that fragile green of historical "foreverness." They do not—they are kept distinct. Held as they are, so tenderly close, they seem designed with painting's eternity in mind.[33]

But what if those blue leaves are not in the wreath at all? What if they are merely an effect of light and shadow, which the artist unthinkingly makes real by translating into paint? Here the circular irony would be obvious, since those effects of light and shadow would first of all be effects of paint on Vermeer's own canvas. But what then is *Vermeer* copying? And what is *his* thought? Perception and image, light and paint: where do things begin, and what process takes its course as the given is transcribed? And how (if at all) does the mind intervene?

These questions are intensified by the (re)appearance of the leaves in

the folds of the giant tapestry, where they also tend from green to blue as they rise upward. (One can also make out there, obscured among the folds, a standing woman's curved skirt, whose colors invert those of the upright model's columnlike lower dress.)[34] The transaction between subject and object, or between object and canvas, is thus triangulated by a weave of abstract forms that is anterior to them both. Alone among Vermeer's curtains, this tapestry shows its back to us, where we can see the web and stitching, dangling thread-ends and all, on the other side of its woven forms—which face inward toward the scene and have to be turned over, not just pulled back, in order to reveal.

And the three sets of leaves read in opposite ways at once. If we start with the wreath on the model's head, there is a progression from the thing itself—already in this case an artifice, an allegorical prop, the color of its leaves in question—to the artist's canvas and its flat, abstract, "copied" image, to the tapestry with its deep folds and *jouissance* of forms. Or we can follow the progression in reverse, starting with the leaves on the tapestry and moving from the wreath to the canvas or from the canvas to the wreath. The question of what (if anything) is before or behind representation (or appearances, or reality) is thus subtly reformulated by the very gesture— the lifting of the tapestry—that appears to give an answer. If the painter's activity seems to assert art's mimetic subordination to a distant, external reality, it is nevertheless within a painting that he paints, and the tapestry that reveals him implies the existence of an imaginative *Urgrund* within which the forms of the real are already woven.[35] (Against the light that floods the painting from an outside source, apparently in obedience to the laws of optics, the tapestry contains its own immanent light, which plays freely among its folds.) In like manner, the painting may open on a world that is already there, benignly supporting the human attempt to replicate it; yet it also intimates the existence of a transcendental consciousness—perhaps merely the artist's reflective self—within which that world is being thought.

Artist in His Studio also situates itself by way of more complicated structural allusions to *Soldier and Young Girl Smiling* and *Couple Standing at a*

Virginal. The emphatic diagonal along which the central relationship is disposed and the strong counteracting horizontals of the background map recall the arrangement of *Soldier and Young Girl Smiling*. Now, however, the means employed in the earlier painting to give the relationship its recessive aspect, and to convey an alien, intrusive quality about male presence, contribute to an overall impression of equanimity. The lowering of the map, the slight elevation of the model, the rotation of the diagonal through ninety degrees, and the increased distance between the viewer and the male figure over whose shoulder the scene is observed, all seem adjustments calculated to unblock the relationship of the earlier painting, and evenly distribute its conflicting aspects throughout the artist's room. The man's presence no longer blocks the opening through which light enters the painting, and as a result the triangular flow that unites the couple across the linear distance between them feels stable and unimpeded. The intervention of the artist's canvas likewise stabilizes the conflicting sensations of nearness and distance in the young girl's presence to the soldier: instead of remaining internal to one another, they are separated out into the artist's long gaze at his model and his arm's length from the image on his canvas.

Perhaps most intricate is the metamorphosis in *Artist in His Studio* of the young girl's triangulation of the soldier's complementary aspects. As in the earlier painting, the artist's gaze directs us to the face of his model, and she leads us back, not this time to the expression hidden on his face, but to a mask that lies bathed in light on the table to his left [50]. This mask is one of the most haunting of Vermeer's displacements. It has the appearance less of a mask than of an actual face—one that has become detached from human life and found its way into the world of objects, where it is no longer subject to the dialectic of looks or the anxiety of expression. And the triangle it completes (from artist to model to mask) connects it by inference with that side of the painter we do not see. It is as if the act of painting were being construed literally as self-effacement, a giving-up of the expressive visage and by that action—as *Girl Asleep* has already intimated—an unmasking of desire. In an important sense there *is* no authorial face on the other side of that fog of brown hair: the image indulges a fantasy of

unimpeded viewing that extends to *Artist in His Studio* itself. Considered thus, the face on the table, even though there is something strangely personal about it (almost as if *it* were the self-portrait), belongs neither to Vermeer nor to his surrogate, but connects both.[36] It materializes the face (in Klee's sense) of the painting itself—that disembodied presence/absence, diffused throughout the whole, for which we have only the terms "atmosphere" and "mood." What can be seen expressed on this face (and felt throughout the image) is the access of a certain grace—a calming, even a closing, of the gaze, and with that an acceptance, beyond resignation, of both anonymity and being visible. It reads more convincingly, in fact, as a death mask than as the mask of tragedy. It is the antithesis of the authorial face implied by *Head of a Young Girl*.

The map on the wall similarly minimizes the distinctions its counterpart in *Soldier and Young Girl Smiling* helps to reinforce. Instead of emphasizing boundaries and stressing the division between a woman's domestic space and a man's worldly consciousness, it places an undivided country between two people and helps measure the model's ever so slight ascendancy over the artist. Even the map's datedness—it depicts the Seventeen United Provinces before the war with Spain and the division of the country—makes it testify to a time before difference and schism.[37] Vermeer subtly acknowledges the utopia of this place-specific background: the sharp vertical crease in the country's upper portion—a sign, paradoxically, of the map's age and wear—approximates the current boundary between Protestant North and Catholic South.[38] (Were this ridge to extend all the way down, it would isolate the painter much as the unexplained vertical in the background of *The Procuress* does the artist-figure of that painting.) Nostalgia, anachronism, and obsolescence may reign in this painting—the artist even works under the double imperial eagle of the Hapsburg monarchy—but they do not undermine what feels present and attainable in *this* space, *this* moment.

The flat black of the artist's hat slices through this mapped background just as the soldier's in *Soldier and Young Girl Smiling*. Yet now Vermeer seems more interested in the creative act than in gendered consciousness: the hat becomes an apt emblem—ironically, in this most reflexive of paint-

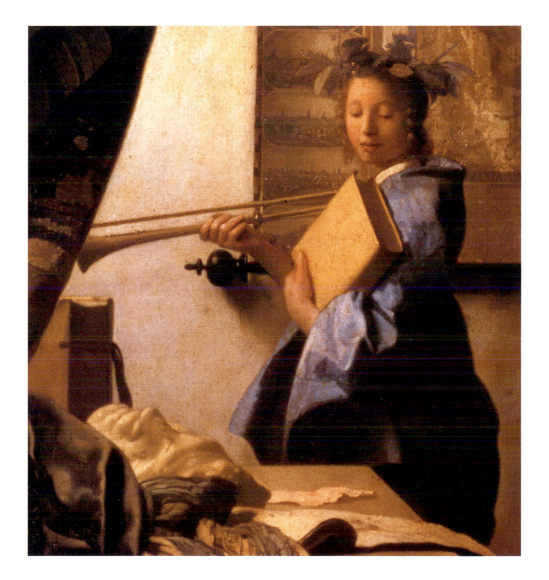

50. Vermeer: *Artist in His Studio* (detail).

ings—for the blind spot at the back of vision, the unrepresentable void where creation thinks. The place of the artist's conception is rather ignobly portrayed as a hole in the painting's fabric, the one area of the image where the magic of representation refuses to take. There is irony in the contrast between this black hole and the laurel wreath that flowers twice; one recalls the black ovoid shell that encases the artist-figure in *The Procuress* and its juxtaposition with the embracing couple who flower on that painting's right.

And though the artist's hat marks an absence, a place of oblivion exactly where his idea intersects the field of historical reality, the top of his easel locates a prominent area in that field, and takes on the appearance of a perspective and a frame—even an apparatus for transcending [51]. These details again correspond to the painting's double irony: if the painter's concern with History and Fame paradoxically involves a retreat into the studio and an anonymous, solipsistic absorption in the pleasures of painting, his activity nevertheless situates him—not that he knows it—near the metaphysical heart of things, and involves a desire to experience the where and the when, the here and the now of the world at a level that historians and mapmakers must presuppose.

Cap and wreath, black hole and flowering blue: between these obvious poles, the map measures the artist and model in more subtly contrastive terms. Both are placed at boundaries, and located where orthogonals meet. The thick horizontal separating the map from its explanatory text (made unreadable by Vermeer) aligns, as we have seen, with the artist's gaze, dividing his head between land mass and legend and intersecting his easel at an unseen point directly before his eyes. To his right, an elaborate layering of planes separates him from the map's far background; to his left, space opens up, and distance suddenly gets measured laterally across land and sea.

The model's head, by contrast, is placed entirely above this horizontal, exactly at the inner map's vertical border. Situated between a series of city profiles and a mapped expanse, she bridges a difference in representation that can be read many ways: margin and center, detail and whole, encompassing and sequential views, cognitive and visual place-recognition, the world seen head-on and "from above" (and in both cases looking far away).[39]

126

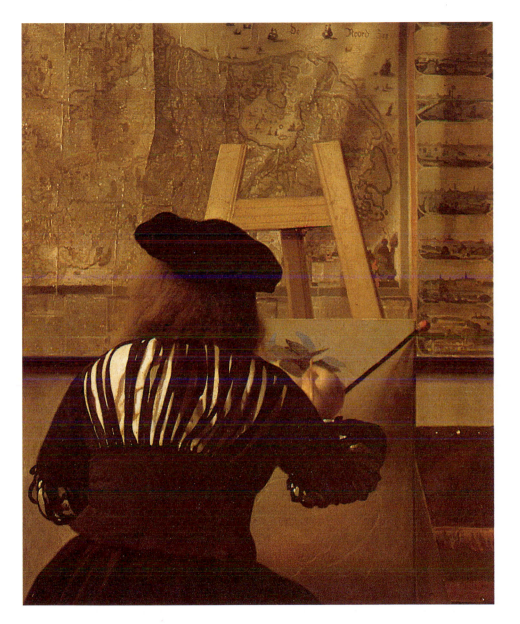

51. Vermeer: *Artist in His Studio* (detail).

Nothing intervenes between her and this background, which elaborately claims her: the horizontal border extends into her mantle's fold, the vertical one branches and flowers in her laurel wreath, the curls on her right are appropriated by the townscape's frame, while those on her left are abstracted (along, perhaps, with a pearl earring) to rhyme with the light-dark pattern of the map's outer edge.

And yet with all this effort at assimilation she still stands out. Situated between two different chartings of the far-off world, her visage—so distant in relation to the artist's gaze—suddenly seems close, its features monumental. And foregrounded by an elaborately mapped expanse, she seems all the more singular and incommensurate. Even the two areas of the map that most obviously counterpoint her face pose it as a question: beside it at the left the "profile" of a city, depicted in intricate, miniaturist detail;[40] above it to the right, a "full-faced" oval with a rectangle beneath it, both outlined in red and framing empty space where text has been erased and Vermeer's own canvas shows through.[41] The map may thus foreground "the flesh of a human presence,"[42] but in doing so it subsumes both flesh and presence in an obscure dialectic of the image. On one side the crowded world inside a frame; on the other a clearing in depiction, the ground reclaimed, space erased and waiting. Between these two extremes "presence" is inserted. A polarity of filling-in and erasure, explanation and occlusion, infiltrates realism and turns "the question of the face"[43] into the question of the *painting*.

The treatment of the artist at his canvas exacerbates this question. His black cap, we can now see, is posed not only against the model's wreath but the map's blank oval: at the one extreme, an enameled hole, its sharp edges impervious to illusion; at the other, space saved up and bounded, the ground within kept free. And the counterpoint goes further. The womblike inlet (the Zuyder Zee) located by the artist's easel is elaborately opposite the closed-off oval above the model's head. The inlet is a represented place—the geography's prime identifying contour. Ships anchor in its harbor and cluster in its vicinity. Within the area it inscribes, the project of land reclamation goes on unabated, constantly revising its borders and narrowing the space they hold. A giant cartouche rides the sea above it (just beneath a

large uninterrupted "DESCRIPTIO"), its inscription framed by a cast of sea monsters and mythological deities and topped by a female allegorical figure (crowned with bay or laurel) not unlike the one the artist is depicting. Set against such signs of the mapping impulse in all its triumph, the distant, landlocked oval with its slender frame of red can seem almost pristine in its emptiness, a welcome refuge from the mania of claiming space and filling-in.

The two extremes are superimposed at the artist's easel, as if to define it as the site of contradictory ambitions. The easel itself reaches up to frame the geographic place, and, as perspective, aims beyond it toward the grandiose cartouche. But the unframed canvas it supports preserves another "empty space" on Vermeer's own canvas. The model's head, so elaborately contextualized by the map, is being transferred to this blank rectangle, as if painting were, as Balzac's Frenhofer describes drawing, a "taking things away from their surroundings."[44] It is almost as if the transit from the model to the canvas involved representation-in-reverse, an undoing of the image realistically achieved, the empty oval enshrined above the model's head as a kind of visionary inspiration. The depicted painter's last/most recent stroke—a "pale intrusion into blue," to adapt another phrase from Stevens[45]—looks especially like erasure.[46]

The treatment of canvas and easel, in fact, produces some of Vermeer's most Magritte-like effects. A strong diagonal propelled by the floor's black X's spans the room's cubicle from foreground to background chair, aligning the easel in a sequence of vertical planes and planted feet that grows denser and more entangled as it recedes. (An alternate path barely opens: between the foreground chair and the artist's bench the X's momentarily lose their form, and smaller rows of stacked diamonds channel brightly through to the model's hem.) To the right and down below, everything appears to support the illusion of measurable space, with the canvas at a certain distance from the rear wall and angled in relation to it. But as the easel's long horizontal emerges from behind the artist's right leg, something strange happens: it seems to bend—as if refracted through water—and grow lighter, less vectorlike. The portion between the artist's legs recedes to the back wall

129

and lines up with it, almost as if it were a section of baseboard.[47] And at the artist's left leg, where we expect the horizontal to emerge and join the easel's opposite support, it disappears completely! This disappearance turns out to make sense in space (though we have to measure to be sure): the place where the supports meet and the easel's left foot touches down does exist in the picture, but it is blocked from view by the artist's stockinged calf and the two left legs of his bench.[48] A tiny sliver of easel may even show through where the contours of the bench-legs part. But the optical illusion of disappearance and incompletion persists.

This illusion conspires with others. The artist's body obscures any signs of the depicted canvas's left edge, and the wall on his left is rendered almost exactly the same way as the canvas on his right. Neither area is painted very thickly, and in both the warp and weft of the underlying canvas shows through. The effect is of a single continuous canvas, which instead of terminating in a clean edge somewhere in front of the artist extends all the way across to include the model—as if she existed on the same surface as the almost-copied leaves (as, of course, "in reality" she does). For a moment the fantasy of this artist painting on Vermeer's canvas asserts itself, as if there were no distinction between the one's image and the other's.[49] This perception can only register, of course, as an aberration in consciousness: inevitably the negative shape between artist and model recedes, and reasserts itself as wall. But we may find ourselves left with a new appreciation of the map's importance: not only as a decorative background and connector of persons, but as a maintainer of the necessary "levels" of reality.

As far as the spatial and atmospheric feel of *Artist in His Studio* is concerned, its most insistent links are with *Couple Standing at a Virginal*. It is in terms of this painting, above all, that *Artist in His Studio* seems to measure its achievement. The emphasis on the cubicle of space encompassed by the picture frame (the layered horizontals of the beamed ceiling are a nearly explicit allusion), the luminous atmosphere, the magical silence, the "presence of a certain hermetic, obsessive, even bewitched element in its adherence to reality,"[50] the sense of a disembodied consciousness brooding over

the whole, all work to situate the artist and his model within the space of concern the couple of the earlier painting occupy.

There is a strong sense of continuity, moreover, between the relationships themselves. Beyond the plainly visible resemblances—the black and white of the artist's costume, his rapt stillness before the object of his attention; the curls, the downturned (and inturned) gaze, the two-tiered dress of the model, the ambivalent torque with which she responds to the artist's presence—there are similar intangibles: the hypnotic attraction, the erotic charge in the space between the couple, drawing them together and holding them apart,[51] the enhanced sense of the instant in which the relationship is poised, the contrary sense of time continuing.

Given these similarities, what immediately strikes one as different about *Artist in His Studio* is its overall sense of ease. It inherits from *Couple Standing at a Virginal* an intensity, yet the tension and the instability disappear. The space of the painting is ordered even more rigorously than that of the earlier work, yet now a benign randomness comes into play. There is a consoling sense of things falling as if by chance into place, exactly where and how they have to be for the general order to hold—as if the means by which the man's hand reached the woman's breast in *The Procuress* had become the governing principle of Vermeer's entire world. The composition as a whole seems to have settled into time, and gravity. One feels it in the seated position of the artist-figure (so different from the man who steadies himself with both hands at the virginal's edge) and in the repose of the discarded mask, which in some strange way has taken the place of the upright, vigilant pitcher of *Couple Standing at a Virginal*. Yet the result is a lightening, an influx of grace, an overcoming of whatever it is that seeks to vacate space in the earlier painting. Objects can hang laxly off a table. Stockings can sag. Nothing has to "hold on" anymore.

This vision—so elaborately contrived on the canvas—of order as self-maintaining and simply given not only frees consciousness (especially viewing consciousness), but generates an air of permissiveness that extends to the central relationship. Vigilance and its surrogates are completely absent here. No superego figure, not even the benignly feminine type of *The Concert*

and *Couple Standing at a Virginal*, watches over the couple; the man is free to look, and the woman openly to constitute herself as an erotic object in his gaze. Her down-gazing, of course, is now admitted as a pose, and his look is sanctioned by the act of painting—where the desire to bring distant things near is countered by the need to realize them at arm's length.[52] As the fulcrum of these demands, the artist-figure should register as a place of divergent impulses; but the viewer is more likely to experience him as a figure of resolved contentment. And the model's pretense, for all its coyness, frames an innocence that seems real. It is as if in *Artist in His Studio* a different logic reigned.

Equally important to the passage from *Couple Standing at a Virginal* to *Artist in His Studio* is the sense of integration the later painting achieves. This integration extends to all facets of the image, from the different spatial registers, to the placement of the central figures, to our own experience as we stand before it. The two incongruous aspects of the woman in the earlier painting—the still, bell-shaped body with its subtle torque, and the gaze in the mirror lit from the left by the entering light, turned down toward and yet away from the man who watches—are united in the figure of the artist's model. The attendant male and the painter dimly implied in the mirror of the earlier painting are likewise combined in the figure of the seated artist. Their relationship is brought forward toward the functional center and enmeshed in a symbiotic give-and-take with its setting. The vertical folds of the model's lower skirt, for instance, appear to support the table (note how their horizontal trim aligns with the black square on the table's foreground leg, and how that leg, obscured in shadow, tends to merge with the cloth hanging limply over it), while they in turn gain a certain weight and monumentality from it.

Even the triangularity of the earlier relationship is assimilated into this newly complex field. The bracketing of the artist between model and canvas has already been mentioned; balancing this triangle is another on the left involving the mask, and similarly transforming the triangle of the earlier painting. Now it is the artist whose face we do not directly glimpse, and he looks counterclockwise instead of clockwise in the direction of his model,

whose face we now plainly see. She in turn appears, again, both to avoid his gaze (as the charade requires) and look down into herself, but her line of sight leads us to a deflected, displaced "image" of a male face, which rests beneath her gaze, unnoticed by the artist. There is thus ultimately in *Artist in His Studio* a circulation of aspects across four terms, not three: from the model to the mask to the artist to the image on his canvas (or vice versa), with the diagonal between the artist and his model crossed by a more enigmatic one between the mask on the table and the image on the canvas. These vectors no longer interweave in the far recesses of a space that broods apart from them; they have become part of the scaffolding of the image as a whole.

Within this scaffolding, the contrasting spatial sensations of *Couple Standing at a Virginal* are fused. The luminous "envelope of quiet air" now extends across the entire frame, and the accessories of the room are distributed evenly throughout it, all in their separate places (however randomly), equally endowed with weight and value. Yet it is the overlapping of these objects on the surface of the canvas that imparts equilibrium and coherence to the three-dimensional space in which they fit. (The only distance bridged in "real" space is that between the artist and his canvas.) The hanging chandelier [52], for instance, perceived strictly as an object in space, looks like a strange winged contrivance hovering in midair somewhere in the near foreground. (One interpreter has even seen it as a phoenix.)[53] It is effectively secured not by the barely perceptible metal ring that attaches it to the ceiling but by its place in the flat mosaic of the painting, where its function is to hold up the heavy map (which similarly gains more support here than from the two small nails that unconvincingly pin it to the background wall) and to bridge the gap between the map and the stacked, horizontal stripes that signify the receding beams of the ceiling.

Similarly, the heavy tapestry folded over the chair is held back more effectively by the edge that crops it on the canvas (or by some force pulling from beyond). The tapestry plays its part in the mosaic by overlapping the heavy end of the model's trumpet just enough to keep it balanced lightly in her hand, while the trumpet reciprocates by helping to keep the tapestry

52. Vermeer: *Artist in His Studio* (detail).

pushed back. (Notice also how the abstract pattern of the map's left edge locks the trumpet's small rounded knob in place.) The thin book of music (?) lies carelessly open, yet the part that hangs over the table's edge intersects the model exactly at the boundary between her blue shawl and her columnar skirt, and precisely bridges gaps between the table and the painter and the painter and the model. It is just one of the "accidental" devices employed by Vermeer to create the amalgam of positive and negative space within which the relationship between artist and model is secured.

134

The interlocking of forms that exist on different vertical planes functions similarly with respect to the painting as a whole. The tip of the painter's maulstick juts out beyond his canvas and is assimilated by the map and its isolated spots of red. The studs on the right side of the chair in the background align exactly with the map's outer edge, while the right edge of the depicted canvas continues the map's inner border. More important is the sharp contour of the tapestry: as it proceeds up the canvas, it links a succession of objects—the chair, the fabric on the table, the upright book, the trumpet, the map—that recedes from the extreme foreground to the far background of the room. Yet as it spans that distance the contour flattens on the canvas: the slice of wall formed by tapestry, map, and trumpet can jump out at the viewer like a piece of bright negative space. Tracing the outline of the right-angle triangle that tapers upward from the table to its apex where map and tapestry "intersect" should be as disconcerting as following the contours of an Escher print; yet the effect is an intuitively satisfying fusion of the two logically discontinuous dimensions of the painting (flat surface and illusionistic space), a reinforcement rather than a subversion of its intense reality.

The almost ostentatiously willed nature of all these overlappings has the effect of raising them to consciousness. As so often in Vermeer, adjustments that for most painters remain submerged at the level of style become elements of the painting's vision. In *Artist in His Studio* that vision has to do with a unity between the world as given and as structured by perception, as perceived and as reconstructed by desire. Perhaps no other painting so knowingly reveals to us "the complexity, the intricacy of the spiritual and emotional webbing under the simple state of peace which is its own homeostatic condition,"[54] while managing to leave that condition so blissfully intact.

This aspect of *Artist in His Studio*'s achievement comes into high relief when one compares the painting with Vermeer's *Allegory of the New Testament* [53]—a work that, like the three genre scenes, gives the impression of a willed failure.[55] Several aspects of *Allegory* suggest that it is conceived in relation to *Artist*: the larger-than-usual dimensions, the tapestry pulled

back on the left and unconvincingly propped against a chair, the identically rendered beamed ceiling, a contrivance hanging from it and overlapping a huge image (in this case a Crucifixion scene) that takes up most of the rear wall. Certainly both the simple homeostasis of *Artist in His Studio* and the intricate spiritual and emotional webbing that underlie it are precisely what feel missing from *Allegory of the New Testament*. Its lifelessness as image, in fact, seems the elaborately constructed pendant to *Artist in His Studio*'s mysterious radiance—as if it were the theatrical counterpart of the latter's self-absorption. The tapestry of *Artist* conceals a light source that transfigures model and room; that of *Allegory*—now merely drawn back instead of turned inside-out—shrouds dead, empty space—a symptom of the spiritual void that pervades the interior as a whole. The presence of the model in *Artist* shines through the pose in which the artist has placed her, redeeming his simplistic concept; conversely the posturing of the woman in *Allegory* undermines the fiction of which she is a part. (One can even fantasize her as its patron.)[56] In *Artist* there is elaborate interplay between the three levels of reality marked by the foreground tapestry, the interior space of the artist and model, and the background map; the three corresponding levels in *Allegory* could not be more disparate. True, there is an obvious counterpoint between the Crucifixion on the back wall and the allegory being represented in the middle ground, but what is most visually striking is the lack of relation between the hyperrealistic bourgeois materialism of the one and the gaunt, pictorially remote spirituality of the other. It is as if we were back to the ironies of the genre scenes, especially those of *Couple with a Glass of Wine*. The tapestry is the one area of exception: it holds a realm of brightly lit pastoral artifice that offers an escape (but no more than that) from the ponderous religiosity that weights the rest of the painting. The two animate figures woven into it—a man and a long-necked horse—enjoy a precious freedom of movement, and they use it to stroll casually away from the mute tableaus and iconographically fixed gestures which the tapestry itself is pulled back to reveal.

Most telling is the different status objects are accorded in the two paintings. The spiritual weight that things are made to bear in *Allegory* para-

53. Vermeer: *Allegory of the New Testament.* 44½ × 34¾ in.
The Metropolitan Museum of Art, New York. Bequest of Michael
Friedsam, 1931. The Friedsam Collection.

doxically deadens them; they lack the intrinsic spirituality that objects possess in *Artist*.[57] (The cornerstone crushing life out of the snake underneath it is like a symbol for the *effect* of allegory.)[58] They testify not, as in the latter painting, to a realm of immanent value, nor even, as their own allegory would have it, to the existence of things hoped for and unseen, but to the pervasiveness of a materialistic, object-ridden culture.[59] And their function as elements in an allegorical schema isolates them, in spite of elaborate formal correspondences in the painting, from any *spiritual* interaction with one another—from that "visible sharing of essence"[60] that is the secret of *Artist in His Studio*'s world. The contrast between the transparent glass sphere that hangs from the ceiling and the snake-crushing slab enacts a grotesque parody of the interplay between things heavy and light, rising and falling, suspended and at rest in Vermeer's most delicately balanced interiors. The deadening effect of *Allegory*, the sense in it of a detritus of consciousness, an absence at the level of the image of what sustains things elsewhere in Vermeer, grows out of both the painting's method and the values it serves. While it would be willful to characterize *Artist in His Studio* as adverse to Christianity, its vision of a world folded peacefully in upon itself, presided over benignly by light, space, weaving, and wry authorial consciousness, could scarcely be more at odds with the scheme of values that *Allegory of the New Testament* conspicuously displays.

Artist in His Studio also integrates into its structure that mirror-realm toward which representation aspires in *Couple Standing at a Virginal*. Now the painter is openly admitted into the image, whose space he shares with the object of his vision, as if in fulfillment of the dream of art dimly glimpsed in the mirror above the virginal in the earlier painting. But in claiming this space *Artist in His Studio* demystifies it. It is discovered not beyond or interior to the image, but in the mundane reality of the artist's studio, made magical by the duration that holds him while he paints.

It is not where the act of painting arrives, nor the finished statement that issues from it (the painter's own allegory notwithstanding), but the painter's ongoing experience within it that matters most here. The sense of art's contentment is focused most resonantly in the almost comic image of

the artist *seated* before his canvas, both feet—which in an earlier incarnation were propped unobtrusively beneath a virginal—now planted firmly on the floor. It is not fame, and certainly not dignity, that the act of painting bestows upon the artist—rather a confirmation of his own mundane existence, the experience, lost to desire and reflection, of physically belonging to a world that is physically present—before, beneath, behind. Art here seeks to quiet desire not so much by pursuing its ends or possessing its objects (these seem just pretexts under which it works its larger purposes) as by restoring within it what was lost with its advent—unity of being, the immanence of the world. And the painting seems fully aware that there may really be nothing "before" art or desire, that the canvas represents an absence in reality, and that the world of immanence always takes shape within a frame.

In a sense the fantasy at the heart of *Artist in His Studio* is not all that different from that of *Young Woman at a Window with a Pitcher* [62], where the spanned human body serves to conduct the light from outside in toward objects. In *Artist in His Studio* the painter also acts as transmitter: his eyes look while his hand paints, as if external reality flowed directly through him onto his canvas, unimpeded by reflection.[61] In the moment the painting captures for us, the painter inhabits his desire (or what reality desires through him), and as such it seems something that might last forever, as its own fulfillment.

Yet against the depicted artist's absorption in an unproblematical, context-free beginning, oblivious to the pressure of ends and consequences, and with what seems like all the time in the world to paint, there is the sense of closure, of arrestedness, of cumulative arrival evoked by *Artist in His Studio* itself. And against the painting's bemused depiction of the artist's experience within the creative process, there is its own ruthlessly finished nature, its perfection of a style intent on leaving nothing visible that might betray its secrets. It seems impossible that Vermeer could have gone about painting *Artist in His Studio* in the "stolid, ingenuous manner"[62] of his surrogate, outlining his model and then coloring her in, piece by piece, starting at the top and working down. Yet so complete is the interlocking of his forms, so equal the value given to every inch of his canvas, that any other

beginning seems almost as implausible. In spite of the painting's apparent obsession with direct visual transcription, one can scarcely imagine what—if anything—was before Vermeer's eyes as he painted it.

Nor are we allowed to take the painting seriously as literal self-representation. There is even a sense in which *Artist in His Studio*, while seeming to fulfill the mirror image of *Couple Standing at a Virginal*, is actually the painting in which Vermeer most radically absents himself from the scene of representation. Painting an artist into the work may be the most effective way of painting himself out of it. The depicted artist's assimilation into the space of the painting is so complete that an aura of metaphysical apartness insulates him from direct connection with anything in the realm outside the image. His untroubled presence there seems the outcome of a relinquishment of the active by the reflective self, and of the image by its author. Anything like a mirror effect or an infinite regress is precisely what the painting's renunciations—its refusal to "identify"—allow it to avoid. Even with all its paradoxes, it is as reassuring to the gaze as Velásquez's *Las Meninas* [77]—where eye and hand are subject to the mind—is disconcerting.

The gestures *Artist in His Studio* makes toward self-representation are further undermined by the painting's treatment of authorial status. We have already noted the hole-in-the-canvas effect of the artist's hat. Only a fog of reddish-brown hair and a hand that looks like a blob of unformed flesh serve to indicate the existence of the person beneath the fantastical costume.[63] The comic attitude suggests a benign but radical distance: Vermeer seems to look upon his surrogate as pure figment rather than mirror image. And yet it is obviously a cherished figment, perhaps one as central to the oeuvre as the unplaced gaze of *Head of a Young Girl*. The sense of authorial investment in an image is as powerful as in any of Rembrandt's self-portraits.

The contrast between the painting's comprehensiveness of vision and the depicted artist's narrowness of focus works in much the same way. The scene of painting is as vulnerable to the peripheral awareness that circumscribes it as the idyllic moment at the center of *Gentleman and Girl with*

Music is to the outer circle of reflection that hems it in. The surprise of *Artist in His Studio*—its *grace*—is that the affirmations implicit in the naïveté with which the depicted artist is able to begin, and to go about his business, getting those leaves exactly the way he wants them, are not subverted by this encircling, reflexive consciousness. Nor does the latter find itself alienated or excluded. The objects on the periphery (the map, the tapestry, the mask on the table) and the implications they carry must no longer, as in the earlier painting, be kept at a distance, outside the sphere of the central relationship; they are integrated into its very structure, if not into the awarenesses of the individuals within it. Likewise the felt presence of the artist/viewer: instead of rejecting us by coolly insisting on our visibility, the painting now peels back its tapestry as if for our benefit, and even provides a chair for our invisible presence within this self-surrounded scene—in a place that is reserved for us *as* viewer, not as someone still driven by a nostalgia for vicarious participation.

Lucidity has been defined as "the refusal of adequate images."[64] The consoling power of *Artist in His Studio* resides in its transcendence of this definition. *Its* lucidity consists in taking that last difficult step beyond skepticism into the act and ethic of creation. In it the ironical distance between (self-)consciousness and its (self-)representations is transformed into a regard for the life of the image and the beings within it. The problematical awareness remains, but the self is effaced in authorial concern. The artist and his model take root in an eternal present; but a relinquishment, a death intrinsic to creation (the mask resting on the table is its visible emblem) is the medium in which they survive.

There is, then, about *Artist in His Studio* a sense of the adequacy of the image (but adequate to what? the obscurity in the definition catches exactly what is elusive in Vermeer's vision)—a sense of the desire that generates art finding its embodiment in what is painted on the canvas, but more by way of bemusedly accepting than passionately achieving it. In this the painting again counters *Head of a Young Girl*, and in the argument between them one can never be sure which has the last word. The phrase from Nietzsche that so hauntingly articulates the urgency of *Head of a Young Girl*—"that

an image may not remain merely an image"—seems no longer to apply to *Artist in His Studio*, where painting seems either to have relinquished or been released from the desire to transcend its own conditions. Yet anyone who comes upon it is struck immediately by its magical reality. And the conditions Nietzsche sets out for the fulfillment of art's desire express beautifully the authorial atmosphere in which Vermeer's painter even now puts the last touches on his leaves:

> Where is innocence? Where there is will to begetting. And for me, he who wants to create beyond himself has the purest will.
> Where is beauty? Where I *have to will* with all my will; where I want to love and perish, that an image may not remain merely an image.

Perhaps the problem is with that phrase "*merely* an image." After everything has been said about Vermeer, it will be the enigma with which his art continues to intrigue us.

PART THREE
MEANING IN VERMEER

In ways that I do not pretend
to understand fully, painting deals
with the only issues that seem to me
to count in our benighted time—
freedom, autonomy, fairness, love.

<div style="text-align: right">

ANDREW FORGE, "Painting
and the Struggle for the Whole Self"[1]

</div>

"WE HAVE BEGUN TO SEE," a recent study of Vermeer informs us, "that seventeenth-century Dutchmen looked at pictures, and at reality, rather differently than we do."[2] What we take to be realistic, affectionately rendered scenes of everyday bourgeois life turn out to have been for their original audience dense with emblematic significance and didactic intent: "A large body of pictures-with-comments, especially prints with inscriptions and emblem books, suggests that many images were both to be enjoyed and to be pondered for the lessons they had to teach. The Dutch had a taste for moralizing that we struggle to imagine today."[3]

Regardless of all that is problematical about the assumptions underlying this emblematic approach, there is no denying that it has yielded genuine insights into the work of Vermeer's contemporaries.[4] But when applied to Vermeer himself, it seems only to diminish the work in question. It is almost as if his paintings were designed to expose the poverty of the method. Witness the conclusion drawn by an iconographic study of *Girl Asleep at a Table* (the title is "Vermeer's *Girl Asleep*: A Moral Emblem"):

> The young woman personifies Sloth, the vice that opens the gate to all the other vices, symbols of which surround her. . . . The apples on the table are attributes of Aphrodite, goddess of love, as are the pearl earrings the girl wears. The apples refer also to the Fall of Man and Original Sin. Fruits, as well as handsome pottery, glassware, and silver utensils, are typical symbols of the vanity of worldly satisfactions. . . . The message of the painting is: Let us be alert to avoid the snares of sensual pleasures. All worldly satisfactions are but vanity. The freedom of our will makes each one of us responsible for renouncing the earthly in favor of divine truth.[5]

The problem, clearly, is that the approach exemplified here takes all too readily to the sort of moralizing it claims we today must struggle to imagine in the unfortunate seventeenth-century Dutchman. The responses it generates are so ill-equipped to deal with the dialectical complexities of Vermeer, and so remote from what any passionate viewer of images—even one prone to deciphering—would think to say about him, that it might seem best left

to its own devices, were not its findings as well as its assumptions being assimilated into the anonymous body of commonly accepted knowledge about the artist. It is bad enough when a contextually oriented study is hailed as "the long-awaited demystification" of Vermeer,[6] but even worse when the unsuspecting purchaser of the UNESCO collection of slides of his paintings is informed matter-of-factly, and without further comment, that the instances of women receiving, reading, or writing letters "are, beyond a shadow of a doubt, allusions to requited or unrequited love," and that both *Woman Putting on Pearls* and *Woman Holding a Balance* have "an emblematic content," that of the former being "'vanity,'" that of the latter, "'the brevity of life.'"[7] Such accounts are so destructive of what in Vermeer does constitute meaning, and what is asserted there in the way of value, that some purpose might be served by attempting to indicate what is inappropriate about them, as well as what it is in Vermeer to which they are responding.

Christ in the House of Martha and Mary [54], probably Vermeer's earliest extant painting, exemplifies in exceptionally pure form the subversive thrust of his relationship to the iconographic practices of his contemporaries. The biblical source for the painting is Luke 10:38–42:

> Now it came to pass, as he went, that he entered into a certain village: and a certain woman named Martha received him into her house. And she had a sister called Mary, who also sat at Jesus's feet, and heard his word. But Martha was cumbered about much serving, and came to him, and said, Lord, dost thou not care that my sister hath left me to serve alone? bid her therefore that she help me. And Jesus answered and said unto her, Martha, Martha, thou art careful and troubled about many things. But one thing is needful: and Mary has chosen that good part, which shall not be taken away from her.

The anecdote was a common topic for seventeenth-century "history" painters, and it is obvious from internal evidence that Vermeer was aware of the tradition.[8] The nature and extent of his departure, however, can be gauged by the inadequacy of reading the painting as a faithful illustration of the text: "Martha, who thinks she is doing her duty to Christ by bustling

about, pauses for a moment at the table; Mary, who ignores the housework in order to listen, sits in rapt attention; and Christ, explaining that 'Mary has chosen the better part,' links the two women with his gaze and broad gesture."[9] This account reintroduces into the painting precisely what has been excluded from it. Vermeer has suppressed the narrative context, and the visual information he does provide neutralizes the judgment that is the point of the original story.[10] His Martha does not bustle about, nor is there the slightest hint of dutifulness about her behavior. She is, if anything, even more raptly attentive than Mary, and her gesture reads as an offering in which her entire being is invested. It is clearly the dialectic between the two women that concerns Vermeer, not a moral distinction between two ways of life.[11] Christ's gesture serves to link the poles of this dialectic—as, indeed, his presence serves to evoke them. The values embraced in this painting are ontological, and they are predicated on a refusal of a conventional moral judgment.

Girl Asleep at a Table provides a more complex example of Vermeer's way of choosing a genre motif with a long history and a rich accumulation of meaning,[12] only to place it in a context that demands a purely intrinsic reading of the image. Comparison with Maes's *The Idle Servant* [55] demonstrates the process of exclusion that Vermeer's uniqueness, especially in the early work, entails. Maes is at great pains to explain his painting to the viewer: the composition locates the main space of the painting, making it clear that the young woman is a servant; the details that surround her announce the theme of idleness and its consequences; and the older woman who stands beside her even indicates how we should respond.

Vermeer, on the other hand, conspicuously abjures such explanatory gestures. The emblematic-looking objects that he does include intensify rather than explain away the enigmatic atmosphere. They signal the presence of significance—perhaps even of a story or its dream or aftermath—but otherwise remain as mute and unyielding as those in most Dutch paintings are transparently expressive. Even the painting on the wall is there more as the sign of a private obsession than of a commonly accessible meaning. All we see is a discarded mask, an obscure object which may be a pear, and,

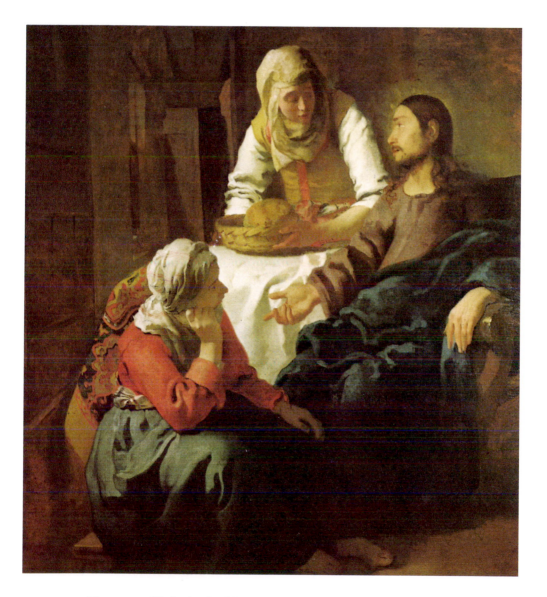

54. Vermeer: *Christ in the House of Martha and Mary.* 62⅛ × 55½ in.
The National Gallery of Scotland, Edinburgh.

55. Nicolaes Maes: *The Idle Servant*. 27½×20¾ in.
The National Gallery, London.

barely decipherable in shadows, part of one naked leg. If we can infer from Vermeer's later work the presence of a naked Cupid (the same painting reappears in *Gentleman and Girl with Music* and *Woman Standing at a Virginal*, each time more plainly visible), we are only drawn that much further into the hermetic inwardness of his oeuvre, whatever iconography the depicted painting may invoke.

In addition, the girl herself is rendered, as we have seen, in ways that

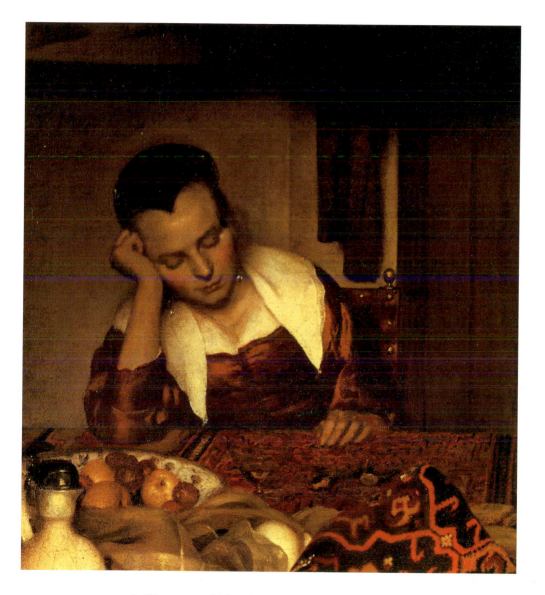

56. Vermeer: *Girl Asleep at a Table* (detail of 25).

prevent a straightforward moral or psychological reading of her presence. The expression on her face changes from sorrow to peacefulness and back again before one's eyes [56]. Her pose suggests sleep, or at least abandonment to some inner event, whether grief, desire, or fantasy; but the hand that rests lightly on the table (it is Vermeer's own addition to the motif)[13] functions as a sign of conscious poise, a delicate reassurance of the continued presence of the world and the self's presence to it. And what can be read as an image of Idleness or Sloth tends to be even more persuasive as a concentration— a state of grace beyond the will's reach, not a state of moral disarray that reigns in the will's absence.

The difficulty in objectively interpreting the young girl draws us into closer relationship to her. We experience a mirroring that reaches back behind subjectivity—as if the image were about the desire that creates such paintings, and the relation that obtains in viewing them. Whatever meanings exist in *Girl Asleep at a Table* pertain to the viewing experience, and they come into their own when the distances that moral and psychological understanding impose fall away.

The stakes become greater when one turns to *Woman Putting on Pearls* and *Woman Holding a Balance*, the paintings by Vermeer (outside *Artist in His Studio* and *Allegory of the New Testament*) most often subjected to an emblematic treatment. In these two works the motif most intimately Vermeer's own, that of a woman standing alone, comes to fruition, and the values inherent in it receive their most confident expression. "Epiphany" may be too extreme a term for the gentle stillness of these paintings, yet in them a sense of life's meaning, its affirmative core, is made manifest. To perceive them as embodying moral lessons that warn against worldly enticements is to mistake the essence of Vermeer.

It is, however, just such an interpretation that has come to be the rule when commentators take up the meaning of these works. The following gloss on *Woman Putting on Pearls* [57] is typical, not only of the approach but of the confusions that result from trying to reconcile its moral conclusions with the obvious pleasure—spiritual as well as sensual—that the paintings afford:

Light streaming into the room gives a warm radiance to the broad space between the woman and the mirror she is looking at, and heightens our sense of the woman's pleasure with her own image. Again we might ask why Vermeer chose this subject. Because it was beautiful, familiar, psychologically interesting? Yes, but another motive must have been the powerful associations attached to images of women adorning themselves. Two centuries before, when Bosch needed someone to personify Superbia (Pride), one of the Seven Deadly Sins, he chose a woman in a well-appointed house dressing herself and looking in a mirror held by the devil. A beautiful woman with pearls and a mirror became one of the commonest embodiments of Vanitas, sinful preoccupation with worldly things, against which we have constant warnings in Dutch art. As the seventeenth century wore on, the trend in genre painting was away from elaborate symbolic apparatus and toward reduced, less obvious, and sometimes cleverly disguised symbolism. But even when the traditional allusions to Vanitas are few, as in the paintings by Terborch and Vermeer, we should assume that they were recognized and understood in their time.

While most people will admit that Vermeer portrayed a situation associated with Vanitas, some have found it hard to believe that he really intended a warning to his audience or that his picture had a moral purpose. It has been suggested that Vermeer merely took over visual traditions for purely aesthetic ends or that the meanings attached to these traditions had dropped away by Vermeer's time. But there is ample evidence that pictures were "read" all through the century, and some of Vermeer's own works demonstrate that he had a taste for the metaphorical, even the arcane; why not recognize the intellectual force of pictures as well as their beauty? His Woman Putting on Pearls is a masterpiece of concentration: a few key elements of traditional Vanitas imagery and the poetry of Vermeer's light and color combine in an image of worldly pleasure that is wonderfully seductive. As so often in Dutch art, the celebration and the warning are one.[14]

This reading is correct, I think, in claiming that *Woman Putting on Pearls* invokes the tradition of Vanitas; what it fails to appreciate is how radically the painting *opposes* that tradition, and how radical a transvaluation it accomplishes with respect to it. Out of the iconography of vanity Vermeer fashions an image of purity and innocence and cherishes it as such. The moment of happiness at the heart of the painting is characterized, in fact, by an almost complete absence of ego. The woman appears to be not so much admiring her pearls in the mirror[15] as offering them to the light: it is as if we were present at a sacrament. Her pleasure, moreover, seems less a matter of the mirror's pull than of the light that streams in through the window, bestowing visibility almost as an act of love. Even the feeling that does issue outward from the woman extends gently in concentric stages: first filling the sphere that extends no farther than her fingertips, then embarking on the long journey toward the mirror. And her gaze's dreamy, unimpeded horizontal is ballasted by vertical elements—the heavy eyelids, the drooping ribbon, the pearl earring, the descending ermine trim—that secure her within the space her hands hold open.[16] Vermeer even contrives to super-impose the initiating and receptive aspects of the woman's experience, by placing the mirror that draws her gaze next to the window that channels light toward her[17]—downplaying the presence of the former, emphasizing the effects of the latter, positioning the woman ambiguously opposite the two. The effect is of a gaze that issues from the subject and is returned, enhanced, by the world on which it opens. Or in the words of Adrian Stokes: "An outward showing goes within."[18] Certainly the distance between vision and its object, or the self and its image, measured here by one of Vermeer's most luminous rear walls, can rarely have been more at peace with itself, less fixated or alienated, than it is in *Woman Putting on Pearls*.

The experience depicted within the painting, moreover, mirrors our own experience as viewers. And—as so often in Vermeer—it is through a subtle kinesis that we relate. The upper arms held in gently against the bell-shaped body, the forearms pulling slightly out and spreading open—vague bodily sensations counterpoised against the fingertips that pull against the ribbon's ends, gathering the necklace around her neck and tightening all

57. Vermeer: *Woman Putting on Pearls*. 21⅝ × 17¾ in. Staatliche
Gemäldegalerie, Berlin-Dahlem.

sensory feeling at that single place: it is like a moment of ontological elation, with all opposing torques in perfect equilibrium, embedded in the midst of something totally mundane and everyday. (The V of the yellow ribbon works like the V of *The Lacemaker*'s [64] bobbins as a focusing device, except that while the lacemaker views what she works on intensely and closely, the woman with the necklace seems content simply to be where she is, observing vaguely and far away what she feels at a point not directly accessible to her gaze.) As she holds this moment—the moment Vermeer captures—she allows us to feel what it is like to be here, now, in this instant, the interim prolonged (recall the cavalier's reluctance to let the gold coin drop) before the knot is tied.

And it would seem as puritanical to regard this imaginary mirroring as nothing more than an extension of the viewer's narcissism as it would to see in the depicted scene only an instance of the woman's vanity. On the contrary, what we are given is "a stable, freestanding view of the outside world,"[19] an image of an autonomous female counterpart, seen at a distance, acknowledged (and loved) as whole and other—a primal figure to introject and mirror inwardly. Vermeer's theme in *Woman Putting on Pearls* is not the temptation of the world but (as in the entire sequence of standing women) the basis of our trust in it and in its goodness. Happiness here is simply a matter of being visible, of being in the visible, wedded to it. A more heartfelt assertion of the immanence of value would be difficult to imagine.

Woman Holding a Balance [58] gives the impression, even more powerfully than *Woman Putting on Pearls*, of being a distillation of values implicit in Vermeer's work as a whole. Indeed, the similarities between the two paintings—the juxtaposition of the mirror and the curtained window, the cloth piled in the left foreground on the heavy wooden table, even the pearl necklace itself, which lies on the table of *Woman Holding a Balance*, a virtual allusion to *Woman Putting on Pearls*—suggest that Vermeer is more conscious than usual in these two paintings of expressing different facets of a single vision.

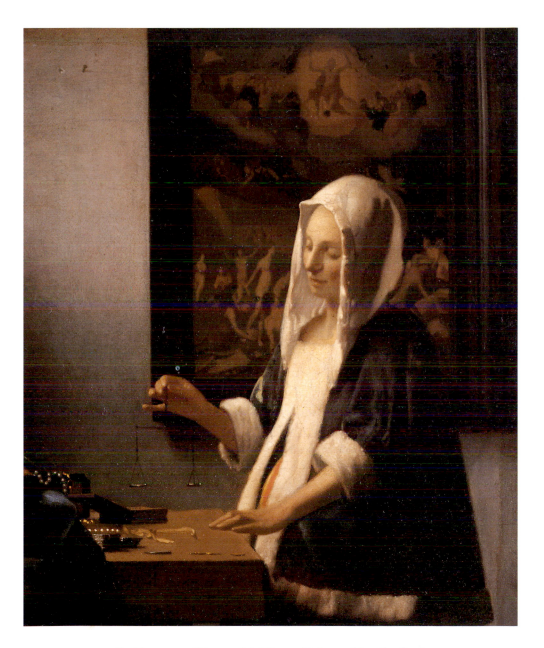

58. Vermeer: *Woman Holding a Balance* (detail of 14).

The values embodied in *Woman Holding a Balance* are asserted against conventional moral and religious judgment even more explicitly than they are in *Woman Putting on Pearls*. A large baroque painting of the Last Judgment hangs conspicuously on the rear wall of the room, situating the woman within an apocalyptic frame of reference and counterpointing her gesture. The light that illuminates her breaks into the painting from above, surrounding her with what at first glance may seem ominous, encroaching shadows; its point of entrance, moreover, resembles the "lurid yellow nimbus"[20] of the Christ of the Last Judgment.

Commentators who have responded to this thematic counterpoint have almost invariably assumed that the painting in the background provides "the key that unlocks the allegory"[21] of Vermeer's work. We are thus told that the gold coins on the table and the pearls spilling from the jewel box represent "the dangers of worldliness," or "everything that mortal man tries vainly, in the face of his mortality, to hold on to" (as if anything in this painting were trying to hold on); and that the woman's presence is an embodiment of "Vanitas," or a reminder of "the transitoriness of human life," or "another statement about the importance of temperance and moderation in the conduct of one's life."[22]

But this, again, is to opt for a meaning that is at odds with the immediate spiritual impact of the painting. *Woman Holding a Balance*, for all its intimations of mortality, provides not a warning but comfort and reassurance. It makes one feel not the vanity of life but its preciousness. Against the violent baroque agitation of the painting behind her, the woman asserts a quiet, imperturbable calm, the quintessence of Vermeer's vision. Against its lurid drama of apocalyptic judgment and the dialectic of omnipotence and despair it generates, she poses a feminine judiciousness, a sense of well-being predicated on balance, equanimity, and pleasure in the finest distinctions.[23] Against a demonic, emaciated fiction of transcendence, she exists as a moving embodiment of mortal life and what is given to us in it. And in all these oppositions, her triumph feels effortless.

The title conventionally given to the painting, *Woman Weighing Gold* or *Woman Weighing Pearls*, is crucially misleading; for close attention [59]

158

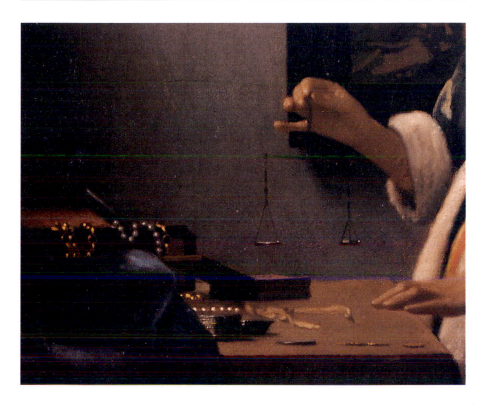

59. Vermeer: *Woman Holding a Balance* (detail).

reveals that the balance is empty, save for two gleams of light that highlight either pan. (It seems appropriate that a gesture so paradigmatic of Vermeer's art should appear concerned with the weighing and balancing of light itself.) The woman is testing the truth of the balance before she uses it to make a measurement. And this requires an absolutely steady hand, coordinated with a gaze that originates in inner stillness—much as painting does. If the gesture is emblematic, what it signifies (and celebrates) is an innate sense of value, the capacity we possess by virtue of a purely inner equilibrium to assess, and pass judgment on, the very means—theologies and moralities as well as physical contrivances—given us to fix our values.

The virtue depicted in *Woman Holding a Balance* is thus, again, onto-logical rather than moral—not just moderation or temperance but feminine power, capacity, *virtù*. The woman's gentle force counters, perhaps over-rules, the Christian schema depicted in her background. Her scales, and by extension the gesture from which they are suspended, invert the upraised arms of both the supplicant in the lower left of the Last Judgment who desperately abandons himself to a transcendent judgment, and those of the Christ who omnipotently controls the drama that unfolds beneath Him. She bears her grace within herself—her pregnancy, and her capacity to judge, to discriminate, are but complementary aspects of it. Set against the longing to rise, and the clash between gravity and grace, her bell-shaped form ac-cepts mortality, buoyed rather than weighed down by it. At the same time, she satisfies no fantasies of transcendence. Though she is the living center of the equilibrium that holds her world in place, she seems happy serving as its fulcrum.

Even the painting's shadows and dark places, which at first may seem encroaching, upon extended viewing can grow mysteriously benign—less threats than necessary counterweights and foils. The thick black orthogo-nals of the depicted painting's frame help locate the woman's suspended hand at the exact center, and provide it background and support. The scale's dark pans (two strips of black) balance gleams of white. The shadows on the upper wall shape the entering light into another spreading nimbus, a blank epiphany within which no figure passes judgment. It is the diffused counterpart of the condensed pearls, whose value also is enhanced by dark-ness. The angled mirror, almost all dark frame, enshrines not an image but a slit of light, which one might relate either to the glowing orange where the woman's morning jacket falls open or to the gleaming edges of the thin gold coins. This framed brightness must be a reflection of the wall's diffused glow, but given the way the mirror concentrates on the woman (its plane facing her, its orthogonals projecting toward her raised hand), the light it holds seems to emanate straight from her.

The massive blue-black cloth in the lower left, in which so much of the painting's darkness is gathered up, feels opposite the woman in some es-

pecially intimate sense. It seems to shape itself in response to her, as her concave complement, a waiting emptiness to match her pregnant fullness. (Its cavity also serves to counterbalance the wall's nimbus—spreading light against pillowed darkness, flat expanse against piled-up folds.) One could view it as facing the woman as a kind of *memento mori* (as in the gendered still lifes by Picasso where skulls face pitchers),[24] but as a waiting absence it again seems eerily benign—prepared more plausibly to receive a newborn child than to swallow up a life. And as a signifier of either death *or* newborn life, the cloth also counterpoints the strongbox—the one giving up its contents, the other waiting to receive.

The question of the shadows' valence becomes most charged where they reach the woman herself. Note the left side of her cowl: the darkness that models it there (in ways that make no sense according to the laws of optics) unmistakably takes the shape of a large open hand.[25] One tends to perceive this effect with a shock: the woman is touched by death (or something worse), and a shadow passes over the entire painting. Yet here especially, initial perceptions soften as one continues looking. Even this dark hand grows benign. Rather than claim her it seems to offer her support, as she in turn peacefully rests her head against it.[26] It even seems to rise up out of her, a component of her equanimity, rather than descend on her from without as some demonic other. Its opposite is the spectral hand placed on the shoulder of the reflection in *Girl Reading a Letter at an Open Window*. Of all the hands in Vermeer, in fact, the one it most resembles is the hand placed on the woman's breast in *The Procuress*.

The gesture of the woman's left hand complements the symbiosis of gravity and light, stability and suspension, nuance and exactitude focused at the fingers of her right. It recalls other details in Vermeer: the hand that preserves the link between the external world and the inwardly absorbed figure of *Girl Asleep at a Table*, and those with which the young woman in *Young Woman at a Window with a Pitcher*, a barely embodied, almost weightless presence holding in place a world created by light, "steadies herself in the moment of rebirth."[27] The left hand of *Woman Holding a Balance* is the mature, supremely confident realization of those

161

60. Vermeer: *The Geographer*. 20⅞ × 18¼ in. Städelsches
Kunstinstitut, Frankfurt/Artothek.

more tentative gestures. The table on which it rests serves less as a physical support—the painting's values would suffer if one felt the woman to be leaning against it[28]—than as a metaphysical touchstone, an anchor for the mind.

The depth of thought that invests the woman's touch becomes evident when one compares *Woman Holding a Balance* with *The Geographer* [60] and *The Astronomer* [61], pendants from Vermeer's later period. The ges-

61. Vermeer: *The Astronomer*. 19¾ × 17¾ in.
Musée du Louvre, Paris.

tures of the three paintings are conceived in intricate relation. The male figures reach out through consciousness in an attempt to map, to encompass the limits of their world, to grasp the realm beyond as thought or image or microcosm; yet in doing so they instinctively tighten their grip on the material dimension that supports their speculations. The woman locates more intuitively (both in her measuring and by virtue of her presence) the center, the balance point, and, suspending it, gently touches down.

The difference appears gendered in Vermeer's mind (one could trace it all the way back to the asymmetrical couples of *The Procuress* and *Soldier and Young Girl Smiling*), yet complexly so. The gaze and gestures of *Young Woman at a Window with a Pitcher* [62], for instance, relate more obviously to those of the two male figures than to those of the woman with the balance (though both women are in a sense weighers). The young woman, like the astronomer, reaches out with her right hand, and, grasping a window's frame, brings an image of the outside in. (The blue sky and clouds seem visible less through the window's glass than in it—just one of the painting's many ambiguities.) With her other hand she grips the handle that an object and the inside world provide her. Her gaze, like the geographer's, drifts toward the light, but it eludes us in a way that his doesn't. One's first tendency is to regard her as looking out the window; but her line of sight, viewed more carefully, seems to fall somewhere within the span of her open arms. The more one looks the less one knows *what* she is doing. As one's commonsense understanding grows baffled, figurative perceptions begin to proliferate, involving her more primordially in her world. She becomes a conductor of light (or a source with rays); a span of attention; a bridge (and balance) between the inside and the outside, the visible and the invisible; a steadier of forms that are scarcely subject to gravity; an almost weightless presence using those forms to keep herself in place. One can even read her spread arms as having just opened the world before her, and herself as gazing—in a spirit that links her to the geographer and the astronomer—into the newly visible space between.

Such ambiguities recede in *Woman Holding a Balance*, where value is asserted in the light of last things, not first. External reality and human presence separate out from each other and reunite in an ethical relation. The tapestry that covers the table elsewhere in Vermeer is pushed back to reveal the thing itself, in its massive, indubitable solidity. The hand that rests on it receives infinitely more stable assurance of the world "out there"—the world toward which we reach—than the foot with which Dr. Johnson kicked his stone to refute skepticism's hold on him. Approached gently, out

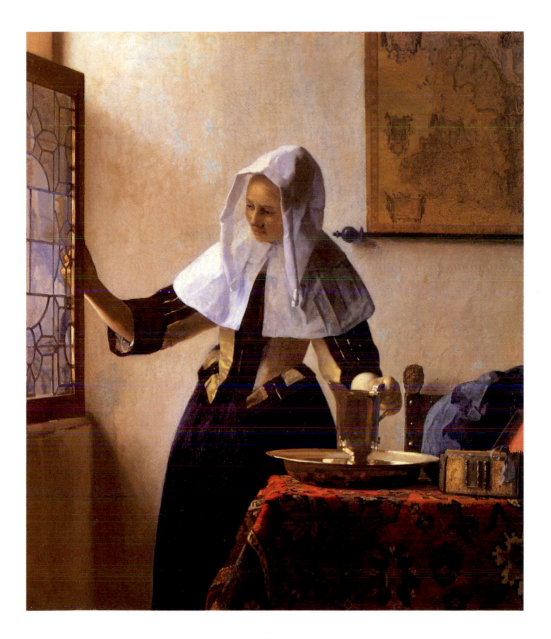

62. Vermeer: *Young Woman at a Window with a Pitcher*. 18 × 16⅛ in.
The Metropolitan Museum of Art, New York.
Gift of Henry G. Marquand, 1889.

of the self's assurance, external reality reciprocates (instead of merely re-isolating the self with the pain of a sore toe). The table appears almost to reach out to meet the woman's hand; at the same time it seems the objective counterpart of her own inner certainty.

And if material reality provides assurance for the woman of *Woman Holding a Balance*, it receives a spiritual value in return: as she places her hand on the table, her gesture is that of a benediction. One again has the sense of the culmination of an idea that has taken many shapes in Vermeer, from the exchange of qualities between the heavy earthenware pitcher and the touch of the woman who holds it in *Woman Pouring Milk* to the impersonal forms that become the coordinates of a world as they collect around the human figure of *Woman in Blue Reading a Letter*. There could scarcely be a greater contrast between this gesture and that of the Christ in the background of *Woman Holding a Balance*, whose upraised arms preside over the apocalyptic destruction of everything that is graced by, and abides in, Vermeer's art.

NOTES

PART ONE: *HEAD OF A YOUNG GIRL*

1. Lawrence Gowing, *Vermeer*, 2nd ed. (1952; New York: Harper and Row, 1970), 43.

2. Adrian Stokes, *Michelangelo: A Study in the Nature of Art* (London: Tavistock, 1955), 84.

3. Compare the riveting effect of Keats's untitled poem:

> This living hand, now warm and capable
> Of earnest grasping, would, if it were cold
> And in the icy silence of the tomb,
> So haunt thy days and chill thy dreaming nights
> That thou wouldst wish thine own heart dry of blood
> So in my veins red life might stream again,
> And thou be conscience-calmed—see, here it is—
> I hold it towards you.

The dynamic of this poem is similar to that of *Head of a Young Girl* [1] in so many respects—not least of all in the difficult "now" it thrusts upon its reader—that one feels that a common problematic of art and its relationship to flesh-and-blood experience must be involved. For an intriguingly relevant discussion of the "impossible imperatives" of the poem, see Jonathan Culler, "Apostrophe," *Diacritics* 7 (Winter 1977): 68–69 and *passim*. To bring Culler's discussion fully to *Head of a Young Girl*, one might remark that it is not only the author who addresses the reader in Keats's poem, but the poem itself, or the life in the poem, or the life from which the poem is taken that addresses the poet.

4. *Woman in Blue Reading a Letter* [2] is the only of Vermeer's interiors framed entirely against the rear wall of the room. The absence of floor, ceiling, or corner

enhances the sensation of a moment suspended in vision; yet it also underscores the capacity of the painting to accomplish itself as a world—to establish gravity, depth, interval, and with them a reassuring sense of space and time—without reference to the room's physical coordinates. (The left portion of wall resembles the open sky of *A View of Delft* [4] more than it does the rear walls of Vermeer's other interiors.) We take our bearings here ontologically. As the woman grows absorbed in her letter, she becomes a still point around which the image of a coherent, free-standing world can gravitate. The forms of that world—otherwise so disparate—respond by enclosing her in "an orderly coolness that nothing will disturb" (Gowing, *Vermeer*, 35).

5. It is often suggested that the women in *Woman in Blue Reading a Letter* [2] and *Woman Holding a Balance* [14] are not pregnant at all but merely dressed in accordance with the prevailing fashion of the 1660s, which makes all women's stomachs appear to protrude. (For the latest statement of this view see Blankert, Montias, and Aillaud, *Vermeer* [New York: Rizzoli, 1986], catalogue entry by Blankert, 181.) Yet Vermeer also paints thin-waisted women, such as the elegant standing figure of *Young Woman at a Window with a Pitcher* [62]. And in none of the similarly clothed women of Vermeer's contemporaries (De Hooch's *Woman Weighing Gold* [81], for instance, quite likely painted in imitation of *Woman Holding A Balance*) is the *idea* of woman's pregnancy communicated, as it is so powerfully in these two paintings by Vermeer. The atmosphere of each seems so pregnant—with a sense of life cherished, cradled, gestating around solitude—that to deny the actual pregnancy in which such feelings find embodiment is to resist the values the paintings generate. What needs to be resisted is the temptation to view Vermeer's pregnancies in the anecdotal, moralizing terms of his less complex contemporaries. One modern commentator, for instance, suggests that *Woman in Blue Reading a Letter* is "a variant on a familiar theme, practically the only context in which pregnancy is shown, the 'sickness without a cure' that ails the many languishing girls in Jan Steen's comic scenes of doctor's visits" (John J. Walsh, Jr., "Vermeer," *The Metropolitan Museum of Art Bulletin* 31 [1973], sec. 5). To perceive the quiet drama of Vermeer's standing woman in the context of Steen's "comic scenes" of "languishing girls" is to overlook precisely what *makes* the painting a Vermeer.

6. The regard of the standing maidservant can be seen as objectifying complementary aspects of this viewpoint from within the recessed scene. Note how her gaze, in its closeness and easy complicity, can edge perilously toward condescension

and detached amusement, even something like ridicule or contempt. In this its par-
adoxes are like those of the anecdotal view itself, which in its apparent interest in
the incidents that make up daily life tends to reduce everything it sees to a "variant
on a familiar theme." The maid's angle of regard may be innocent here (just as *The
Love Letter* [3] itself may be only playfully superficial), but the gaze in Vermeer
which hers resembles most closely is that of the male figure in *Woman Drinking
with a Gentleman* [17]. The latter gaze is probably the most negatively rendered
look in all of Vermeer; for a discussion see Part Two, "Painterly Inhibitions," pp.
40–43.

It might seem unlikely that a painter would paint so intricate a picture out of
ironical intent. But one of the things I hope to establish in this study is the elabo-
rately contrapuntal nature of Vermeer's oeuvre—and the existence within it of a
strong proclivity for negative reflection. His vision evolves largely in terms of a
preoccupation with what it is not, what it opposes, what counterbalances it, and
what, at each stage of its progress, it takes farther. I will argue later that the "fail-
ure" of *Allegory of the New Testament* [53] is also deliberate, and that its emptiness
as image stands in a similarly ironic relationship to *Artist in His Studio* [49], whose
enlivenedness it underscores by way of contrast.

7. See Gowing, *Vermeer*, 45.

8. I am indebted for some of the terms of this discussion to the work of Geoffrey
Hartman, especially "Maurice Blanchot, Philosopher-Novelist," in *Beyond For-
malism* (New Haven, Conn.: Yale University Press, 1970), 100–103, and "Spectral
Symbolism and Authorial Self in Keats's 'Hyperion,'" in *The Fate of Reading* (Chi-
cago: University of Chicago Press, 1975), 57–59, 65–66.

9. Compare Lacan's gnomic remark in "Of the Gaze as *Objet Petit a*": "When,
in love, I solicit a look, what is profoundly unsatisfying and always missing is that—
You never look at me from the place from which I see you." *Head of a Young Girl* [1]
makes us feel this moment—the meeting of identical gazes, the being-looked-at
from one's place of longing—and at the same time experience its absolute impos-
sibility. Lacan's discussion bears elaborately on Vermeer's painting: see *The Four
Fundamental Concepts of Psychoanalysis*, ed. Jacques-Alain Miller, trans. Alan Sher-
idan (New York: W. W. Norton, 1978), 65–127; the sentence quoted is on p. 103.

10. *Thus Spake Zarathustra*, Part Two, "Of Immaculate Perception," trans. R. J.
Hollingdale (London: Penguin Books, 1961), 145–56.

11. Gowing, *Vermeer*, 38.

63. Vermeer: *Woman Pouring Milk* (detail of 5).

12. Footwarmers appear frequently in the work of Vermeer's contemporaries, where they are always clearly identified and often in use, usually supporting a seated woman's foot. But Vermeer seems deliberately to have estranged the one in *Woman Pouring Milk* [63], both by its placement and by his bizarre optical treatment of its look. There was even a time when the footwarmer was taken to be a mousetrap: see Piero Bianconi, *The Complete Paintings of Vermeer* (New York: Abrams, 1967), 90. Though the basis for this identification was iconographic, one would like to think that the sense of strangeness that attaches to the object sublim-

inally reinforced it. As Irving Massey notes: "Objects . . . which have not been brought into the life of the mind . . . are the ones that create anxiety. We cannot forget them; they remain unabsorbed; in their neutrality there is something unassimilable and menacing" (*The Gaping Pig: Literature and Metamorphosis* [Berkeley and Los Angeles: University of California Press, 1976], 63).

Menacing or not, Vermeer's footwarmer does remain in some important sense "other." It and the milk pitcher require each other, not just as mundane objects but as metaphysical opposites, equally mysterious in their own ways. The one is held in hand, involved in transactions that sustain life, open to the viewer's humanizing impulses and willingly giving up its contents; the other is unused and without a necessary place, turned half aside and partially disclosing some obscure, inert form over which the eyes, regardless of what they know, must labor to visualize as a simple earthenware cup. (Note that cup's kinship with the pitcher: in both cases red earthenware surrounding a black hole.) The pitcher exists at the heart of a domesticated human world, whereas the footwarmer rests just outside that world's boundaries. (The figures painted on the tiles behind it are assorted itinerants, bearing their belongings on their backs.) As such the painting's entire dialectic could be said to depend on this weighted object. Note how the footwarmer supports the luminous expanse of emptiness that rises from it columnlike, just beyond the realm of things and tasks. (There is even an impression—especially strong since the painting's recent cleaning—of light and warmth radiating over the tiles' horizon line, like traces of a sunrise or a sunset—as if in some expanded metaphoric sense the footwarmer *were* in use.) This vacant, light-filled expanse of wall on the right is punctuated by a single hole, which, positioned directly above the footwarmer, reinforces the columnar effect, while at the same time establishing a counterpoint with the protruding nail on the left. In all these respects the footwarmer can be seen as a necessary counterweight to the accumulation of "world" that piles up as if in challenge to the wall's epiphany.

13. One critic even locates it in "oneiric" space: see Martin Pops, *Vermeer: Consciousness and the Chamber of Being* (Ann Arbor, Mich.: UMI Research Press, 1984), 1–26.

14. Gaston Bachelard, *The Poetics of Space*, trans. Maria Jolas (New York: Orion, 1964), 222.

15. Gowing, *Vermeer*, 26.

16. Gowing, *Vermeer*, 137.

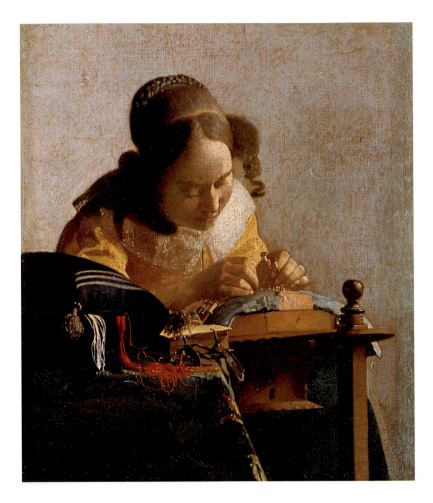

64. Vermeer: *The Lacemaker*. 9⅞ × 8¼ in.
Musée du Louvre, Paris.

17. The reference here and in the next paragraph is to the last scene of Shakespeare's *The Winter's Tale*, which enacts a powerful fantasy of stubbornly unrelinquished grief recovering the lost good object by resuscitating a work of art.

18. *The Lacemaker* [64] presents an antithetical statement of face and head and their relationship. In it the features seem molded from the head rather than stamped on it—as if they were its topography or terrain. The vision is of a benignly corporeal oneness of aspect, which encourages in the viewer an uncanny sense of coming close—as if managing to cross the threshold of the frame without breaking the membrane of the fiction. Consider Gowing's response: "weight and volume, the lovely bulk of the head, seem in their lucent translation almost within our measure. . . . We have come upon female life in its whole secluded richness: engrossed in itself it is seen entire and unimpaired" (*Vermeer*, 46–47).

Head of a Young Girl and *The Lacemaker*, in fact, are companion paintings in more ways than one. The absorption away from the viewer in *The Lacemaker* is intense in exact proportion to the absorption *with* the viewer in *Head of a Young Girl*. And both paintings entertain mirror-fantasies of an impossible coinciding—the one reflecting the artist in his gaze, the other in his work. Consider *The Lacemaker*: one imagines Vermeer applying paint to this small canvas with the same rapt, minutely focused attention his subject devotes to her labor (the support for her lace appears similar in size to the painting itself), his hand mirroring both of hers as it represents them and the area of their activity. I will suggest later that the painter in *Artist in His Studio* [49] is positioned between the two extremes that *Head of a Young Girl* and *The Lacemaker* define—his gaze transfixed by the distant model and his hand inches from the canvas, veiling and at the same time merging with the image it depicts. For a discussion see Part Two, "The Enigma of the Image," pp. 120–32.

19. It is as if the two components of the turban existed to give form to the spiritual tendencies of the colors they bear. Cf. Wassily Kandinsky: "If two circles are painted respectively yellow and blue, brief concentration will reveal in the yellow a spreading movement out from the center, and a noticeable approach to the spectator. The blue, on the other hand, moves in upon itself, like a snail retreating into its shell, and draws away from the spectator" (*Concerning the Spiritual in Art*, trans. M. T. H. Sadler [New York: Dover, 1977], 36–37).

20. Yet Vermeer's dialectic characteristically eludes this simple antithesis: for the white of the eyes reaches out with a value that exceeds in turn that of the pendant's yellow.

21. Only in the triangular area of the background bordered by the shoulder, the left cheek, and the straight line of the turban has Vermeer lightened the black and employed tonal contrasts that suggest the depths and shadows of three-dimensional space. It is largely in terms of this lightening effect that we read the roundness and withdrawn, recessive qualities of the head. The barely indicated nape of the neck acquires a special poignancy as one begins to feel what is at stake in this area of the canvas.

22. Cf. Paul Claudel, *The Eye Listens*, trans. Elsie Pell (New York: Philosophical Library, 1950), 274, 290:

> The pearl at the bottom of the sea is born all alone, of living flesh; pure and round, it frees itself, immortal, from that ephemeral being that has given it birth. It is the image of that lesion which the desire for perfection causes in us, and that slowly results in this priceless globule. . . . The soul, wounded and impregnated, possesses deep within itself, a device which permits it to solidify time into eternity.

23. The two quoted phrases form a couplet in Shakespeare's *Romeo and Juliet*; they are Romeo's response to his first sight of Juliet at the Capulets' ball.

24. Compare the opening stanza of John Donne's "A Valediction: Of Weeping," a text which voices, in its obliquity, many of the feelings to which *Head of a Young Girl* gives form:

> Let me pour forth
> My tears before thy face, whilst I stay here,
> For thy face coins them, and thy stamp they bear,
> And by this mintage they are something worth,
> For thus they bee
> Pregnant of thee;
> Fruits of much grief they are, emblems of more;
> When a tear falls, that Thou falls which it bore,
> So thou and I are nothing then, when on a divers shore.

25. Note the strangely contrived, perhaps even sardonic resolution of this motif in *Allegory of the New Testament* [65], where a transparent glass sphere hangs from

65. Vermeer: *Allegory of the New Testament* (detail of 53).

a blue ribbon tied to the ceiling of a room. For a discussion see Part Two, "The Enigma of the Image," pp. 135–38.

26. The line of this displacement is almost exactly indicated by the slant of the blue part of the turban. It is also reinforced by the pearl's gleam, positioned in the upper left so that it duplicates the gleam on the eye's iris, while at the same time pointing in the eye's direction, echoing its white. Indeed, these linking contrivances are so marked that one might be tempted to see the pearl as a transformed *eye*, removed to the area of listening, where it stares surrealistically from the void. Such a perception would reinforce the eerie relationship between the girl's features and

the faceless element around her. But Vermeer makes the pearl's liquid appearance so emphatic, and the sense of feelings still straining toward completion so strong, that one can scarcely dispense with the mediation of the "elided" tear. Whatever transformations *Head of a Young Girl* accomplishes seem initiated and infiltrated by grief. Even the song from *The Tempest* that provides an epigraph for this chapter ("Those are pearls that were his eyes") recounts a metamorphosis that takes place at the bottom of the sea, and the music that accompanies it comes out of nowhere to allay the grief of a son who sits "weeping again the king my father's wrack."

PART TWO: ART AND SEXUALITY

I · PAINTERLY INHIBITIONS

1. Huysmans's description of Degas's women exhibits the very compulsion to degrade that he claims to find in the paintings:

> The better to recapitulate her origins, he selects a woman who is fat, pot-bellied, and short, burying all grace of outline under tubular rolls of skin, losing, from the plastic viewpoint, all dignity, all grace of line; making her, in fact, regardless of the class to which she may belong, a pork-butcher's wife, a female butcher, in short a creature whose vulgar shape and heavy features suggest her continence and determine her horribleness!
>
> Here we have a red-head, dumpy and stuffed, back bent, so that the sacrum sticks out from the stretched, bulging buttocks; she is straining to curl her arm over her shoulder so as to squeeze a sponge, the water from which is trickling down her spine and splashing off the small of her back; here we have a blonde, thick-set, stocky, standing up, also with her back turned; she has completed her maintenance work and, with her hands on her rump, is stretching herself with a rather masculine movement, like a man warming himself in front of the fire, lifting his coat-tails. Then again we see a big, squatting lump leaning right over to one side, raising herself on one leg and passing an arm underneath, to catch herself in the zinc basin. The last of them, seen full-face for once, is drying the upper part of her belly.
>
> Such, in brief, are the merciless positions assigned by this iconoclast to the being usually showered with fulsome gallantries. In these pastels

176

there is a suggestion of mutilated stumps, of the rolling motion of a legless cripple—a whole series of attitudes inherent in woman, even when she is young and pretty, adorable when lying down or standing up; but frog-like and simian when, like these women, she has to stoop to masking her deterioration by this grooming (*Certains* [Stock, 1889]; quoted in Jean Bouret, *Degas*, trans. Daphne Woodward [New York: Tudor, 1965], 190–91).

Isolated in his maleness by these women who exist apart from him without regard for his presence, and no doubt threatened by the feelings of vulnerability they arouse in him, the critic's latent misogyny emerges, which he displaces onto the artist, and then celebrates as iconoclasm. (Huysmans is exceptional in this last regard. Most contemporary critics projected the same lavish misogyny onto the paintings, but expressed outrage at finding it there.) The act of description becomes an elaborate defense mechanism, reasserting with a vengeance the male animus—and with it mastery over the image—that Degas disempowers. For a more elaborate analysis (both social and psychological) of this response, see Charles Bernheimer, "Degas's Brothels: Voyeurism and Ideology," *Representations* 20 (1987):158–86.

2. In recent years commentary on Degas's nudes has begun to grow more complex: see especially Norma Broude, "Degas's 'Misogyny,'" *Art Bulletin* 59 (1977):95–107; Eunice Lipton, *Looking into Degas: Uneasy Images of Women and Modern Life* (Berkeley & Los Angeles: University of California Press, 1986), 151–86; Carol Armstrong, "Edgar Degas and the Representation of the Female Body," in *The Female Body in Western Culture: Contemporary Perspectives*, ed. Susan Rubin Suleiman (Cambridge: Harvard University Press, 1986), 223–42; and Charles Bernheimer, "Degas's Brothels" (see note 1 above for complete reference). But the old stereotypes still thrive. For a recent instance see Bram Dijkstra, *Idols of Perversity: Fantasies of Feminine Evil in Fin-de-Siècle Culture* (New York: Oxford University Press, 1986), 286–88, who views Degas's nudes as unrelentingly misogynistic and praises the acuity with which contemporary critics like Huysmans perceived the painter's true intentions.

3. Elie Faure, *History of Art: Modern Art*, trans. Walter Pach (1924; rpt. Garden City, N.Y.: Garden City Publishing Co., 1937), 394–96.

4. François Mathey, *The Impressionists*, trans. Jean Steinberg (New York: Praeger, 1961), 188–89.

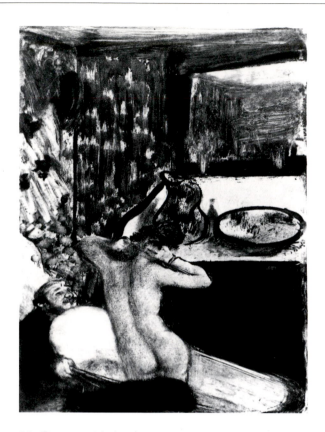

66. Degas: *Admiration*. Monotype, 8⁷⁄₁₆ × 6⁵⁄₁₆ in.
Bibliothèque d'Art et d'Archéologie, Paris.
Fondation Jacques Doucet.

5. In a few of his monotypes Degas does include men in spaces that belong to women. In almost every instance they are portrayed as uncomfortable and isolated, excluded by the black, funereal trappings that ensure their social and sexual status, in contrast to the uninhibitedness and disregard the women manifest in their presence. (See Bernheimer, "Degas's Brothels," 165–70, for acute analyses of several of these monotypes.) Openly self-contemptuous images of male desire often appear in the monotypes, especially in the ones depicting brothel scenes. Yet even in the most disturbing [66], it is remarkable how free the portrayal of the women themselves

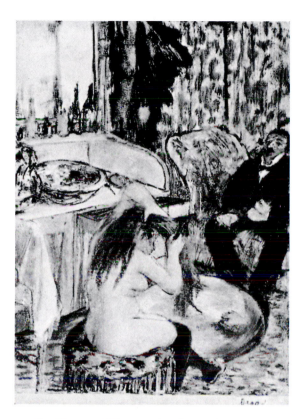

67. Degas: *Woman Combing Her Hair*.
Pastel over monotype, 8⁷⁄₁₆ × 6⁵⁄₁₆ in.
Location unknown.

tends to remain from the projections of masculine inhibition and its retaliatory animus. (In this they differ profoundly from Manet's *Olympia*, Cézanne's *A Modern Olympia* and *The Eternal Female*, or even Picasso's numerous variations on the theme of isolated male attendance on oblivious and/or all-encroaching female presence.) In *Woman Combing Her Hair* [67], for instance, the woman's open, uninhibited presence is rendered simply, directly, even perhaps tenderly, and certainly without any mediating animus; indeed, even the dark feelings about the transfixed male self—as sexual desirer, bourgeois commodifier, maintainer of proprieties—are

strangely lightened. Degas seems almost to enjoy the discomfiture of the suitor with whom as a man he is so complexly identified. The sense of humor may seem on reflection cruel, but it manifests itself in the image as wryly sympathetic. The mood of the whole could even be described as acceptant and self-forgiving; yet the split between the artist who conceives the situation and the erotically motivated male who lives it seems absolute, and the vision offered would seem to deny any possibility of intimacy, sexual or otherwise, between men and women.

6. "From Poetic Realism to Pop Art," *Modern Language Notes* 84 (1969):672.

7. The source for Vermeer's arrangement has long been recognized as Jacob van Loo's *Diana and Her Companions* [68]. Vermeer intricately reorganizes the Van Loo—condensing seven figures to four, gathering up disparate gestures and three distinct groupings into a single self-absorbed scene. The force of the arrangement transforms a centrifugal into a centripetal dynamic (the dog plays a key role here), strips away everything mythological except the scene of looking, and insinuates into the pagan moment a subliminal Christianity. It is a vivid paradigm for the elaborate responsiveness to the work of his contemporaries that underlies the private, idiosyncratic nature of Vermeer's early work. Especially interesting is the metal basin and the crumpled towel made to resemble a bird drinking from it at the bottom edge of the painting. The *trompe l'oeil* aspect of this detail seems uncharacteristic of Vermeer, and lacking in rationale, until one notices that it replaces a dish in the Van Loo filled with two very real but dead birds. Viewed in the light of this replacement, the detail suddenly seems pregnant with themes most intimate to Vermeer: the life of things, as opposed to the inertness of a gross naturalism; the vivifying play of artifice; art's own reparative impulse, as it attempts to exorcise death and brute fact with metaphors of a chaste purity; and the disguised traces of mortality that survive into the work of art—as a kind of authorial secret, perhaps the other side of that immaculateness and unpenetrated hush which Vermeer cultivates.

8. All of Vermeer's early paintings could technically be called "genre scenes," but the term will be used in this study to refer only to *Woman Drinking with a Gentleman* [16], *Gentleman and Girl with Music* [18], and *Couple with a Glass of Wine* [21].

9. Lawrence Gowing, *Vermeer* (1952; New York: Harper & Row, 1970), 52.

10. The order in which *Woman Drinking with a Gentleman* [16], *Gentleman and Girl with Music* [18], and *Couple with a Glass of Wine* [21] are discussed here is the

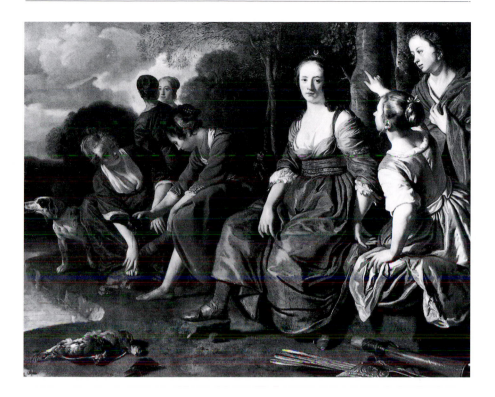

68. Jacob van Loo: *Diana and Her Companions.* 52¾ × 63¾ in.
Bode Museum, Berlin.

one most commonly assigned them in recent editions of Vermeer. (For a convenient summary of the order in which all the paintings appear in the major editions of Vermeer through 1975, see Christopher Wright, *Vermeer* [London: Oresko, 1976], 82–85.) None of the three paintings is dated; the development under discussion is conceptual, not chronological. *Woman Drinking with a Gentleman* does give the impression, both in idea and execution, of being the earliest of the three; while *Couple with a Glass of Wine*, with its almost schematic elaboration of themes the other paintings more indirectly embody, seems likely to have been painted last. But all three obviously belong to the same moment in Vermeer's oeuvre, and they could be arranged in any sequence without affecting the interpretation here. (For a different interpretation based on a different sequence, see Martin Pops, *Vermeer: Con-*

sciousness and the Chamber of Being [Ann Arbor, Mich.: UMI Research Press, 1984], 41–46.) In terms of size, as well as design and color scheme, *Woman Drinking with a Gentleman* (25½ × 30¼ in.) and *Couple with a Glass of Wine* (30¾ × 26½ in.) are obvious pendants (cf. especially the identical leaded-glass windows), while the smaller *Gentleman and Girl with Music* (14½ × 16½ in.) relates to *Soldier and Young Girl Smiling* [37] (19 × 17 in.), which is usually dated earlier than the other paintings. The similarity in size between the latter paintings reinforces the visual link discussed in note 16, below.

11. Pierre Descargues, *Vermeer*, trans. James Emmons (Geneva: Skira, 1966), 128.

12. The man's posture seems an explicit adjustment of the suitor's in *Woman Drinking with a Gentleman* [16]—almost as if they were moments in a sequence. At the same time, his position with respect to the woman—his left arm encircling her, his right hand, thumb up, almost touching hers, recalls the openly erotic embrace of *The Procuress* [31]. Notice also the illusion of continuity between the sheet of music and the white garment on the woman's lap—possibly another suggestion of the sublimation involved in music-making.

13. Harry Berger, in an interesting discussion of *Gentleman and Girl with Music* [18], applies Gowing's description of the expression on the face of the model in *Artist in His Studio* [49] to that of the woman who looks at us from the earlier painting: "She both invites the painter's attention and as tenderly wards it off" (Gowing, *Vermeer*, 54; Berger, "Conspicuous Exclusion in Vermeer: An Essay in Renaissance Pastoral," *Yale French Studies* 47 [1972]:255). Yet what is so unsettling about the look is that it neither invites the artist's attention nor wards it off. The expression of *Artist in His Studio* is part of an elaborate solution to the problems that the gaze of *Gentleman and Girl with Music* exacerbates.

14. Both Berger and Gowing refer to the painting as *Girl Interrupted at Her Music*, but seem to assume that it is the man within the painting who has interrupted her (Berger, "Conspicuous Exclusion," 254–55; Gowing, *Vermeer*, 48–49, 113–18). Yet this contradicts most viewers' immediate sensation of being themselves the interrupter of a scene quietly and intimately in progress. It also suggests the way the scene, like some of the others involving male presence, conspires to split the viewer, placing him simultaneously on opposite sides of the viewing threshold. (The effect is analogous to those optical illusions in which single contours outline simultaneous gestalts—e.g., vase and facing profiles—between which perception can only alternate.) Hence the tendency to take the look that confronts us as a displaced response

to the represented male's attention and feel the intimacy of the scene interrupted from within.

15. For a discussion of this motif in the work of Vermeer's contemporaries, see E. de Jongh, "Erotica in Vogelperspectief. De dubbelzinnigheid van een reeks 17de eewuse genrevoorstellingen," *Simiolus* 9 (1968):22-74.

16. The chair in *Woman Drinking with a Gentleman* [16] belongs to the world of things; in *Gentleman and Girl with Music* [18] it suggests a human absence. Its position in the extreme foreground of the latter painting recalls the chair of *Soldier and Young Girl Smiling* [37]; perhaps there is a subliminal memory of the behind-the-back consciousness its finials represent in the (probably) earlier painting. If so, has the man departed from this consciousness and crossed fully into the space of the painting, where he now leans over the object of his attention, unaware of the finials' continued gaze? Or has he receded to the place of the artist/viewer to haunt the scene of his absence, still subject to the woman's look? The finials will continue to pose the issue of the viewing threshold even in the later works that seem to have resolved it. In *Woman Tuning a Lute* [69], for instance, they are rapt listeners. And in *Young Woman at a Window with a Pitcher* [62], the faint shadow that reaches up toward the right sleeve of the woman unmistakably takes the shape of the lion's-head finial seen in profile—companion to the one against the back wall facing forward. Here the motif grows especially mysterious. What real object could possibly cast this shape? Surely not the full-face finial within the scene. Is it projected from where *we* are, a last remaining trace of the shadow-casting consciousness this light-filled painting seems to have totally vanquished? Or is it a spectral memory within the frame of all those early onlookers?

17. Compare the elaborately revised disposition of the standing and seated figures in the much later *Woman Writing a Letter with Her Maid* [70]. Here, where the two figures are female, and no importunate male intrudes (though a communication is still the basis of their exchange), Vermeer's dialectic grows benign.

18. This object has been identified as both a spiraling serpent (held by Dialectia) and as reins and/or a bridle (held by Temperantia); see Blankert, Montias, and Aillaud, *Vermeer* (New York: Rizzoli, 1986), 178, for references.

19. The mawkish expression on the woman's face is probably partly due to, or at least falsely accentuated by, a faulty restoration. Yet it is in harmony with the painting's overall mood and conception. An active distaste for the transaction in which the woman is involved seems the painting's organizing principle; her look can

69. Vermeer: *Woman Tuning a Lute*. 20¼ × 18 in. The Metropolitan Museum of Art, New York. Bequest of Collis P. Huntington, 1925.

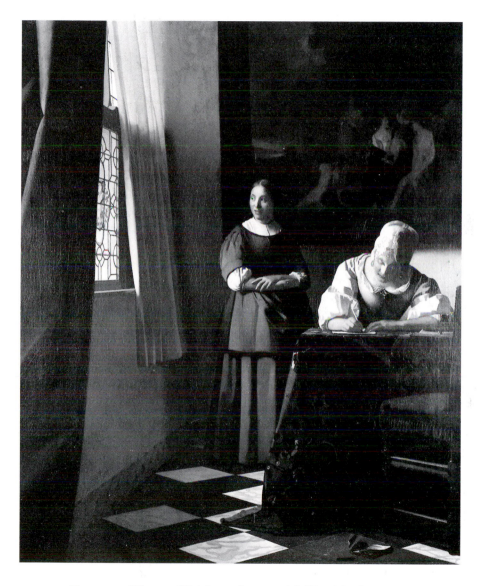

70. Vermeer: *Woman Writing a Letter with Her Maid.* 28 × 23¼ in.
Collection Sir Alfred Beit, Bart., Blessington, Ireland.

scarcely be a matter of accident. In its original form, however, it may have elicited from the viewer something more complex than mere aversion. Gowing's account of the force with which she meets the viewer's eyes—"as if in appeal to be released from the oppressive charade" (*Vermeer*, 117)—comes close, and could easily be assimilated to the reading of the painting being offered here.

20. *Girl Reading a Letter at an Open Window* [23] and *Girl Asleep at a Table* [25] are usually dated slightly earlier than the three genre scenes. Although the stylistic evidence for this chronology is tenuous, I do not mean to question it in speaking of changes that take place in the transition from the paintings of couples to those of single women. The beginning of Vermeer's oeuvre is marked by alternation rather than clear-cut development (the first two paintings, *Christ in the House of Martha and Mary* [54] and *Diana and Her Companions* [15], already embody the two poles of his thought), with the scenes involving interaction between the sexes outnumbering those of female solitude eight to three. Although the difference between *Girl Reading a Letter at an Open Window* [24] and the three genre scenes is essentially conceptual, it does prefigure the development that evolves over the long course of Vermeer's work: after *The Concert* [39] and *Couple Standing at a Virginal* [44], men and women will share the same space in only one of the subsequent paintings—and then equivocally, in *Artist in His Studio* [49].

21. There is disagreement over what the attitude of the central figure is meant to signify. In the 1696 sale, the painting was catalogued as "Een dronke slapende meyd aen een tafel" ("a drunken sleeping maid at a table"). More recent iconographic investigations have identified it variously as the grief of disappointed love and as the sleep of Idleness or Sloth. But the pose seems calculated to elude whatever frame of reference one brings to bear on it. Vermeer seems interested in portraying a state of self-absorption in which opposites converge: sleep and wakefulness, dream and conscious reverie, abandonment and concentration of self, full and empty consciousness, withdrawal and continued presence. For further discussion of the deliberate ambiguity of the painting, see Part Three, "Meaning in Vermeer," pp. 148–52.

22. Gowing, *Vermeer*, 51.

23. Madlyn Millner Kahr, "Vermeer's *Girl Asleep*: A Moral Emblem," *Metropolitan Museum of Art Journal* 6 (1972):127.

24. X-ray photographs of *Girl Asleep at a Table* [71] reveal the head and shoulders of a man wearing a hat in the place now occupied by the mirror, and a dog standing

71. Vermeer: *Girl Asleep at a Table*
(X-ray detail of 25).

187

in the half-open doorway, looking intently into the concealed space of the background room. The painting is thus a transitional piece in the literal sense: we can observe Vermeer through these uncharacteristic revisions substituting a direct imaginative involvement with his subject matter for a mediated, ambivalent representation of it. In the process certain impediments to his vision disappear. The dog in the original composition both directs and prevents passage over the threshold. It represents curiosity and desire yet stands alert against them. (In *Diana and Her Companions* [15] this same dog is a self-absorbed onlooker, oblivious to the viewer's presence; the alerted animal planned for *Girl Asleep* is like a memory-trace of the Van Loo *Diana* [68] which Vermeer's earlier painting revised.) It is almost as if in deciding to leave certain moods and feelings disembodied, Vermeer opened up the pathway through that door and in the process discovered the pull of space itself, an attraction tangent to the erotic theme.

II · TWO EARLY PAINTINGS

1. We know that Vermeer's mother-in-law owned the Van Baburen *Procuress* [40]. Vermeer depicts it twice: first in *The Concert* [39] and then again later in the London National Gallery *Young Woman Seated at a Virginal*. The painting seems to have served for Vermeer as a touchstone for clarifying his own viewpoint; for further discussion see Part Two, "The Enigma of the Image," pp. 92–96.

2. John Walsh, for instance, reproduces a *Merry Company* by Isack Elyas next to Vermeer's *Procuress* [31] and comments that in the former "a background painting of the destruction of man by the Flood makes the moral lesson explicit: beware indulgence": see John J. Walsh, Jr., "Vermeer," *The Museum of Modern Art Bulletin* 31 [1973], sec. 3.

3. We have already seen how this woman is the precursor of those solitary, Madonna-like women who culminate in the weigher of *Woman Holding a Balance* [14]. There are also iconographic precedents (which of course *could* be interpreted ironically) for her purity and capacity to reassure. Her lovely clear glass, for instance, whose transparent content differs so pointedly from the toasting cavalier's murky wine, is an attribute more proper to an Eyckian Virgin than a Steenian whore. Pellucid carafes like this were among the most frequent Marian symbols:

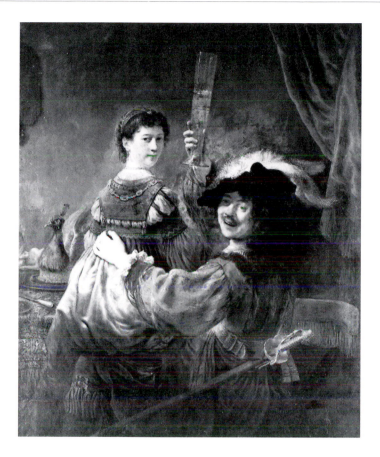

72. Rembrandt: *Self-Portrait with Saskia (The Prodigal Son in the Tavern)*. 63⅜ × 51⅝ in. Staatliche Kunstsammlungen, Gemäldegalerie, Dresden.

see Erwin Panofsky, *Early Netherlandish Painting*, vol. 1 (Cambridge, Mass.: Harvard University Press, 1953), 144 and reproductions.

4. The figure has often been compared to Rembrandt's depiction of himself in certain engravings (see Piero Bianconi, *The Complete Paintings of Vermeer* [New York: Abrams, 1967], 87) and in his *Self-Portrait with Saskia (The Prodigal Son in the Tavern)* [72]. An equally striking resemblance has recently been pointed out

between Vermeer's figure and a fictionalized self-portrait in Frans van Mieris's *The Charlatan*. (For the latter see Blankert, Montias, and Aillaud, *Vermeer* [New York: Rizzoli, 1986], 40.) Such evidence suggests that by the late 1650s this face, with its nonspecific evocation of Rembrandt, had become for Dutch artists an almost generic type for self-representation.

A complicated iconographic tradition that depicted an artist in his studio playing a lute or violin instead of working at his canvas was in vogue among Vermeer's Dutch and Flemish contemporaries. The underlying theme, according to Hans Joachim Raupp ("Musik in Atelier," *Oud Holland* 92 [1978]:106–28), is the conflict between the artist's vocation and the temptations of worldly, hedonistic indulgence. The conventional valences are both complicated and reversed in *The Procuress* [31], where sexuality bestows the worldliness—here positive rather than negative—from which the artist-figure—grasping lute handle rather than brush—is cut off. One wonders if Rembrandt's portrait of himself with Saskia might not be *his* attempt, within this convention, to invert the prodigal son theme, and declare himself for life, not art. *The Procuress* would then become a critique (as if taking Saskia's perspective, and elaborating on her look) of what makes that declaration protest too much.

5. Vermeer's inspiration here seems to derive from his Utrecht predecessors: compare Van Couwenbergh's *Brothel Scene* [73], in which a lone figure on the left, isolated from the erotic interplay of a couple to his right, holds a tobacco pipe in his hand and gazes disconsolately toward the viewer.

6. The gender of this figure is ambiguous; iconographically uninitiated viewers tend to divide evenly between those who view it as male and those who view it as female. I have opted for the feminine pronoun because the figure seems to me to play the procuress to the woman's prostitute, and hence fulfill one of the expectations of the typical brothel scene (cf. [40] and [74]). But the gender cues seem deliberately ambiguous, and as such allow for two different and equally suggestive readings of the left-to-right procession of the figures: either man-man-man-woman or man-woman-man-woman.

7. Gowing discusses the contemporary device of "enclosing the composition with a darkened figure outlined against the light," which he regards as part of the "common stock" of the painters of Haarlem; see his *Vermeer* (1952; New York: Harper & Row, 1970), 104–5. Walsh ("Vermeer," sec. 2), refers to the Utrecht artist Gerard van Honthorst's "trick of lighting in which a candle silhouettes a man and

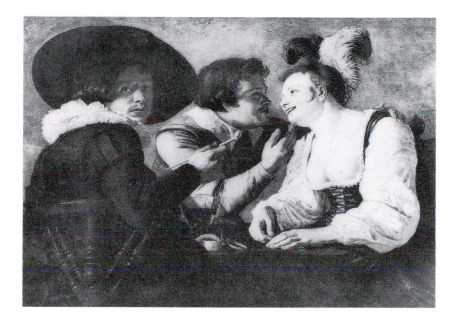

73. Christiaen van Couwenbergh: *Brothel Scene*. 43⅝ × 30⅜ in.
Formerly private collection, Belgium. Present location unknown.

casts brilliant light on a smiling girl." The *Procuress* by Van Honthorst [74] that
Walsh reproduces so closely resembles Vermeer's *Soldier and Young Girl Smiling*
[37] that one is tempted to regard it as a direct source upon which Vermeer works
complex adjustments: bundling up the young girl in modesty (while preserving
almost exactly her face and its eager, radiant expression), pulling back the two par-
ticipants into their respective spaces, increasing the discrepancy in age and size,
"blocking" the man's extended arm, shifting the open palm from the man to the
woman, replacing the haglike procuress with the chair's finials. To posit icono-
graphic awareness of the Van Honthorst (especially with its over-the-shoulder pro-
curess) in *Soldier and Young Girl Smiling* would strengthen the link between the
latter painting and Vermeer's own *Procuress* [31].

8. There are many subtle variations in Vermeer on this motif of a detached,
reflective presence or half-presence in the background or hovering over the shoul-
der of a figure absorbed in the immediacy of the moment. The employment of the

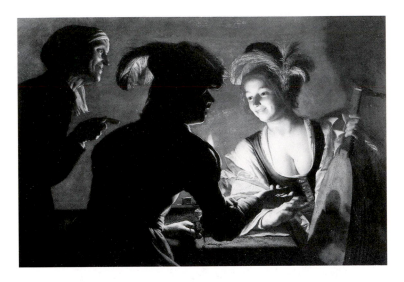

74. Gerard van Honthorst: *The Procuress*. 28 × 41⅜ in.
Central Museum, Utrecht.

lion's-head finials in the early paintings, the reflection in the window of *Girl Reading a Letter at an Open Window* [23], the half-open door with its mirror in *Girl Asleep at a Table* [25], and the twin-aspectness of the figures in *Couple with a Glass of Wine* [21] and *Woman Writing a Letter with Her Maid* [70] have already been discussed; the mirror-image in *Couple Standing at a Virginal* [44] and the place of the viewer in *Artist in His Studio* [49] will be treated in the next section.

9. P. T. A. Swillens notes that a "strong perspective divergence" is generally characteristic of Vermeer's paintings, and in some instances is even more pronounced technically (though not affectually) than in *Soldier and Young Girl Smiling* [37]: see his *Johannes Vermeer, Painter of Delft, 1632–1675*, trans. C. M. Breuning-Williamson (New York: Studio Publications, 1950), 98. But Harry Berger ("Conspicuous Exclusion in Vermeer," *Yale French Studies* 47 [1972]:258) is surely right in claiming that the effect is not, as Swillens suggests, to give the spectator the illusion of being in the room, but rather "to assimilate the officer more closely to our space and remove the girl in her radiant cubicle farther from us."

10. Compare, for instance, the bent arm and hand of the cavalier in De Hooch's *Backgammon Players* [75]. Gowing discusses some of the conventions upon which

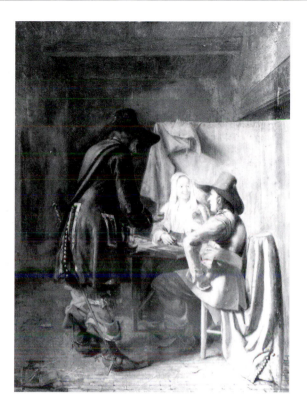

75. Pieter de Hooch: *Backgammon Players*.
18⅛×13 in. The National Gallery of
Ireland, Dublin.

the painting is based and reproduces an interesting series of paintings by Vermeer's contemporaries in *Vermeer*, 104–9.

11. Walsh, "Vermeer," sec. 2.

12. Berger, "Conspicuous Exclusion," 260.

13. Maurice Merleau-Ponty, *The Visible and the Invisible*, trans. Alphonso Lingis, ed. Claude Lefort (Evanston, Ill.: Northwestern University Press, 1968), 134.

14. Berger ("Conspicuous Exclusion," 259) notes this detail and interprets it in a similar light.

15. The hole-in-the-canvas effect has already been noted in connection with the hat of the cavalier in *Woman Drinking with a Gentleman* [16]; it is even more pronounced in the hat of the painter in *Artist in His Studio* [49]. All these black hats stand in opposition to the aura that emanates from Christ's head in what may be Vermeer's first painting, *Christ in the House of Martha and Mary* [54]. It is as if Vermeer spent the rest of his career revising this early work's conception of the sexes.

16. See James A. Welu, "Vermeer: His Cartographic Sources," *The Art Bulletin* 57 (1975):532.

17. Ludwig Goldscheider, *Jan Vermeer: The Paintings* (London: Phaidon, 1958), 19.

18. Berger, "Conspicuous Exclusion," 259.

19. Gowing, *Vermeer*, 51.

20. Berger, "Conspicuous Exclusion," 258.

III · THE ENIGMA OF THE IMAGE

1. Neither *The Concert* [39] nor *Couple Standing at a Virginal* [44] is dated. It is unclear whether *The Concert* is the earlier of the two paintings or a later variation. Their ordering in what follows is meant to imply, as in the previous discussion of the three genre scenes, a conceptual rather than a chronological sequence.

2. A. P. de Mirimonde reads the painting in just these terms: see his "Les sujets musicaux chez Vermeer de Delft," *Gazette des Beaux-Arts* 57 (1961):42. An alternate interpretation, in which the standing woman becomes an embodiment of Temperance and the three musicians exemplars of "moderate" behavior, is attempted by Ignacio L. Moreno, "Vermeer's *The Concert*: A Study in Harmony and Contrasts," *Rutgers Art Review* 3 (1982):51–57.

3. The triangle that connects the two paintings with the man's strange head is further underscored by the way the black "halo" of the Van Baburen cavalier repeats the oval treetop in the landscape's sky, and by the way the progression of dark mosaic pieces in the Van Baburen's lower left continues the diagonal of the guitar player's sash.

4. Kaja Silverman has theorized about contemporary attempts to install a maternal figure in the place of the masculine superego, always at the level of sound; see her *The Acoustic Mirror: The Female Voice in Psychoanalysis and Cinema* (Bloom-

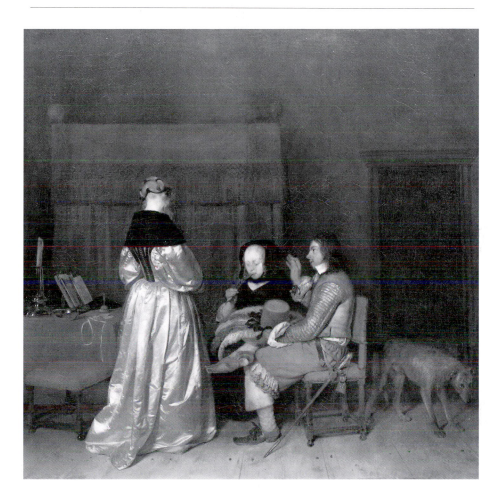

76. Gerard ter Borch: *Parental Admonition*. 28 × 28¾ in.
Rijksmuseum, Amsterdam.

ington: University of Indiana Press, 1988), especially the chapter entitled "The
Fantasy of the Maternal Voice," where she discusses French psychoanalytic theorist
Guy Rosolato's "dream" (as she calls it) of "substituting the mother's singing voice
for the father's prohibitory voice" (99).

5. The standing woman's gesture bears intriguing resemblances to the raised
hand of the man in Ter Borch's *Parental Admonition* [76], another painting of an

ambiguous threesome. Ter Borch's painting was long regarded as a domestic scene in which a father instructs his daughter while his wife deferentially lends her presence—hence the title, inherited from the eighteenth century and made famous by Goethe. Now, however, critics tend to view the painting as a brothel scene, though recently a claim has been made that it depicts a marriage proposal. (For the differing views see *Masters of Seventeenth-Century Dutch Genre Painting*, ed. Peter Sutton [Philadelphia: University of Pennsylvania Press, 1984], xlv, and the catalogue entry therein by Jan Kelch, 144–45.) All these interpretations are in a sense motivated by the painting; together they witness the milieu created by Ter Borch's special brand of nuance and ambiguity, in which razor-sharp readings of gesture and expression are required to negotiate and/or decipher hyperrefined social situations. One would like to know if Vermeer was familiar with *Parental Admonition*, and if so, how *he* viewed it: his concert trio elaborately revises Ter Borch's threesome, and his standing woman's raised hand, as if in specific response to the ambiguity of the other painting's central gesture, deftly steers clear of both admonitory and mercenary connotations. Certainly Vermeer knew and responded intricately to Ter Borch's work (we know the two artists were acquainted), which in turn probably took many of its cues from Vermeer's. The tilted wine glass in *Woman Drinking with a Gentleman* [16], for instance, if not a specific reference to *Parental Admonition*, is unmistakably "Terborchian" in its inflection, while the woman in *Couple Standing at a Virginal* [44], even though she may be mediated through a painting by Van Mieris, seems in even more direct relationship to her counterpart in *Parental Admonition*. It would be tempting to regard Vermeer's project, especially in the genre scenes, as an elaborate rejoinder to Ter Borch's—the one refining anecdote, the other emptying it to find new space. As the hand of the woman in *The Concert* [39] rises, it lifts clear of psychology and social situation and becomes a gesture of a different order.

6. Versions of this counterbalanced female pair, one standing, the other seated, appear throughout Vermeer, starting—as with so many of his preoccupations— with *Christ in the House of Martha and Mary* [54], extending to the trio of mistresses and maids whose relationship hinges on the writing, reading, or delivery of a letter (*The Love Letter* [3], *Woman Writing a Letter with Her Maid* [70], and the Frick Collection *Woman and Her Maid*), and culminating in the explicit pendants now in the London National Gallery, *Woman Standing at a Virginal* [20] and *Young Woman Seated at a Virginal*.

7. The virginal player's bodice is that of *Soldier and Young Girl Smiling* [37] and *Girl Reading a Letter at an Open Window* [23], while her skirt, her seated position, and her chair's back recall aspects of the three genre scenes.

8. Given *The Concert*'s [39] uncertain place within the oeuvre, this progression from left to right may either look forward to the achievement of the mature standing figures or reflect back on the development that led to them.

9. And would the landscape of his imagination be arcadian, bacchanalian, or unpopulated and wild?

10. Lawrence Gowing, *Vermeer* (1952; New York: Harper & Row, 1970), 44.

11. Gowing was the first to recognize this cropped image as a Roman Charity; see his *Vermeer*, 124–27. The specific painting has not been identified, but we know from an inventory that Vermeer's mother-in-law owned such a "painting of one who sucks the breast." The subject, well-known in the seventeenth century, originates from Valerius Maximus, and shows Pero suckling her father, Cimon, who is starving to death in prison. Gowing, noting that "it is difficult to put limits to the meaning of Vermeer's web of symbolism and illustration," calls attention to the fact that the name of the protagonist in the Roman Charity is also that of the ancient Greek painter supposed to have discovered perspective art (*Vermeer*, 126, n. 84).

12. The sense of a maternal replacement at the level of the superego is reinforced by the half-seen Roman Charity, in which the father, stripped, bound, condemned to death (and already decapitated by Vermeer's own frame), now nurses at the daughter's breast. The background paintings in Vermeer often suggest oblique meditations on the spirit that presides in the space they occupy. In his later *Woman Writing a Letter with Her Maid* [70], a space of shared female solitude is decorated by a large *Finding of Moses*—its protagonist the Old Testament patriarch and lawgiver, but in the pre-oedipal scene depicted still an infant, taken up into a female realm presided over by a pagan queen and her entourage—as if the hounded Actaeon outside the frame in *Diana and Her Companions* [15] had become in this late work the baby Moses received into the image.

13. Critics tend to respond to the absence of narrative in *Couple Standing at a Virginal* [44] by creating their own story of the painting. Thus Blankert cites approvingly de Mirimonde's "plausible" argument that "the two figures have played a duet and that the man has risen from his chair and put his bass viol down behind it" (Blankert, Montias, and Aillaud, *Vermeer* [New York: Rizzoli, 1986], 183). Such

interpretations are useful for the way they underscore the aspects of the image that resist them. Looking at Vermeer's painting, it seems inconceivable that there might be any moment other than the one which holds the couple now, that there might have been a narrative sequence leading up to the tableau in which they have their places, or that there might be routes within the dense mosaic which they (especially the man) are free to travel.

14. We have already noted Vermeer's use of condensed and extended diagonals in *Girl Asleep at a Table* [25], *Woman Pouring Milk* [5], and *The Concert* [39], and of long and short paths to the object of attention in *Soldier and Young Girl Smiling* [37]. *Girl Asleep*, Vermeer's first attempt at a dialectic of the imagination, provides an especially rich precedent for *Couple Standing at a Virginal* [44]: the condensed vector leading through an area of material density to the sleeping girl; the extended one through empty space into a sparsely furnished cubicle presided over by a mirror companioned with a cropped windowsill. Geoffrey Hartman's discussion of an imagination in the novels of Virginia Woolf "which can either actively fill space or passively blend with it and die" seems relevant to both paintings: see his "Virginia's Web," in *Beyond Formalism* (New Haven, Conn.: Yale University Press, 1970), 51–84; the quotation is on p. 73.

15. Gowing, *Vermeer*, 18.

16. Pierre Descargues, *Vermeer*, trans. James Emmons (Geneva: Skira, 1966), 81. The critic's remark sublimates elements of a wish fulfillment that is powerfully regressive: were we to sit down on the floor and magically find ourselves in the heart of the painting, we would also find ourselves (the use of the plural feels crucial to the fantasy) returned to children playing, with the tapestry's maternal lap nearby. It is notable that in the one painting by Vermeer where children are depicted, precisely this configuration appears. In *A Street in Delft* [47], a boy and a girl—yet another intense, solitary couple at right angles to each other—do sit down on the ground, playing on a tiled walkway at something typically undisclosed. In the doorway to their right, a maternal figure sits reassuringly at the dark threshold, absorbed in sewing or making lace. The romance of each music scene is imbued with this configuration of assurance: the seated couple of *The Concert* [39] subliminally participate in it, while the tense upright figures of *Couple Standing at a Virginal* [44] are haunted by it. In *Artist in His Studio* [49], it is the figure of the painter himself who, sitting down on his bench, magically finds himself in the heart of a painting.

17. Gowing, *Vermeer*, 46. This emphasis on the painting's inlay is especially striking in Vermeer's treatment of the vertical portion of the blue chair. As Arthur Wheelock notes (*Vermeer* [New York: Abrams, 1981], 102), its brass studs have been painted so thickly that they visibly protrude from the canvas—even though as a depicted object the chair recedes and locates the couple far back in the spatial envelope.

18. Martin Pops, *Vermeer: Consciousness and the Chamber of Being* (Ann Arbor, Mich.: UMI Research Press, 1984), 49.

19. Christopher Wright, *Vermeer* (London: Oresko, 1976), 11.

20. Gowing, *Vermeer*, 44.

21. The right hand of the man in *Couple Standing at a Virginal* [44] also recalls that of Christ in *Christ in the House of Martha and Mary* [54]; the woman's reflected aspect, moreover, angles toward him almost exactly as Martha bends toward Christ.

22. Gowing, *Vermeer*, 52. Forced by the woman's presence to extrapolate, we may or may not find the resulting variants of the inscription she blocks (*comes/consors, doloris/dolorum*) significant. But the fact remains that we must guess at what we cannot see, and that alternative readings are possible. Indeed, the woman's placement before the inscription tantalizes us with many interpretative themes: texts traversing bodies, bodies blocking texts, middles that must be inferred, ends that must be supplied, gaps that can be filled with different readings.

23. Gowing, *Vermeer*, 52.

24. The mirror image can even seem to see through the man to the bound hands behind his back. It is as if the nurturing daughter censored in the Roman Charity has moved inside the mirror, shorn of her maternal aspect, the vestige of a scandalous desire now gazing powerless and unacknowledged from the realm of images, a parallel aspect of the man's own unrequited gaze.

25. Though, again, such authorial fulfillment seems predicated on a tying of hands, and a censoring of the fantasy potentially visible on the right. If the mirror's glimpse of the painter's apparatus anticipates *Artist in His Studio* [49], the gaze it holds, admitted, confronted, responded to wholly, could easily become that of *Head of a Young Girl* [1]. One can read in the man's resisting stance an attempt *not* to feel that look, to keep his attention focused on the relationship at hand—his rigid posture (in contrast to the arching back behind him) a protection against feelings that threaten to invade him.

26. Bianconi, *The Complete Paintings*, 91.

27. I am indebted to Hal Rowlands for this perception.

28. Lawrence Gowing, "*An Artist in His Studio*: Reflections on Representation and the Art of Vermeer," *Art News Annual* 23 (1954):89.

29. The allegorical interpretations of *Artist in His Studio* [49] are summarized by Piero Bianconi, *The Complete Paintings of Vermeer* (New York: Abrams, 1967), 94, and James A. Welu, "Vermeer: His Cartographic Sources," *The Art Bulletin* 57 (1975):540–41.

30. The featureless rendering of the artist's hand can thus be seen as a thematic calculation on Vermeer's part, and not just the reflex of an idiosyncratically optical style. Vermeer, when he wishes, can model—or convey modeling's effect—as well as anyone: consider the mask on the table, the hand's opposite in so many ways. His treatment of the hand is also another index of his wry approach to the issue of the artist's virtuosity, and his ego-effacing attitude in this painting toward authorial status in general. One is reminded of the hand holding the brush in Velásquez's *Las Meninas* [77], a painting equally complex in its attitude toward authorship, virtuosity, and the capture of images. Indeed, these two hands, like the paintings themselves, might have been conceived in intimate opposition: the one hand poised knifelike in midair, its fingers merging with the brush they hold and with the brilliant lightning-strokes of paint that render both; the other (made to resemble unformed flesh, an instrument totally without volition or intelligence) resting on a maulstick, appropriated by the image as it works—or waits.

31. Quoted and translated by Welu, "Vermeer: His Cartographic Sources," 540.

32. The entire tableau, in fact, undergoes such a change. Just as Vermeer's paintings of solitary female subjects have a way of reaching back behind their contemporary genre-scene contexts to more solemn Eyckian occasions (annunciations, Madonnas pregnant or reading or enthroned, etc.), so *Artist in His Studio* [49] manages to invoke, in a way no other seventeenth-century depiction of an artist with his model does, the tradition of *Saint Luke Painting the Virgin*. The outmoded and the ghost of something sacred mingle, here as elsewhere in Vermeer. The model's blue shawl—once the Virgin's attribute—contributes centrally to this effect.

33. The tender embrace of these two colors—the model's taking them to heart—feels almost talismanic. It is like an emblem of Vermeer's own investment in them. Recall Van Gogh: "Do you know a painter called Vermeer who has painted, among other things, a very beautiful *pregnant* Dutch lady? The palette of this strange painter is blue, citron yellow, pearl gray, black, white. There are, certainly, on close

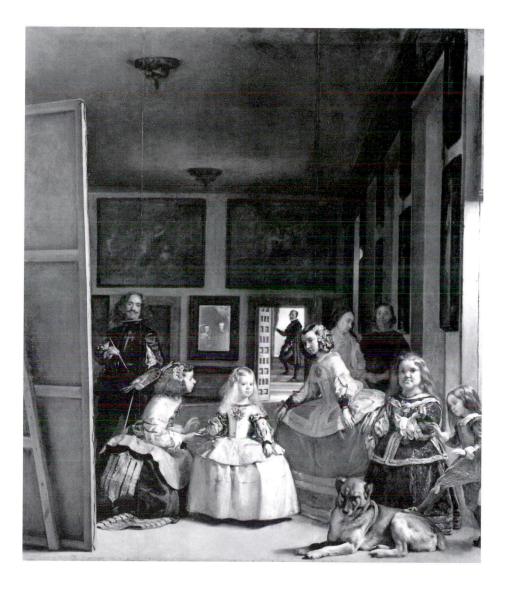

77. Velásquez: *Las Meninas*. 125 × 118½ in. Museo del Prado, Madrid.

examination, all the riches of a complete palette in his rare pictures; but the combination of citron yellow, pale blue, pearl gray is as characteristic of him as black, white, gray, and pink are of Velásquez" (letter to Emile Bernard, July 1888; see *The Complete Letters of Vincent van Gogh*, 3 vols. [Greenwich, Conn.: New York Graphic Society, 1958], 3:503–4).

34. Svetlana Alpers calls attention to this figure's presence in *The Art of Describing: Dutch Art in the Seventeenth Century* (Chicago: University of Chicago Press, 1983), 108.

35. The twinned leaves reappear in the shadowy part of the tapestry in the lower left foreground of *The Lacemaker* [64]. Their presence there, decontextualized and grown so large, seems more mythopoeic than decorative—as if they were the signature, countering the painter's own at the upper right, of the impersonal imaginative force (only nominally identifiable as nature) which weaves its purposes through the medium of the artist's intentions.

36. Thus another triangle linking painter, mask, and artist/viewer is grafted onto the one linking painter, mask, and model, so that we find ourselves at opposite ends from the model along a line bisected by another connecting painter and mask.

37. Vermeer's map reproduces (or gives the effect of reproducing) an actual one published by Claes Janz. Visscher [78], a single copy of which is preserved in the Bibliothèque Nationale, Paris: see James A. Welu, "The Map in Vermeer's *Art of Painting*," *Imago Mundi* 30 (1978):9–30. The city profiles that border Vermeer's map do not appear on the Visscher, though they may have originally been part of it. Delft does not seem to be among them.

38. Welu, "Vermeer: His Cartographic Sources," 541, n. 62; see also Pops, *Vermeer*, 64. The map's vertical axis is east-west rather than north-south (this is true also of Visscher's original), so that the country's coast is at the map's top.

39. Contemporary viewers would have also recognized a distinction between "chorography" (the detailed depiction of particular places) and "geography" (the mathematical projection of entire realms); for a discussion see Alpers, *The Art of Describing*, 133–35.

40. Alpers, in her analysis of *Artist in His Studio*, calls attention to Vermeer's juxtaposition of face and "profile," and connects it with the Ptolemaic analogy—illustrated by the Flemish geographer and surveyor Apianus with juxtapositions exactly like Vermeer's—between the mapping of a world and the picturing of a face.

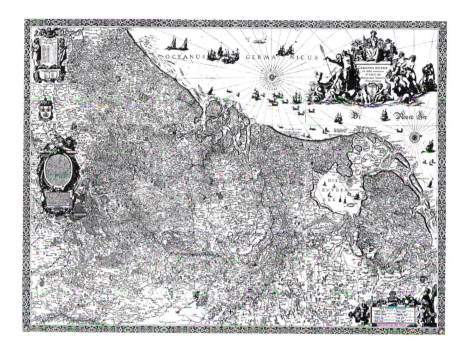

78. Claes Janz. Visscher: *Map of the Seventeen Provinces*. 43¾ × 60¼ in.
Bibliothèque Nationale, Paris.

Many of the speculations that follow owe their genesis to this moment in Alpers's
discussion: see *The Art of Describing*, 134, 167.

41. The link between the model's face and the map's oval is strengthened by the
way both have rectangular forms placed just beneath them. The oval and the rec-
tangle in Visscher's map contain lengthy descriptive legends (one in Dutch, the
other in Latin; for translations see Welu, "The Map in Vermeer's *Art of Painting*,"
27–28) that praise the Seventeen Provinces; the effect of omission or erasure in Ver-
meer's transcription is striking—as is the blankness of the model's book, which in
Ripa's formula for the Muse of History should be a volume by Thucydides.

42. Alpers, *The Art of Describing*, 167.

43. The phrase is Harry Berger's: see "Some Vanity of His Art: Conspicuous Ex-
clusion and Pastoral in Vermeer," in *Second World and Green World: Studies in Re-*

naissance Fiction-Making (Berkeley and Los Angeles: University of California Press, 1988), 485f. The sense of the model's face as located ontologically "between" the empty oval with its underlying canvas and the fleshy presence of the artist's hand is somewhat obscured by retouchings which have given the face a warmer, more conventionally painted look. One suspects that in its original form this face was more transparent to Vermeer's canvas, and conveyed something of the same liminal existence as the face of *The Lacemaker* [64]. See Gowing, *Vermeer*, 143, n. 117, for comments on these retouchings.

44. Balzac, *The Unknown Masterpiece*; for the passage and an interesting discussion, see Dore Ashton, *A Fable of Modern Art* (London: Thames and Hudson, 1980), 21. The question then arises: is this "decontextualizing" a function of the artist's project or our perspective? Does the depicted artist omit the map's background (deliberately or unthinkingly), or does it only frame her from where we stand? Perhaps from his angle he sees straight through that triangle-shaped aperture, and paints her against a light source or an expanse of blank wall exactly as he sees her.

45. Wallace Stevens, "The Man with the Blue Guitar," xiii, l. 1.

46. Where the model's blue shawl hangs over her right arm a similar phenomenon occurs. Just where we would expect its folds to fall behind and below the table, it drapes back winglike (shadows make the folds over her left arm behave similarly), so that an inlet of space appears between it and the mask lying on the table. But the visual effect is more complex. Vermeer has applied paint a bit more thickly in this inlet, so that it can appear a positive rather than a negative shape—as if the lower contour of the shawl were not its own but that of some other object which intervenes between it and the mask in an elaborate recession of planes. One eventually corrects this latter (mis)perception, but, once experienced, the effect of negative space cutting into the shawl continues to compete with that of the shawl unfurling gracefully against a background of wall. It seems appropriate that the model should be subject to the same effect of intrusion or erasure as her image taking shape on the depicted canvas.

47. The chair in the background counterpoints this effect: its seat and legs angle to the right, while its back lines up parallel to the wall.

48. One thus notices the way this artist is transfixed by the line extending from the top left of his easel down to the left legs of his bench.

49. A complementary fantasy asserts itself at the top of the depicted canvas,

where the map and the easel's descending legs meet its thin upper edge. The effect, rather than of one object in space blocking others that extend behind it, is of a sharp horizontal "cut" in representation. The edge seems to slice straight through the area above it, as if the artist were painting on a flap of overlapping canvas or on an area scraped clean. (The cropped legs of the easel, looked at long enough, will seem not just to terminate at this edge but rest upon it, even though as "cut" it has no thickness.) Against the reassuring fullness of the image, we are offered a momentary definition of the unframed canvas as a "dangerous supplement," as negative space with a vengeance.

50. Bianconi, *The Complete Paintings*, 94.

51. The negative funnel shape between the artist and model recalls the space between the man and woman in both *Couple Standing at a Virginal* [44] and *Soldier and Young Girl Smiling* [37].

52. Looking back to *Couple Standing at a Virginal* [44], we can think of the two figures of *Artist in His Studio* [49] as breaking the impasse of the earlier painting by (re)claiming its detached mirror image in their respective ways: the model internalizing it as her private image of herself posed before this man; the artist reaching out in that direction, not to make contact, but to paint his image of her on his canvas.

53. Sabine Eiche, "'The Artist in His Studio' by Jan Vermeer: About a Chandelier," *Gazette des Beaux-Arts* 6 (May/June 1982):203–4.

54. Irving Massey, *The Gaping Pig: Literature and Metamorphosis* (Berkeley and Los Angeles: University of California Press, 1976), 194–95. Vermeer's painting even *shows* us this underpinning, in the exaggerated scaffolding of the easel and in the webbing on the tapestry's reverse.

55. Harry Berger makes an elaborate and, to my mind, persuasive case for the ironical intent of *Allegory of the New Testament* [53], without referring to *Artist in His Studio* [49]: see his "Conspicuous Exclusion," 244–52. For a witty reading of elements of "hysteria" in the image (spilled blood, crushed snake, Faith's wide legs and "wild turning"), see Pops, *Vermeer*, 71–74.

56. One might say that the subliminal content of this painting is the obverse of that of *Couple with a Glass of Wine* [21]: if in the former the artist's posing of his model lurks beneath the depicted suitor's advances, here an impression of the depicted woman as having commissioned a pious allegory which shows her in her finery and is destined to hang in the living room where a Crucifixion temporarily

serves as prop, subversively underlies the allegorical scene. Even if one remains immune to this perception, the frequency with which commentators speculate about *Allegory of the New Testament* [53] as a commissioned piece seems remarkable. Consider, for instance, Blankert's attempts to account for what he regards as its "peculiarities": "Even if we understand the symbolism, it is unclear why the scene takes place in a fashionable Dutch living room. It would seem that Vermeer wanted to make a history painting of the type of *Mary Magdalene Forsakes the World in Favor of Christ* . . . while at the same time producing one of his own typical interiors. These peculiarities are most readily explained by the assumption that the subject was dictated by someone other than Vermeer himself, presumably the patron who commissioned the piece. The best candidates are the learned Jesuit fathers who lived a few doors down the street from Vermeer. The patron may well have been a wealthy Catholic of Delft, who, desiring a devotional piece, naturally turned to a fellow Catholic, Vermeer. Probably the patron was impressed by the use of allegory in *The Art of Painting*, which Vermeer still had in his home, and asked for an allegory of faith with a similar composition" (Blankert, Montias, and Aillaud, *Vermeer*, 146). This little story is sheer fantasy, of course, but it does seem poetically apt, though not quite in the way Blankert intends. The rich patron, impressed (like the critic) by what he sees as (no more than) "the allegory" of *Artist in His Studio* [49], orders one for himself, and gets exactly what he pays for. It seems that some such fiction of "painting for the others" is required to account for this painting's elaborately sardonic awareness of its own bad faith. (One might invent a similar story to account for *The Love Letter* [3].)

57. Vermeer's choice of objects is for the most part dictated by the descriptions in Ripa's *Iconologia* of "Faith": "Faith is also represented by a Woman, who is sitting and watching very attentively, holding a Chalice in her right hand, resting her left on a Book, that stands on a fixed cornerstone, that is to say *Christ*, having the word under her feet. She is dressed in sky blue with a crimson outer garment. Beneath the cornerstone a serpent lies crushed, and Death with his arrows broken. Next to this lies an Apple, the cause of Sin. She is crowned with Laurel leaves, which means, that we conquer by Faith. Behind her hangs a crown of thorns on a nail. Which all speaks for itself, needing little explanation. In the distance Abraham is also seen, where he was about to sacrifice his son." The dress and posture of Vermeer's figure have been derived from another of Ripa's allegorical figures, "Catholic or universal faith": "A woman dressed in white, who holds her right hand

on her breast, and in her left a chalice, which she regards intently." (For translations and references see Blankert's catalogue entry in Blankert, Montias, and Aillaud, *Vermeer*, 193.) Vermeer's hanging glass sphere, conspicuously missing from this iconography, has been related by E. de Jongh to an emblem book in which a similar object hangs from an angel's hand, illustrating (as the text explains) the human mind's capacity to encompass belief in God, just as a small glass sphere can reflect the universe (E. de Jongh, "Pearls of Virtue, Pearls of Vice," *Simiolus* 8 [1975–76]:74). The visual effect of all this iconographic overload, however, is a sense of things strewn and dislocated. A deliberate mindlessness seems at work in the construction. The glass sphere, especially, is not so easily explained by the discovery of a "source." It is held up not by an angel's hand but by a troublingly realistic blue ribbon, suspended from a fastidiously tied bow. And as Vermeer's own enigmatic addition to the allegory, it tends to haunt the scene more like a symbol of "vanity" than "belief." A virtuoso self-display of painterly skill competing side by side with the hanging Christ and feebly closed in above the grief of John; a hermetic "world" in which dabs of paint lead like a path far back to a bank of open windows where Vermeer's familiar, longed-for light comes through; a mirror reflecting the world that curves behind our backs—none of this rests very easily with the pious allegory of faith in which the glass sphere is suspended.

58. Here Vermeer's altering of the iconography seems especially sardonic. The cornerstone, no longer "fixed" beneath the book on which the woman rests her hand, appears to have been dislodged from the allegory, cast out into the tile periphery where its crushing of the snake seems the effect of a lucky hit. It indeed requires "faith" to read this inert slab as Christ.

59. Berger makes this point more elaborately; see "Conspicuous Exclusion," 249–50.

60. Gowing, *Vermeer*, 45.

61. For the obverse fantasy of painting as unrelenting consciousness (and thus "impossible" in a different sense), compare again Velásquez's *Las Meninas* [77], which turns the elements of *Artist in His Studio* [49] inside out. Note there the gaps—momentary yet unclosable—between canvas and artist, brush and palette, palette and canvas, and also the hand suspended in midair, between the image that turns its back on us and the authorial eyes that gaze out penetratingly—yet at the same time distractedly, as if lost in thought—toward their absent object, whose place we may or may not occupy.

62. Gowing, *Vermeer*, 141.

63. Bianconi notes that both the painter's "gala" costume and its immaculate appearance are in striking contrast to the way Vermeer's contemporaries normally represented themselves and their surrogates. Other art historians have found the style of the artist's clothing to be deliberately anachronistic, dating back to the fashions of the previous century or even to medieval times. (For references, see Bianconi, *The Complete Paintings*, 94). Very little visual evidence for this historicizing of the painter's costume has been offered, however, and it may be largely an attempt to rationalize the purely fanciful (or deliberately unbelievable) nature of his black-and-white garb. Nevertheless, to the degree that the costume does hark back to a bygone era, the irony of a painter—here a living anachronism—paying homage to the Muse of History is further underscored.

64. Massey, *The Gaping Pig*, 92.

PART THREE: MEANING IN VERMEER

1. *Artforum* 14 (1975):48.

2. John J. Walsh, Jr., "Vermeer," *The Metropolitan Museum of Art Bulletin* (1971), sec. 3.

3. Walsh, "Vermeer," sec. 3.

4. The seminal work in this area is E. de Jongh's; see his *Zinne-en minnebeelden in de schilderkunst van de 17e eeuw* (Amsterdam: Nederlands Openbaar Kunstbezit, 1967); *Tot Leering en Vermaak* (Amsterdam: Rijksmuseum, 1976); "Grape Symbolism in Paintings of the 16th and 17th Centuries," *Simiolus* 7 (1974):166–91; and "Pearls of Virtue and Pearls of Vice," *Simiolus* 8 (1975–76):69–97.

5. Madlyn Millner Kahr, "Vermeer's *Girl Asleep*: A Moral Emblem," *Metropolitan Museum of Art Journal* 6 (1972):127, 131. Kahr's essay offers an especially vivid instance of the way iconographers tend to discount differences as they correlate similarities. Consider the process by which Kahr establishes the woodcut illustration of Ripa's description of Accidia as "a possible direct source for Vermeer's Girl Asleep":

Ripa's specifications for the personification of *Vadsigheyt* (Indolence, Sloth) called for a seated old woman with her hand under her left cheek, holding a scroll with the inscription "Torpor iners. De traege Mensch is veddsigh." ("The idle person is slothful.") Her elbow is on her knee, her head inclined and covered with a black cloth, and in her right hand she holds a torpedo fish. (The idea that the body grows numb [*torpescere*] at the touch of the electric ray or crampfish, whence the fish was called *torpedo*, goes back to Pliny.)

Vermeer exchanged Ripa's old woman for a young one, had her support her head with her right hand instead of her left, and omitted both the scroll and the fish. None of these changes is surprising in a painting of this time and especially this master.

After all these changes, what remains of Ripa? The differences are so massive that the connection itself can seem a function of the critic's thesis. (And yet Kahr's essay is still considered exemplary by reigning experts in Vermeer. It is cited, for instance, as a "most careful study" in Blankert, Montias, and Aillaud, *Vermeer* [New York: Rizzoli, 1986], 172.) If we wish to find sources or analogues for the posture of the figure in Vermeer's *Girl Asleep* [25], we need search no farther than the meditative Mary of his own earlier painting. The closeness of these two figures should be enough to prevent us from viewing the *Girl Asleep* as unproblematically either drunken *or* asleep. From early on in Vermeer's oeuvre, internal developments tend to complicate and/or override external references.

6. Christopher Brown, *Simiolus* 9 (1977):56; review of Blankert, *Johannes Vermeer van Delft, 1632–1675*, with contributions by Rob Ruurs and William van de Watering (Utrecht & Antwerp: Uitgeverij Het Spectrum B.V. 1975), trans. as *Vermeer of Delft: Complete Edition of the Paintings* (London: Phaidon, 1978).

7. A. B. de Vries, *Vermeer*, UNESCO slides "Painting and Sculpture" series (Paris, 1969), 29, 36.

8. Compare the version by Erasmus Quellinus [79], which is probably the chief source for Vermeer's painting. The doors in the background, as well as the similarities in the handling of drapery and in the arrangement of the group of Christ and Mary, all suggest that Vermeer knew the actual picture; see Lawrence Gowing, *Vermeer* (1952; New York: Harper & Row, 1970), 80.

9. Walsh, "Vermeer," sec. 2.

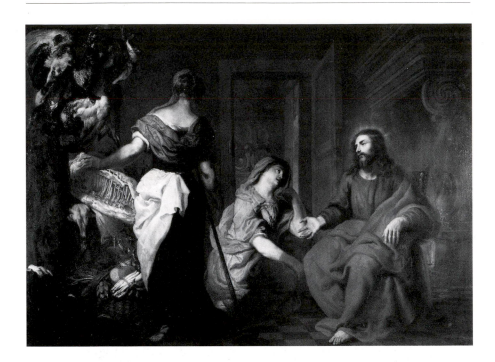

79. Erasmus Quellinus: *Christ in the House of Martha and Mary.*
67¾ × 95¾ in. Musée des Beaux-Arts, Valenciennes.

10. Vermeer's uniqueness in this regard can be gathered from the more typical Dutch treatment of the subject in the painting questionably attributed to Jan Steen [80]. The painter here too appears to be working from a direct knowledge of the version by Quellinus, but he modifies in the opposite direction—establishing and elaborating the narrative framework, littering the composition with emblematic objects, and stressing (however clumsily) both the ethical distinction between the two women and the didactic nature of Christ's gesture.

11. The subsequent course of Vermeer's oeuvre confirms where the interest of this early painting lies. Versions of the dialectic between Mary and Martha proliferate in his work, with the poles sometimes combining in solitary figures, sometimes separating into complementary pairs, and in the process unfolding its varied aspects: seated and standing, active and passive, offering (or transmitting) and re-

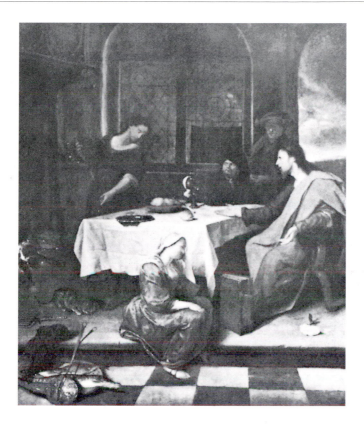

80. Jan Steen (?): *Christ in the House of Martha and Mary*. 41¾ × 35 in. Location unknown.

ceiving, withdrawn and immersed, meditatively disengaged and involved in the enterprise of making life cohere. The contrast is also between two modes of attention: one based on listening, the other on intense visual concentration that also involves the hands. The listening mode becomes especially interesting in Vermeer as it develops into something metaphorical and enters into combination with its opposite. Figures staring off into space or engaged in some task seem to be hearing something, as if audibly in touch with the invisible. The idea is worked out explicitly in *Woman Tuning a Lute* [69]; the two modes are overtly counterpointed in

Woman Writing a Letter with Her Maid [70]; and the fusion becomes most mysterious in *Young Woman at a Window with a Pitcher* [62].

12. Pointed out by Gowing, *Vermeer*, 92.

13. Simon Schama notes that in many Dutch genre paintings of "the drunken sleep" the free arm "dandles loosely but strategically at the crotch holding the attributes of the sleeper's folly: a pipe or a *roemer*": see his *The Embarrassment of Riches: An Interpretation of Dutch Culture in the Golden Age* (New York: Alfred A. Knopf, 1987), 208 and ills. 102–6. To the degree that Vermeer's painting does situate itself in relation to this genre (but there are other iconographies: note the arm that Mary lets "dandle" in her "crotch" in both Quellinus's and Steen's *Christ in the House of Martha and Mary* [79, 80]), his invention of the girl's *poised* hand, delicately in touch with the table, would seem an especially emphatic index of difference. Schama goes on: "Where the hand is empty, the debris of their pleasure lies beside them on a table, or haphazardly (and sometimes smashed) on the floor. Far more often the sleeper is observed by the mischievously awake who make him or her the butt of their ridicule or the object of their plunder" (*The Embarrassment of Riches*, 208–9). When one turns from this account of the genre to Vermeer's image, what one sees again is *difference*: no onlookers of any sort, no "debris," the clear wine glass scarcely visible and still containing wine, neither it nor the jug of wine sitting close at hand, and the latter clearly out of reach. None of this, however, is enough to prevent Schama from citing *Girl Asleep* [25] as merely a "variation" on the theme.

14. Walsh, "Vermeer," sec. 8.

15. Vermeer even seems to go out of his way to place the mirror too high on the wall to reflect the pearls at all. It is as if they would have to be slightly "raised up" in order to enter the mirror's realm. We can rationalize this perception, of course, by thinking of the mirror as tilting slightly downward, as of course all hanging mirrors do. But the visual impression persists, and gives subliminal force to the strangely moving lift of the woman's hands.

16. This downward pull, meanwhile, is counteracted both by the lift of the hands and by the subtle lilt of the painting as a whole.

17. Compare the earlier juxtaposition of mirror and window in the background space of *Girl Asleep* [25], where both seem so unresponsive to the gaze.

18. *Inside Out: An Essay in the Psychology and Aesthetic Appeal of Space* (London: Faber, 1947), 32.

19. Andrew Forge, "Painting and the Struggle for the Whole Self," 48.

20. Walsh, "Vermeer," sec. 8.

21. Hans Koningsberger, *The World of Vermeer, 1632–1675* (New York: Time, 1967), 152.

22. Walsh, "Vermeer," sec. 8; Koningsberger, *The World of Vermeer*, 152; Blankert, *Johannes Vermeer*, 64; Walsh, op. cit.; Arthur K. Wheelock, Jr., *Art Bulletin* 59 (1977):440; review of Blankert, *Johannes Vermeer*. Several commentators note the resemblance between the woman's jewel box and a strongbox. But before drawing moral conclusions, we should recall the same object's presence in *Woman in Blue Reading a Letter* [2] and *Young Woman at a Window with a Pitcher* [62], where it is part of an elaborate weaving of things open and closed, hidden and disclosed, containing and contained, weathered and pristine. In *Woman Holding a Balance* [14] the pearls veritably cascade out of their container, reflecting light like sparkling water. The strongbox seems willingly to give up its contents, which are not lost but welcomed by the light. If there is a counterpoint here, it may be with the woman's pregnancy, not with the transience of worldly things. And even if we relate the jewel casket to the painting on the wall rather than to the woman's presence, the more likely analogy is with graves opening up (to an epiphany of light, not to a Last Judgment) than with death claiming its due.

23. The area of the Last Judgment directly behind the woman is commonly occupied (at least in earlier Netherlandish painting) by Saint Michael in his role as weigher of souls. The woman's positioning before that painting could thus be interpreted as a subtle reinforcement of the Vanitas theme, her own weighing a reminder or mundane prefiguration of Saint Michael's apocalyptic role. But she seems to intervene more radically than this. Her presence blots out Saint Michael's place, makes it unviewable, nonexistent, on Vermeer's canvas. Rather than extending the background painting's vision into the mundane space of the room, her presence seems to superimpose on that vision an entirely different ethos of weighing.

24. For a discussion see Leo Steinberg, "The Skulls of Picasso," in *Other Criteria* (New York: Oxford University Press, 1972), 115–18.

25. This perception becomes especially compelling in an area where there is such an emphasis on hands—the woman's, the judging Christ's, those of the supplicants all around her.

26. As if this shadow hand provided the support—no longer an external necessity here—that actual hands provide in *Girl Asleep at a Table* [25] and *Christ in the House of Martha and Mary* [54].

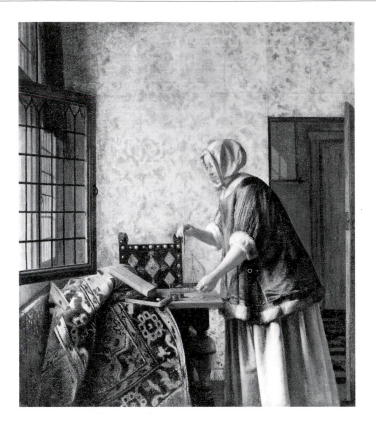

81. Pieter de Hooch: *Woman Weighing Gold*.
24 × 20⅞ in. Staatliche Gemäldegalerie, Berlin-Dahlem.

27. Gowing, *Vermeer*, 42.

28. As can be judged from De Hooch's treatment of the same subject [81], where the woman's bent posture (she seems pulled down by the scales' weight) feels like the negation of everything affirmative in the Vermeer. Comparing the two paintings makes one realize the degree to which Vermeer's weigher, even in her stillness, elicits a kinesthetic response: everything depends on our direct experience of an imperturbable center of gravity, a position back behind the place of weighing where the scales are felt (pleasurably) as nearly weightless—not so much pulling down the hand as counterbalancing its lifting impulse.

INDEX

Paintings by Vermeer are listed individually; page numbers in italics refer to illustrations.

INDEX